More Praise for *Honeymoon at Sea*

"Sailors, readers who would live the sailing dream through the pages of personal experience, and those who would navigate their own treacherous relationship waters to better understand their lives and the lure of travel will find *Honeymoon at Sea* especially revealing in its ability to traverse other cultures while exploring the nautical world's characters and challenges.

As she works on being fluent in Spanish and in the language of love and independence, Redmond finds she is growing into her prowess as a writer and a sailor alike. She brings her readers along for an unexpected foray into new experiences that will especially delight armchair travelers interested in stories of living simpler lives and experiencing such riches."

—Diane Donovan, *Midwest Book Review*

"In her poignant and entrancing memoir, *Honeymoon at Sea*, Jennifer Silva Redmond evocatively recalls the intrigue of an adventurous but lovely extended honeymoon spent sailing the beautiful but changeable waters of Mexico, imbibing exotic cuisines and locales, and wandering pristine empty beaches — each unique moment a morsel of savory goodness…her fascinating and exotic recollections evoke the dual mystery and pleasure of recent marriage and solo traveling with a truly loving partner. Together with brief flashes of personal history, her story reflects and illuminates the journey of life itself. More gratifying still, hidden beneath the surface of her wonderfully written words lies the heart-warming evocation of what it truly means to live."

—Joel Dennstedt, *Independent Books*

"Like a rolling ocean swell, Jennifer Silva Redmond's romantic sailing memoir sweeps you from the captivating story of her bohemian youth in Venice Beach through her years acting in NYC and into the welcoming arms of her husband, Russel. She tells the story in graceful prose, with the stark beauty of Baja California and the Mexican coast providing a colorful backdrop to her maiden voyage."

—Jeanine Kitchel, *Where the Sky is Born:*
Living in the Land of the Maya

"As enlightening as it is fun. I loved seeing the places I knew, and those I didn't, through her eyes, and feeling them in her heart. The author beautifully shares the spiritual journey that was a huge part of their physical journey. Her memoir increased my appreciation for life's adventures—especially for the complex simplicity of love."

—Ann Hazard, author of *Cartwheels in the*
Sand and *Agave Sunsets*

"If you've ever fantasized about living on a sailboat, read this. You will travel along with the author and her husband as they experience life and love in a paradise of their own making. This beautifully written book will entice you to live life more simply, understanding that the heart of an adventure is the manner in which you navigate it."

—Lori Oliver-Tierney, author of *Trudge:*
A Midlife Crisis on the John Muir Trail

"Jennifer Silva Redmond is in many ways a quintessential Californian; her family blends Mexican and Okie. She is secular yet spiritual, an aesthete born into the working class. But that's only the exterior of the story. As this candid narrative vividly chronicles, the author has done what most of us lack the courage to do: live life all the way up."

—Raul Ramos y Sanchez, *Mustang To Paducah; The Skinny Years*

Honeymoon at Sea

Honeymoon at Sea

How I Found Myself Living on a Small Boat

Jennifer Silva Redmond

Toronto, 2023

RE: Books

Copyright © Jennifer Silva Redmond.

www.rebooks.ca

Published in Canada by RE: Books.

ADDRESS:
re:books
95 Summerhill Avenue
Townhouse #10
Toronto, ON
M4T 1B1
www.rebooks.ca

First RE: Books Edition: September 2022

ISBN: 978-1-7389452-0-7
eBook ISBN: 978-1-7389452-1-4

Printed and bound in Canada.
1 3 5 7 9 10 8 6 4 2
Cover design by: Jordan Lunn

To Russel, for everything

"There is no solace on earth for us—for such as we—
Who search for some hidden city that we shall never see.
Only the Road, and the Dawn, the Sun, the Wind, and the Rain
And the Watch-fire under stars, and sleep, and the Road again."
—From "The Seekers," by John Masefield (1878–1967)

"If you want to get to know someone,
take a long trip in a small boat."
—My grandfather, Elmo Edward "Al" Shea





PROLOGUE

You Live on a Boat?

San Diego, California, October 2019

A FEW MINUTES AFTER SUNRISE, I climbed up the companionway stairs to feed the dog and check if the solar panels needed to be adjusted to catch the sun's earliest rays. Back down below, I used the foot pump to bring water from the tank tucked under the boat's settee to fill the teapot, lit the propane stove, and started making coffee and tea. My husband Russel is a coffee drinker and not a morning person, unless he's on watch and still awake from the night before. My own coffee habit was kicked when I first moved aboard a small sailboat at twenty-eight, fresh from New York City, where I'd been pursuing an acting career and waiting tables. This spring I turned fifty-eight, for those who care.

That first boat, *Watchfire*, was our home for almost fifteen years. We bought the Coronado sailboat we live on, *Watchfire 2*, in the summer of 2004. Most landlubbers would find our current boat, at 35 feet, to be less than spacious. But since we sailed to Mexico and Central America, went through the Panama Canal to Florida, and came back along the Intracoastal Waterway to Texas on a 26-foot boat, the extra space we have feels quite luxurious.

When I recount our first long sea voyage, the number one question people ask is: "How did you two get along so well in that tiny space?" My reply is always the same: If you are in love and like spending a great deal of time together, then a small boat

has room to spare. If you aren't thrilled to be with your partner 24 hours a day, then no yacht in the world is big enough.

This morning, after a quick breakfast, Russel logged on to the computer to start his morning class (he teaches screenwriting online at San Diego City College) while I put on my shoes. Up in the cockpit, our small mixed-breed dog Ready was already whining softly with anticipation. In minutes, Ready and I were loaded into our yellow Portland Pudgy dinghy, her on lookout position in the bow and me rowing.

I love morning walks, whenever we are able to get to shore. Russel and I have hiked along Baja ridgetops, over shifting Pacific sand dunes, and along muddy tropical paths—often accompanied by our canine companion. Ready, our second dog, has already served eight years before the mast.

This morning, a couple of tourists stopped to gawk as I beached the dinghy at Coronado Tidelands Park. They continued to ogle us as we got out of the dinghy and moseyed along the waterfront, playing fetch and taking in the beautiful morning. They soon caught up with us, and I prepared for the usual interrogation.

"Do you live on your boat?"

"Yes, I do."

"Is that—" the man pointed at the sandy herd of dinghies on the small beach, "the only way to get to shore?"

I explained it was possible to row (or motor) a dinghy around the bay to a dinghy dock, but that location wasn't as close to the park, bus, and grocery store.

He shook his head. "Well, you're young."

I gauged him to be ten years older than me, about Russel's age.

"Yes," I said, "and hoping to stay that way." This was delivered with a combination of wry smile and flexing arms designed to amuse.

"You ever *go* anywhere?" the man asked, a bit testily.

"We've sailed her up to Morro Bay and Monterey. Planning to head up to San Francisco Bay next summer."

We discussed the dangers of rounding Point Conception—clearly, he knew something about the California coast—and I admitted that we'd motor-sailed that whole day, after waiting a week for a perfect "weather window."

He said I really knew my stuff.

"I should. We started out in 1989, on a smaller sailboat. I didn't know a thing about sailing when we left here, heading to Cabo San Lucas as newlyweds. My husband called it a recipe for divorce. We planned to be in Baja for a couple of months and ended up staying in the Sea of Cortez almost a year before we went down to Panama."

"You go through the Canal?"

"Yeah, and on to Florida. We brought the boat back to San Diego in 1993 and then sailed down to Baja again in 1996. We love Mexico, but we both work from the boat, so we are staying in California for now."

"What did you do last night when it was so stormy?" This was from his companion, a petite, birdlike woman of about sixty.

"We closed the hatches and stayed inside," I said with a smile. "Boats are meant to keep the water out."

No reason to go into the sudden deluge at midnight and our wet scrambling in the boat's cockpit. Wrestling the unwieldy cushions down into the small cabin while half-asleep is a familiar challenge that never gets easier.

"Do you like living on a boat?" the woman asked, perhaps unaware she was shaking her head slightly as she spoke.

Do I like living on a boat?

A dozen images crowded my mind—from the practical hassles like hauling jugs of water and diesel across the muddy expanse of a low-tide beach, into the dinghy, and up onto the boat, or heating water to do dishes, to the sublime joys of basking in the cockpit on

a sunny day, admiring the ever-changing cityscape across the bay, or going sailing at a moment's notice.

I pictured the two of us snuggling together in our cozy v-berth as rain pattered onto the deck above us, our vessel secure on its mooring in the wind-tossed bay.

"No," I said with a grin, "I don't like it. I *love* it."

A Matter of Timing
January 5th, 1989

ASPRINKLE OF RAIN CAME THROUGH the open window as I pulled away from the curb. Russel stood there, watching me go. My lips hummed from his kisses. With the window rolled up, he became a blurry shape. Switching my foot from clutch to gas, I was grateful to concentrate on driving—living in New York City, you get out of practice. Clutch, shift, gas. Turning slowly at the next stop sign for one last look back, and tooting my horn at his distant form, I accelerated out of the turn. Clutch, shift, gas.

Clusters of faux-Spanish houses, their red tiles ruffled against the rain, lined the sloping street down to the Pacific Coast Highway. Looking past the highway to the flat blue line of the harbor was briefly disorienting; I was still a bit surprised to find myself in San Diego. Coming back for a family Christmas had seemed like the ideal way to take a break from thinking about my life and my future. Of course, that concept was shattered after today.

The last few hours with Russel already seemed unreal. But the car was real, and this busy freeway entrance certainly was. *God, look at the traffic.* As I merged into the slow lane my mind rejoined, *Russel is real, too, isn't he?* My mouth was dry, my lips still tender; my body was well aware of what was real—his mouth on mine. The jury was still out on his words.

The freeway was a mass of shifting metals and glass, slowly coagulating north. How had I let all that time go by today, knowing I'd have to fight traffic all the way to LAX? There was no way to have left any sooner.

I'd finally called him, after two weeks of telling myself I wouldn't—a friendly call just to see what he was up to. I'd found myself driving by his house a few times in the past week, trying to spot him or his old VW bus. Feeling ridiculous, like a kid with a crush, like the teenager I was when we first met.

Standing at a pay phone at the service station three blocks from his house, I held my breath and dialed the number I still knew by heart. He answered the phone in his usual way, "Russel Redmond," and I repeated it wonderingly, "Russel . . . Redmond." He knew my voice instantly, saying, "Snit . . . is that you?" The long-ago nickname he'd bestowed made me laugh my answer, that it was, in fact, me.

"I was nearby and thought . . . on the off chance—"

"Oh, Jenny, this is such bad timing."

He had plans he couldn't escape from, a dinner with big art patrons. He was committed to attending and was bringing a date. Big surprise. We made plans for breakfast, a good second place. Was his dinner date a woman? Naturally. Would the date go on past dinner? Would he be with her that night? I supposed so, but didn't ask, and tried not to think about *that*. I was awake most of the night, thinking about *that*.

I'd stayed at my grandparents. My grandmother, called Nena, knew something was up as soon as she saw me. Casually, I explained to her about the phone call to Russel and our breakfast date.

Nena did not look surprised, which surprised me.

"Be careful," she said. "You remember?"

I remembered.

In the morning, feeling hungover from lack of sleep, I managed to dress up more than usual without looking as if I'd tried too hard.

That was followed by an hour of pacing the wall-to-wall carpeting, drinking cups of Nena's weak Constant Comment tea. I left early, pleading errands. Driving the long way across the city on meandering, tree-lined residential streets still got me there a few minutes early.

He was already out front, hunkered down, back resting against a stucco wall. I waved and parked across the street, and then he was there beside me. We hugged like old friends and leaned against the car as I told him about having to pick my mom up at LAX that night, and how her Christmas trip to Hawaii had overlapped with my holiday vacation.

Then we kissed. I can't remember who started it, but we were kissing. First sweetly, then passionately, right there in the street. I hadn't wanted to stop, to think, to talk, and would have been happy to go on kissing forever. Finally, he took my hand and led me across the street and down the steps to his ground-floor studio.

Once we started talking, the hours disappeared. Instant friends again, co-conspirators, each other's greatest supporter and cheerleader. We talked about our work and our lives. His first big art commission was a bank calendar that showcased his many different styles of drawing and painting. The play I was co-producing and acting in was due to start rehearsals in a week.

A silence came over us.

"My heart is pounding," I said, looking into his eyes. "I'm so scared."

"I'm scared, too."

"Why?"

He smiled, shakily. "Because you're the only woman for me, you always were, and I'm afraid of losing you again."

My hands gripped the steering wheel as tightly as I'd held him, and I shivered with desire. My body knows what it wants. *But I want him in every way, not just physically.* The windshield wipers cleared the

view, but the rainwater came flooding back in a hundred tiny rivers. Rows of brake lights stretched endlessly at the junction of the two northbound freeways, their unreal scarlet glowing in the half-light of gray skies.

Settling back against the headrest, trying to unlock my shoulders and relax my rigid neck, I clicked on the radio. The traffic report detailed what anyone could see, and I snapped it off. Hours after a single margarita, I was far from buzzed, but my head ached.

We'd finally headed out to get lunch after talking through breakfast without saying anything definite. In his car, we were stifled, reduced to banalities.

"How do you like living in New York?" he asked.

I stumbled over something about it being fine and laughed. *New York, where is that? Oh, that place I used to live, now I live here in this VW bus with you.* I questioned him about his next commission, but couldn't hear the answer over the roaring in my head.

We had gotten pregnant while we were dating in 1984, despite using a diaphragm, and had agreed to terminate that pregnancy. Not long after that, he'd broken up with me, as gently as it could be done, but my heart was still broken. It was clear to me that I would be susceptible to him if I stayed in San Diego, and end up being either a friend with benefits—did I mention the sex was great?—or a pathetic mess.

After our five years apart, I was living in a great apartment on the Upper West Side with my best friend Jimmy and his lover, all set to star in a play Jimmy wrote, had gotten my Actor's Equity card, and had the best job waiting tables at a lovely French restaurant. I couldn't give all that up for a few nice words.

Walking across the central lawn at Old Town, Russel said something that implied a future between us, and I laughed.

"Cut the bull. We've been through this before. I want a home, a family, children, and you don't. It's simple."

"It is not simple, nothing's simple," he said. "I do want a family, I want you. We would be a family. And I want kids, too, someday, and a home as well. We have the chance to do all that, starting now."

"Starting now or someday? Come on, I know you."

Turning to me, he said, "You don't *know* me, you *knew* me."

I kept walking, silent.

That could be true.

We called a truce and ordered lunch out in the courtyard at Casa Bandini, complete with strolling mariachis and huge frozen fresh-peach margaritas. A gust of wind tossed the umbrellas around overhead. A light rain started, stopped, started again.

Over coffee, he asked if there was anyone in my life, and I gave him the whole story. I'd just broken up with a great guy after living with him for four years, and had begun seeing someone new, but it wasn't serious. Russel seemed relieved at that, so I tried to make the relationship sound more promising than it was.

He made me laugh with the story of running into my mom a few years prior and how she'd bragged about my career and my wonderful relationship.

"It was wonderful at that point," I protested. "Good old Mom."

He started in again, saying my mom has always loved him and that she was going to be so happy for us. I allowed myself to be swayed. The way he looks, the way he looks at me. I love him, I always have.

He wants me, but does he really love *me?*

As he drove us back to his house, I asked the question aloud.

Startled, he looked over at me. "You know I do," he said.

"How could I know that?"

"Because I told you." His eyes on the road, voice exasperated.

"You told me a *lot* of things."

I could see from his reaction that he was hurt. *Good, it was meant to hurt.*

We didn't speak again until he parked in front of his studio.

I got out briskly and walked toward my mom's car. "I have to be at the airport at seven, and now with the rain and all. . ."

"Jenny."

I stopped, clutching my things to my chest.

"Don't go yet." He put his arms around me, my purse and sweater between us. "We have important things to decide. When will you be back from LA, and when do you fly back to New York?" He talked into my hair, and I kept my face pressed against his shoulder.

Somehow we made a plan as he followed me over to the car, and I agreed to call him as soon as I was back from LA.

It was getting late, and the clouds made it almost dark by the time I was in my car and ready to go. I'd been rushing in an attempt to put off leaving. Clearing my throat didn't help shift the lump in it. *Don't cry.* Feeling exposed, I covered myself as best I could with a laugh.

He leaned in to look into my eyes, and the laughter died in my throat. We kissed goodbye, and I drove away.

I'd imagined our meeting so many times; this could be one more fantasy, or worse, some whim of his that won't survive the night.

Frustrated, I pounded the steering wheel, closed my eyes, and breathed in and out; I opened them, and was still there in stopped traffic. Still stuck.

Perhaps it was all a matter of timing, like he said, and now the time is right for us.

He said he didn't call because he cared too much, not too little. I never called him, either. But it was his move. His idea to break up five years earlier, supposedly to concentrate on his career. His plan was that we should take time off from each other and "see what happened."

Settled in New York, I left him a short message with my new number. He didn't call back. The ball was in his court, and it was easy to convince myself not to call again. Soon I was going whole days without yearning for him. Weeks of silence turned into months. When the months became years, even the thrilling ache of expectation was a dim memory.

During those five years I got a job, met a nice man, took acting classes with a brilliant teacher, lived with the nice man, got an even better job. Recently, I had moved out of my cool East River apartment and left my lovely relationship because I couldn't see where it was heading. Or because I could see *exactly* where it was heading. The nice man and I had never discussed marriage, but if we stayed together long enough, it was bound to happen. And marriage, as an end in itself, was not a goal of mine.

On my own, I'd begun to sense that anything was possible. I remembered feeling that way as a small child, but somehow, I'd lost the knack for it in my teens. Now I was, if not exactly confident, then *sure*, at least of myself.

But Russel kept surfacing in my mind. The man who got away. One day, simply to cheer myself up, I wondered aloud, "Maybe he thinks about me, too." Calling him from New York seemed too calculated, but from San Diego I could make a casual call.

That moment had been the catalyst that brought me all the way here. *Where the hell is that?* My laughter echoed loudly in the closed car. The traffic was moving, and I sped up. Suddenly, I couldn't wait to get to the airport, to see my mom and tell her all about this. Russel was right; she was going to be excited for us.

I'm excited for us.

Casting Off the Lines
San Diego, November 1989

SIX MONTHS AFTER OUR WEDDING, Russel and I left San Diego, heading for Baja California in his 26-foot sloop, *Watchfire.* Our plan was to head south along the coast to Cabo San Lucas, sail up into the Sea of Cortez for a couple of months, then sail east to New York City via the Panama Canal. After working toward the big day for months, we were forced to untie the dock lines and shove off, as my new husband said, "in order to stop the preparations."

At that point, my sailing experience was limited to day sails. We'd gone up to Mission Bay one weekend, and that was the only time I'd spent the night at anchor. Russel had coached me in the basics of sailing, first in a dinghy, and then in *Watchfire.* I'd taken the helm for a few hours on the bay. He saw my white-knuckle grip on the tiller and smiled reassuringly, saying, "You aren't flying an F-18, Jenny. *Relax.*" We'd taken a basic seamanship class at a local yacht club—quite redundant for Russel (he'd been sailing for twenty years), quite enlightening for me, a novice sailor. We'd even studied celestial navigation to learn how to steer by the sun and stars with a sextant, but our only practice in the art so far was off the Ocean Beach pier.

What made me believe I could go off in a 26-foot boat on a nearly thousand-mile trip at that point, I'll never know. I wasn't

afraid, though talking to friends could give me the willies, since they tended to talk about shipwrecks and pirates, and how to rescue oneself from them. My grandmother said it best when she remarked to my mother, "at least she's a good swimmer."

Part of the reason for my confidence was that Russel had been working on upgrading *Watchfire* for eight years, and sailing it, much of that time solo. If he could sail the boat upwind to Catalina by himself, he could surely sail downwind to Cabo with my well-meaning but extremely inexperienced assistance.

The first night was a test of my resolve. We sailed out to Los Coronados, two islands in Mexican waters only a few hours from San Diego, and anchored in the lee of the larger island, out of the breeze. The anchorage was what's called a *roadstead*, not a true bay, only a spot that is protected from prevailing winds. But the ocean swell wrapped around the island's point, rocking *Watchfire* from side to side all night, bringing this new reality home to me in a visceral way. Russel was up every hour checking the anchor, which didn't help settle my uneasiness.

The following morning at dawn, the sun came up huge and red. The seas were glassy calm, the skies clear, and a massive military ship could be seen against the fiery horizon. When I pointed it out, Russel said, "It's a Mexican destroyer," like he'd say, "That's a classic Chevy." His nonchalance was reassuring.

We used our trusty 8-hp Yamaha outboard to motor out from the anchorage, trying to catch the light morning breeze. Russel pointed out the paw-print-like wind ripples called "cat's paws." When he'd hoisted the mainsail, I shut off the engine from my position at the tiller. In the sudden quiet, he pulled out the big headsail and hanked it (fastened it with attachments called hanks) onto the forestay. Then he hoisted the sail with the halyard as I winched the jib sheet tight. I'd quickly learned to call the rope lines that run up the mast *halyards*, and those that run fore-and-aft *sheets*.

Soon we were sailing downwind toward Ensenada. I'd thrown together a very simple breakfast—the coffee was instant, to give an idea of my haste—and only steered for a few minutes while Russel put up the sails, but the morning had been exhausting. Propped against a full sail bag up on deck, I noted our anchorage and departure time in my journal, then leaned back against the sail bag in the weak sunlight. When Russel called out *honey, look,* I dutifully got up and stared out at the water where he pointed. Dolphins.

Dozens of dolphins broke the water with their sleek gray backs, chasing our wake, catching us, and racing alongside the boat. A few stayed and frolicked in the bow wake, taking turns riding the small waves on either side of the bow. We looked down at them and they looked up at us, smiling as if to say, *isn't this fun?* My spirits lifted as quickly as the last of the mist, and as the sun shone down brightly, I laughed aloud from sheer joy. I was at sea, one of two passengers on our very own boat, sailing into adventure.

Todos Santos Island, off Ensenada, was our first *real* landfall. Not only had it been night when we anchored at Los Coronados, but boaters were not allowed to land on the forbidding, rocky shores of those islands. Todos Santos, by contrast, looked as lush and welcoming as a tropical island, and we reached the tiny anchorage there on our second day with the sun still high.

This bay required bow-and-stern anchoring, so we dropped the bow anchor, which was all I'd seen used to that point, and revved the outboard in reverse to dig the anchor into the ocean floor. Then Russel rowed our inflatable Achilles dinghy over to the rock wall with a long coil of stern anchor *rode* (never called rope, since, as Russel says, "There's no rope on a boat but the rope you smoke"). He fastened the rode to a big metal ring set into the wall, as he'd done on previous occasions there.

As Russel was familiar with the anchorage, and since *Watchfire* was tied to the wall and could not drag anchor, we set off rather

quickly for shore. Hiking up the steep cliffs, we startled sea birds that dove at us screaming, but once they had chased us out of their territory and up onto the bluffs, we were able to wander unbothered.

Russel showed me, from a careful distance, the canyons where thousands of birds nested in spring; some lived there year round but he said the island would be covered with white at nesting season. We stayed well off those areas, afraid to foul them with human scent, and watched in wonder as pelicans dove off the steep faces of rock.

An hour passed as we wandered, then climbed to a high point overlooking our tiny anchorage. Glimpsed from atop the highest promontory, the scene below was an artist's dream. The sea sparkled, waves crashed foamy-white along the steep rocky sides of the island, faraway boats gleamed white on the horizon, and the city of Ensenada, a busy port, could only be glimpsed.

"Oh, damn it!" Russel said. "Freakin' powerboat. Wouldn't you know it?"

Indeed, a rather large motor yacht was steaming into our cozy cove. The skipper brought it about smartly and was soon backing down toward the ring in the wall.

A petite woman stepped into a small skiff and buzzed over to fasten their stern line. *Watchfire's* blue hull was dwarfed by the hulking white yacht, and our dreams of a romantic solo evening at anchor were shattered.

As the rays of sun shifted lower, we scrambled back down the path to our dinghy and rowed out to the boat. As Russel got closer, he recognized the boat and began to laugh. "Who'd of thunk it?" he said, "John Rains."

John Rains and his co-captain/wife Pat Miller were authors and two of the best-known West Coast delivery captains (experienced sailors who were licensed to sail or power a boat up or down the coast for a fee), and Russel had attended a seminar they'd presented the previous year.

The four of us said brief hellos, and then we rowed back to *Watchfire*, smug that we were in fine company and didn't need to worry about the many possible fiascos associated with novice boaters in a shared anchorage. Over a year later, the photo they took of our two boats in that bay graced the cover of a *Cruising World* issue.

* * *

Early the next morning, the toilet—oops, the *head*—wouldn't flush, at the exact time when you definitely need it to flush. Russel was sure that I had put something forbidden down it (you're never supposed to flush toilet paper), and my pleas of innocence went unheard.

Finally, he sat me down and said, "Okay, Jennifer, I promise not to get mad. Now tell me what you did!"

I burst out laughing at his patriarchal tone, and he soon saw the humor in it. The culprit turned out to be a nearly-finished-roll of toilet tissue that *fell* into the head and got stuck in the pipes. It was a dirty job to get it out, but we were still giggling over Russel's funny line when we motored out of our Todos Santos anchorage, bound for Punta Baja. At the tiller with a big smile on my face, I was sure our marriage was going to be okay, as long as we could always find the humor in circumstances when "shit happens."

Since the sea was flat calm and we were under power, Russel decided to troll for a fish. We had purchased a fishing pole and lures, not to mention an official Mexican fishing license, but we hadn't thrown out a line yet. After I set the auto helm to keep our course, Russel readied the pole and cast the lure into our churning wake. He let quite a bit of line out and was just fastening

the pole to the stern pulpit with a bungee when it bent nearly double. I slowed the outboard engine down and he reeled in our catch, a plump little tuna about a foot long; my guidebook to the common fishes showed it was a red-fleshed Mexican Bonita, quite delicious if cooked and eaten while fresh. He held it high as we shouted with glee. Less than 48 hours at sea and we were living the dream.

Unplanned Beginnings
1961–69

I WAS BORN IN 1961 AT the very end of the boom of babies. The last of three, I was, if not accidental, at least unplanned. My mom was Judy, and my dad was Jim; my brothers, born 51 weeks apart, were Joe and John. My parents named me Jennifer, but they swear the alliterative naming was, if not accidental, at least unplanned.

Married in 1957, my mother had, like the good Mexican-American Catholic girl she was, begun having children immediately—my oldest brother was born days before their first anniversary. Voluptuous since puberty, my mom found it hard to lose weight after childbirth and soon began to find solace in overeating. Being a housewife made it easy to indulge in binge-eating. At 21, she weighed over 350 pounds and struggled to cope with two toddlers and a baby.

My Anglo-Irish father may have had a drinking problem before he married, but a job and money brought time and opportunity for his booze hobby.

My parents had, as many couples do, very different styles of communicating. My mom was prone to yelling and throwing things when she got mad. My dad would go cold and quiet, usually leaving the room, and often the house. My mother's loneliness and her subsequent anger grew with each departure and, not too surprisingly, my dad began to stay away longer and longer.

Money was tight, another bone of contention. If my father disappeared on payday, we'd eat whatever was left in the cupboards.

Once, we had pancakes for breakfast, lunch, and dinner, and my mom made a game of it so that we kids laughed. My father, having been raised in a white, middle-class home, probably couldn't conceive of anyone going hungry. My mom was a child of divorce, who knew firsthand about eating beans and rice for dinner. And she wouldn't go to her mother for help, as Nena had been vehemently against her marrying so young.

My parents separated when I was three, and my dad got an apartment of his own. It was all one room with a tiny kitchenette and a bathroom with no bath, only a shower. My brothers thought it was really neat the one time we saw it. It looked like a big playhouse to me; the fact that he was moving out escaped my notice, perhaps because I hadn't seen that much of him on a day-to-day basis before that.

My brothers were my translators and ambassadors. There was no need to talk, as Joe or John could decipher my babblings and bring me what I wanted. They carried me around and played with me patiently. At almost three, skipping from baby talk directly to sentences, my first dinnertime comment was, "I don't want no green beans."

When my father was transferred to an office in Bakersfield the following year, my parents gave their marriage another try. We moved into a small square house on a block of houses that all looked the same. My dad bought us an above-ground pool to beat the intense heat. My mother found Overeaters Anonymous and began to shed the weight. She still hid herself in tent-like dresses, but she made a few friends for the first time in her married life. Having won a blue-water swimming medal as a teenager, my mom taught me to swim; she would swim in the backyard pool with me, but only if there was no one else to see her.

Feeling abandoned the first day my brothers both left the house to walk the few blocks to school, I was inconsolable. Mom told me

that I would soon be going with them, but I wanted to go *now*. No, she said, since my birthday was in May, I had to wait until September to start kindergarten.

Later that first lonely morning, my mom called me away from where I sat staring out the window. She'd set the kitchen table with my toy tea set and seated my dolls and toy animals around it. Wide-eyed, I watched her pour purple Kool-Aid for each guest and chat to them animatedly. I joined in the game and the rest of the day passed quickly enough.

In the weeks to come, my mom taught me songs from her high school musicals, and I gobbled up the music and lyrics. I loved costumes, no matter how simple. With a towel around my neck I became Mighty Mouse, and some dime store pearls made me a princess.

On the weekends, my brothers tolerated my constant tagging along. Having learned how to supply them with dirt clods for their "wars" against neighbor boys in the closest empty lot, I named myself the "Ammunition Girl." I improvised a song about "amminition" being my "dooty," dashing out into the middle of the fray to pick up unexploded dirt clods, utterly unafraid and lucky enough to never get hit.

My only memory of kindergarten is my first acting role as the Witch in *Hansel and Gretel.* I wore a gray wig and painted warts, and sang, "Nibble nibble, like a mouse, who is nibbling at my house?"

My parents had failed to find the happy family life they sought in suburbia, so in 1967 they agreed to start fresh in a very different place. Both were avid readers and had followed the writings of the Beat Generation and the birth of the hippies with scandalized admiration. Since nothing in their lives was working very successfully, including my dad, it was time to take a leap. They packed our few furnishings

in a U-Haul (we were already a peripatetic clan and traveled light), and we headed to Venice, California.

And that, Nena once said, "is when all the trouble started." She believed that the whole change in my parents' lives began with drugs. It is true that my mother's artist brother came back from a Navy stint, bringing pearls and knowledge from the Orient. He gave the pearls to Nena and got my parents stoned on marijuana for the first time. But drugs were only a part of their "joint" evolution, or maybe they were a symptom of it.

In the late 1960s, one of the hippest places in Los Angeles was Venice, especially the area known simply as "The Canals." Small wooden houses fronted on the waterways and backed on narrow alley-like streets.

My parents rented a small apartment near the school where I started the first grade. With her new curvaceous figure, my mom got a job as a cocktail waitress and moonlighted at Winchell's Donuts. She started taking voice lessons in Hollywood, and took me along in her convertible. I wandered the grounds of her teacher's "mansion," during class, spotting Dionne Warwick waiting for her private lesson.

My dad soon moved out again, this time for good, but just down the street. He grew his hair long, added a bushy beard, got a job as a baggage handler with Pan Am, and hung out at the beach with a group of hippie acolytes who called him "The Reverend." Sometimes he'd take us out for hot dogs or a movie, sort of like a doting uncle. He was a likable guy who never mastered behaving appropriately as a father, but I'd rather concentrate on remembering the few things he did right.

The summer of 1968 we practically lived at the beach, Joe and John and I, and only went home to eat and sleep. Ages nine, eight, and seven, we swam like fishes and could spend all day playing in

the surf and sand, or wandering the boardwalk. When we moved to the Canals, we lost none of this since it was only six blocks inland. However, the Canals were such a full world that leaving them, even for a day at the beach, was always hard.

In the Canals in those days, each house held at least one family, some two or three—sort of mini communes. The peak lifestyle to be achieved was to spend as little time as possible at work and devote yourself to matters of consequence—which could be anything from gardening to cooking to patching your jeans, all while pondering obscure political stances. There was much talk of the Vietnam War, and of peace.

The small house on Linnie Canal had two tiny bedrooms and a large backyard, and we loved it instantly. We moved in with nothing but clothes, books, and my beloved pink canopy bed. Blissfully unaware of how hopelessly middle-class it was, I slept in my bourgeois bed, while my mom put her mattress on the floor and hung an Indian print blanket on the windows that faced the alley. The final touch was a huge wooden cable spool. Laid flat, it formed a wide round table surrounded by big pillows, and we all sat around it on the floor in a nook off the kitchen, which became the gathering place.

My mom cooked constantly, seemingly with no effort. When people stopped by, plenty of thick soup, fresh bread, and salad appeared. She would stir a pot, carry on a phone call and a live conversation while listening to music and breaking into song.

People were captivated by my mother, by her beauty and energy, myself included. She looked like Joan Baez and could hold a roomful of people mesmerized as she read her poetry or talked about her dreams. Our house always had room for one more. Kids hitchhiking to a semester at Berkeley who needed a place to crash or coming home from the "summer of love" and not quite up to the reunion with the folks. They always moved on with a poem in their hand,

a new patch on their jeans, or a "new" tie-dyed shirt on their back. A few even had new names, courtesy of my mother, never one to stand on ceremony. "You don't look like a Richard," she'd say, and before they left, they'd become D'Artagnan. My mother made everything an adventure, and people were caught up in the drama and the fun.

A turntable sat on a cinder block and plank shelf beside the spool table, with two big stereo speakers on the floor beside it. One of my favorite activities was to lie there, head between the speakers, and fall into the music. Raised on reading, I became obsessed with lyrics. Most of our albums, including The Beatles' White Album, Crosby, Stills, Nash and Young, and Judy Collins, had lyrics printed on the album cover, but deciphering the meaning was challenging. What was a "harlequin," and why would it "hover nearby"? I invented stories to explain it all, my imagination fired by the enigmatic poetry.

Outside the kitchen door was a grassy, overgrown yard with fig trees and a path to the low white picket fence at the rear. I woke early, before even the ducks were awake and would creep out, barefoot and shivering, to the canal gate and stand watching the world come to life. Snooping was my joy; to be honest, other people's lives fascinated me. I would walk the dirt edge of the water and peek in people's yards and even, given the opportunity, their windows.

One neighboring couple even found me inside their house after I followed their Doberman-Weimaraner mix in through the dog door. I loved dogs, and the canals abounded with them, many roaming free in the alleys. I'd impersonated a canine from the time I was old enough to bark. A note in my baby book says in my mother's hand, "Jenny thinks she's a dog."

We listened to the moon landing on a transistor radio at the beach while we barbecued hot dogs. I toasted marshmallows and stared up at the big moon, imagining what was going on up there as the astronauts' voices were relayed to Earth. My brothers played at being spacemen as readily as soldiers, despite having "No War Toys,"

but space was scary. Picturing myself floating alone in blackness, I yearned to see my cozy little house.

Walking down the dusty alleys, we siblings joked about kids in what we called "Charlie Brown neighborhoods" who had every toy they wanted, but even as we envied them, we felt special. Taking our little oasis for granted, we never lost sight of its uniqueness. We thought at that time that the people we knew were leading the way, that all of us were. And soon the world would be a peaceful place of communal brotherhood.

We relished being different, revolutionary, and precociously political around adults, but at school we tried to blend in. Among the schoolyard gang we resented anything that marked us as outsiders, the hand-me-down clothes with patches and embroidery and our healthy brown bag lunches. I would trade my peanut butter and honey on whole grain for bologna on Wonder Bread. Apples and granola became Twinkies and Fritos.

As we walked the dozen blocks home, we transformed back into flower children. My braids were quickly undone; Joe and John shed windbreakers and untucked their shirts. Shoes came off last, sitting on the first canal bridge, pulling off our socks. We tied our shoes together by the laces and walked barefoot, our calloused brown feet nearly impervious from months of walking on hot sand and asphalt.

We sang the Beatles' anthems out loud, teaming up to harmonize and chime in with horn sounds. I knew that all we needed was love. We had that and never truly wanted for more.

Night Passage
November 1989

THE FIRST FEW NIGHTS OUT, we anchored each evening since Russel wanted to make the trip easy on me for as long as possible. Anchoring after a long day's sail was heavenly, even in a desolate cove. Tucked snugly behind a headland, the water was calm, though the boat rocked gently. Soon it was normal to cook with the stove tilting slightly all the while. I'd stocked plenty of food for a month or more, until we reached Cabo San Lucas, and made up some casserole-type dishes of chicken, rice, and veggies for the first few nights. Mostly, we were too tired to do much except heat, eat, and fall asleep. Lulled by the movement of the boat, I slept deeply and well.

Each day I grew more confident steering and helping to raise and lower the mainsail and jib. We had six different headsails, one for every weather condition, but on the way down the coast with a strong, steady breeze, we mostly stuck with the biggest and heaviest. Once we had the sails set for the day, we could lounge in the cockpit, talking over the day's run and planning the next leg of our journey. We had chosen our anchorages months earlier, while dreaming over Baja charts, but left some choices for later, once we saw how my skills developed.

When Russel pointed to the flyspeck on our chart that was the Islas San Benito and suggested we make it our next stop, I was captivated. We'd read about the colonies of elephant seals and sea

lions on the islands and knew the anchorage was well protected. The photos showed a village with a tiny white church on a hill. When I realized that the plan would mean an overnight voyage, I was only briefly daunted. "I have to take a solo watch eventually," I reasoned. "It might as well be now."

Early the next morning we hoisted the anchor, and soon we were sailing with a brisk breeze, racing before the swells under a clear sky. At noon, with land completely out of sight, we brought out the sextant to find our position through celestial navigation (no GPS back then). We'd easily divided up the two tasks of this age-old method of navigation: Russel "shot the sun" by looking through the sextant and bringing the bottom of the sun down to the horizon, something I found nauseating. I did the arithmetic and figuring, something he found impossible. Marking a penciled "X" across our previous line of position, voilà, we'd found our latitude. We were heading straight for the tiny islands, though we wouldn't be able to spot them until the next day.

That afternoon, we took turns at the helm as usual, but I was constantly aware that I'd be alone at the tiller that night. We decided on a rotation of four-hour watches from dusk to dawn. And I reviewed how to mark our speed and advance our running position on the chart. Russel wouldn't be far away while he slept, but I was determined to get through my solo shift without assistance.

All too soon, dinner was over, the sun was setting, and it was time for me to take the first watch. Russel kissed me goodnight and went below. In the fading light, I could just see his profile as he read in the forward berth. I stuck my head down a little while later and called softly to him.

"Don't worry, I'll be fine. Try to get some sleep. It'll be your turn soon enough."

The wind had died down from its peak earlier that day, but there was enough breeze to keep the sails pulling quietly.

The seas pushed us southward in gentle nudges every few seconds but hardly made a sound. The red compass light glowed faintly at first, then more brightly as I steered us toward our invisible destination. That wavering number would be my only constant for the next few hours.

The stars slowly appeared as the darkness deepened around the boat. Despite the fact that I was surrounded by miles and miles of open water, I felt suffocated and claustrophobic. I found myself holding my breath and tried hard to breathe normally. My ears strained for the sound of surf breaking on the jagged rocks I pictured in our path. Peering ahead, I tried to spot something, anything, while my mind conjured images of surfacing whales, sunken vessels, and uncharted reefs hovering below the surface of the black water.

As Orion rose in the sky, I wondered if astronauts feared the dark and whether they hated to turn off their interior lights at night to sleep. I tried to imagine what it must be like, floating in space so far from this little blue ball we call home. Not too different from floating on a dark sea, I guessed. But at least I could swim back to shore, if I had to.

Shaking myself out of this fearful reverie, I hooked up the autopilot and did a quick horizon check from on deck, turning in a full circle with my eyes focused on the line between sea and sky, checking for the lights of ships. The faint glow from our boat's running lights cast a golden halo on the water around us as we slowly moved through the shimmering water. Looking up, I could see an infinity of stars in their age-old patterns across the ceiling of the night. Their crystalline twinkling was extraordinarily bright this far from civilization's neon brightness.

Back in the cockpit, I checked the compass heading again. We were right on course. Noting our speed, I went below to mark our position on the chart and record our last hour's progress of four nautical miles.

Returning to my wooden bench, I stared skyward, waiting for my eyes to adjust to the lack of light. I concentrated on the swoosh of water along the hull, trying to soothe my mind and shut out visions of collisions and shipwrecks.

The sailors of old had traversed entire oceans in this way, dependent solely upon their wits, the stars and planets above, and a sextant. It must have been difficult for young cabin boys on their first sea voyage and out of sight of land for the first time. At least I'd been on a ship before. For that matter, I'd been up in dozens of airplanes, something those long-ago deckhands would have considered magic, if not black magic.

Chuckling to myself, I loosened the jib sheet to enable the sail to catch what wind was left. We were still ghosting slowly along, and I wanted to put off starting the noisy motor unless we stopped moving altogether. I stood and scanned the invisible horizon again, before settling back against the cushions.

As the boat gently rocked forward and the constellations moved across the sky, I came to feel as if I were held in some great hand, not in the sense of a heavenly figure watching over me, but as if I were resting upon the skin of an awesome being, a unity of life and consciousness that was mind-boggling in its immensity. The sheer grandeur of the universe was apparent to me in those few hours—not that I could begin to grasp its totality, but I could conceive of the reality of it, rather than an intellectual concept of it.

It was out there, all around me, under the ocean and beneath the earth, as well as in every direction through space and into the infinite, and as amazing as that was, even more astounding was that I was here, somehow an integral though microscopically minuscule part of it. It's the kind of feeling that can drive you insane or make you feel, as I did, very truly sane.

A line from the *Desiderata* came to me: "You are a child of the Universe, no less than the trees and the stars / You have a right to be

here / And whether or not it is clear to you / No doubt the Universe is unfolding as it should."

It was clearly true that we had a right to be here. But trusting in the process of the unfolding universe takes more than that. It takes something like faith. Faith to trust that the boat won't sink, that the vast majority of reefs have been charted, and that the island we aim for is there, in the darkness, at the end of a sometimes wavering line of position. When the night is moonless, it's difficult to believe there will ever be a moon, or that when enough hours have passed, the horizon will brighten again.

Naturally, the sun did come up the next morning, after many watches had been taken and the moon had come and gone. Later that day, we sighted the Islas San Benito, little smudges on the horizon precisely where our navigation had told us they would be. Much later that afternoon we finally drew close, rounded the point, made our way into the bay while carefully watching the depth sounder, and anchored *Watchfire* safely once again.

That night at dinner, we celebrated our landfall with a bottle of rather warm champagne and a toast to our developing skill as navigators. Then Russel lifted his glass to me and said, "To your first night passage."

I didn't think about it at the time, but it wasn't really my first. We are always, after all, traveling through the night, our ever-spinning world eternally half shadowed in space. Our choice is whether to fear the darkness or trust in it and have faith in the coming of day.

Party Animals

THE BAY AT SAN BENITOS was snug and calm, with plenty of room to avoid anchoring too close to the only other sailboat, slightly larger than ours and flying a Canadian flag. When the breeze came up at twilight, we could hear voices raised in what sounded like good cheer. After dinner, eager for some unbroken sleep, we headed to our v-berth rather early. At 10 p.m., we were awakened by the sound of hooting and hollering from the other boat. We lowered the hatch, leaving only a slight crack for a bit of ventilation.

At midnight, they were still at it. Russel closed the hatch firmly to shut out the sound of revelry. "Man, those Canadians really know how to party."

Early the next morning, I crept out of bed and quickly got dressed in thick sweats. Baja is not warm in late November.

I pulled out the grinder and the coffee beans I'd carefully stashed in screw-top plastic containers. Everything had a very specific place since we had supplies enough for a month's meals and drinks all packed away on a 26-foot boat. Fruit and veggies were stored in a net hammock that swayed above the combination galley counter and ice chest top. The ice was long gone, but the empty ice box was insulated, and the bottom of it was low enough in the boat to keep things cool.

Putting the appropriate amount of beans in the top of the grinder, I turned the crank. I'd received an electric coffee grinder from my friend Nancy as a wedding present, but it did me little good here at anchor. This little wooden grinder had been a gift from Russel's best man, David, and did the trick nicely. The grinder, which sounded like some sort of dwarf engine—*errr, errr, errr*—served as a gentle wake-up sound for Russel, who considered the hours before coffee to be too early to be awake.

I'd stopped drinking coffee right after I moved aboard, realizing there wasn't enough room in the small boat for me on caffeine. After years of drinking coffee morning, noon, and night at my many restaurant jobs in LA and NYC (like so many aspiring actors, I waited tables to survive), it was surprisingly easy for me to switch to peppermint tea.

Shifting our sleeping and waking hours had been an adjustment. Due to work *and* play, both of us had been night owls for many years, and adapting to the "early to bed, early to rise" hours of sailors was quite a change. It turned out that, by nature, I am an early riser, so once I was caffeine free and had no late-night work schedules, I rose with the sun. Since I got up before Russel, it seemed only right that I make coffee. It also made less mess than when my half-awake husband attempted to pour grounds into a filter.

We sat outside to share our morning fruit and surveyed the scene, where brown mountains rose above the small blue bay. It was clear that these islands were much too interesting a spot to skip in a rush to get to Turtle Bay. Instead, we'd stay there a day and sail to Bahia de Tortuga on Thanksgiving Day. We could celebrate it a day late. After all, who cared about our silly holiday in Mexico, anyway?

A bit later, we lowered the dinghy and rowed to shore to explore the small island. The tiny village was more than the usual fish camp, judging by the presence of a whitewashed church with a steeple.

We rowed the other way, more interested in the natural beauty and wildlife that abounded in the remote setting.

Rowing toward the small landing beach, we passed by the Canadian sailboat and were hailed by our neighbors. We veered over to say hello, surprised that the young couple in the cockpit were up and receiving after such a late night. The boat's name was *Copacetic*, and all seemed that way with Kevin and Laurel. Drifting beside their boat in our inflatable dinghy, we exchanged the usual who-what-where introductory stuff, and they invited us up for coffee. We accepted with raised eyebrows, both silently asking why they'd want early guests.

Aboard, we found the sailboat spic-and-span, with not a boat cushion out of place. We hemmed and hawed, and finally I referred obliquely to their party the night before. They looked quite puzzled, so Russel assured them that the noise hadn't kept us awake, just that we were surprised to find them so chipper after such a late night's carousing.

The two of them exchanged confused glances, and then Laurel looked over at the beach and started laughing.

"You must have heard the seals," she said.

Kevin smiled and pointed shoreward. "We're anchored right off a beach that's home to a colony of elephant seals, and they bark all night long."

They were amused that their little boat could have been mistaken for a hot social venue. Adding to the laughter, we described to them our night of awe at their "party animal" prowess.

We said goodbye and rowed in to see the seals, but didn't find any on the closest beach. After exploring a few other small beaches, we found a sunny, secluded cove with a dense line-up of sandy female elephant seal bodies packed in across the sand like sardines in a tin. Their fur was dry and light brown, with none of the sleekness we were used to seeing. We walked fairly close to the seals,

and not one stirred. Flies buzzed around their eyes and nostrils, causing not a ripple of skin in response.

We questioned each other in whispers. Could these poor dry seals be sick? Or worse, were they dead?

Finally, we got close enough to alert the harem, and the seals slowly looked up, one by one, all yawning and shaking their heads sleepily.

These party animals weren't dead, they were dead tired.

Welcome to Blue-Water Sailing

SAILING WAS A WHOLE NEW world, and, even after having captained the boat alone overnight, I wasn't fully confident at the helm while leaving a rocky anchorage. Sailing south past Cedros Island, I was already a bit seasick and wondered aloud why it would be any different from the previous days. Russel explained: the following seas that had pushed us on our way "downhill"—the coast of California has a year-round southward current and typically the winds blow from the north as well—had shifted slightly off center, or was quartering, so the stern was being pushed slightly sideways with every passing wave.

The combination of pitch, the front-to-back tipping of a sailboat smartly underway, combined with yaw, the side-to-side motion caused by side waves, is the cause of all the problems. He called it by the French name, *mal de mer*, a slightly more sophisticated term that didn't make my stomach feel any better.

I found out much later (yes, I researched it) that the US Navy has spent tens of millions of dollars trying to develop a magic pill to keep sailors from getting seasick. About 40 percent of new sailors do experience some form of mal de mer and cease to be as useful or dependable on watch as they puke up their guts. Most people can lie down and conquer their queasiness, but that all goes away once you get upright again. Certain things tend to induce more nausea,

like being tired or the smell of food or gasoline. Oddly, the whole problem is caused by genetics, perhaps by differences in the inner ear since the disorder is really a sort of vertigo.

I was endeavoring to be the world's best first mate, so finding out I got seasick was a crushing blow. I'd been queasy on our big sail up to Mission Bay a few months earlier, but we both figured it was just because I was nervous. It wasn't.

The morning we left the San Benito Islands, I was quickly nauseous, my mouth watering and my stomach clenching. Focusing on the horizon, I took my ginger pills and hoped for the best.

The seas made it imperative that we motor sail, as we had to maintain a certain speed to get into Turtle Bay before dark. Having done a couple of night-approach entries to anchorages on previous days, we knew that coming in after dark to even an empty bay can be trying. Entering a busy harbor like Turtle Bay at night would be exceptionally challenging. So the little outboard engine snarled away, hour after hour, putting a faint whiff of engine smoke into the air and lending yet another level to my queasiness.

For those who have led charmed lives and never been seasick, lucky you! It is much like a bad stomach flu, without the diarrhea or fever and chills. The result is extreme fatigue and lethargy. A few hours of it can be debilitating.

Soon, I was exhausted and weak, and the thought of standing up to go to the head and pee (a trip of about 6 feet) was overwhelming. If I remained supine and quite still, I could keep from throwing up. I'd made some snacks for Russel to eat at the helm, but I couldn't keep anything down myself, not even water.

We were more than halfway to Turtle Bay when Russel called me up to the cockpit. Shaky and no doubt green, I ascended the three stairs and leaned in the companionway door, shivering from the cold. The sun was hidden by thick gray clouds, and the breeze on our nose was freshening, which means getting stronger.

Russel was apologetic, explaining that the seas were overwhelming the autopilot, so he had to hand steer. It made no sense for me to start steering, as I was clearly too tired to be much use, and he didn't really want to turn the tricky steering dance over to me at that moment, anyway, having just mastered it himself.

I nodded, wondering where all this was going.

We were running out of fuel for the outboard. Could I possibly go up on deck, untie the jerry jug of fuel that was lashed to the lifelines, and bring it down?

Of course, I could. I *had* to.

Below, I dressed warmly and put on my life vest. Stepping from the cockpit seat up onto the deck, balancing as we were tilted to and fro by the big Pacific swells, I shuffled in a crouch up to the red plastic 5-gallon jugs and began to untie the closest one. Each lift of the deck was followed by a sickening drop into the trough of the next wave, which almost caused my stomach to exit through my mouth. Never have I had such trouble untying a simple bowline—a knot I could tie with my eyes closed at anchor. When the jug was unfastened, I slid it back toward the cockpit.

Russel reached out one hand to help me lift it down to the cockpit sole and then began refilling the outboard's supply tank while holding the tiller straight and balancing all the above. About halfway through the process, the stink and the movement caught up to me, and I rushed to the low side of the cockpit. With my stomach completely empty, I threw up watery green bile for a few minutes.

By then, Russel had finished the refueling process and was back to steering. He glanced over apologetically. I smiled back weakly and turned to slide down onto the cockpit's bench seat.

"Welcome to blue-water sailing," he said.

I stifled an answer about where he could put sailing and the whole freaking ocean and gingerly made my way back down the three stairs to the salon. Welcome to blue-water sailing, indeed.

As we closed in on Turtle Bay at twilight, I came up, sick as I was, and took over the helm so Russel could get ready to anchor. The seas had calmed down, but there were still whitecaps, which glowed blueish-white from tiny bioluminescent marine creatures. As we got closer to shore, I glimpsed long streaks of light flashing by underwater. On closer inspection, they turned out to be bioluminescent dolphins—having gotten covered in the glowing algae as they swam.

We leaned out from the boat, me at the tiller and Russel on the bow, pointing each one out as it raced by, oohing and aahing. It was like seeing a comet pass by underwater, each glowing dolphin streaking by with its long, star-bright, sparkling tail. The glowing dolphins escorted us all the way to the harbor entrance. And just like that, my stomach settled down.

I was fine again. And really hungry.

Tortillas and Cheese

B AHIA DE TORTUGA IS A popular spot for those traveling
long distances by boat to stop, due to the presence of fresh
water and a fuel dock. That first morning in Turtle Bay we
slept in as best as we could, meaning Russel dozed and I stayed in
bed reading. Though racked with guilt about him having to handle
the boat solo so often, there was not much I could do about being
seasick. I made a note to buy Dramamine. Benadryl, which I'd been
relying on, works if the sea is not too rough, but it turns out that you
can't count on the ocean being agreeable.

We finally got ourselves together enough to dinghy into the dock
through the fleet of anchored cruising boats. It was surprising to
see so many boats together, as that hadn't been the case since San
Diego. We wandered the streets of the town in a bit of a daze.
It was midday on Friday, the day after Thanksgiving, and I was ready
for a restaurant meal. In a cozy cafe, I ordered *chilequilas*—tortillas
and cheese in a red sauce—a family staple in my house growing up.
Turns out, in Mexico, they are served for breakfast, with eggs. It was
lunchtime, but they whipped the delicious dish up for me *especial*.
We each had a cold Pacifico before the meal, which was bliss. Our
Miller Lite had been tepid for over a week since the ice melted.

Finally getting to practice speaking Spanish, I was thrilled to be
understood. The dusty little town was full of *tiendas* selling almost

everything we needed, and the people were very friendly and patient with my bad grammar. They smiled as I stumbled through sentences, and often replied to me in excellent English. Not too surprising, as we were only a few hours south of the border by car.

The markets were full of items with Costco stickers. My friend Roxanne was a member of Costco in San Diego and had taken me to provision with dry goods before we left on the trip—the huge box of just-add-water pancake mix might still come in handy. So far, we'd eaten mostly cereal for breakfast. I bought a dozen eggs and some soft Oaxacan cheese, then spotted a *tortilleria*. There's nothing like corn tortillas so fresh they are still warm, so I purchased a half kilo. The tall stack cost about 50 cents due to the government's controls over the price of staple foods. Milk is also price-controlled in Mexico, along with rice and beans, so no one ever starves.

Neither Russel nor I drank much milk, but we did use it for cereal, so I got a few pints in those waxed stay-fresh boxes. We still had plenty of beans and rice on board, the ideal protein combination, but it was impossible to refuse fresh supplies. We loaded up with as many veggies as we could carry, mostly iceberg lettuce, tomatoes, the fat gray squash called *calabacita* that tastes like a bitter zucchini, plus cabbage, onions, and potatoes, which last the longest.

After buying a *media barra de hielo* or half-block of ice, we hustled along the streets as fast as possible, loaded down as we were with our full grocery bags, back to the dinghy dock. The Achilles was fully loaded in minutes, and we rowed out to the boat. It was always a race against time to get the ice aboard and into the boat's built-in insulated ice chest before it melted too much.

We'd been informed at the fuel dock that there was no gasoline but that it should arrive tonight or *mañana*. Our first mañana in Mexico (word has it that mañana doesn't actually mean "tomorrow," only "not today"). Fresh water would also be gotten from the town spigot on our next trip to shore; apparently, water was always

available there, but insufficient water pressure made the process of filling jugs very slow.

I was already dreading the 220-mile jump that would constitute our next leg, taking us all the way to the big safe anchorage of Santa Maria Bay. We were used to stopping to anchor almost every night, but if we *didn't* cut straight across the big bight to the south of us, it would add about 50 miles to our trip. That'd be another day, *at least*. Plus, the wind was favorable to go straight to Santa Maria in a couple of days, if the 72-hour weather forecast held true.

In case of an emergency, I knew how to use the VHF radio to call other boats or to call for help, but the local VHF "net" the next morning was a first for me. Russel had told me about how local cruisers would set up a time to network in or near each spot where boaters congregated. That way, everyone in the harbor can check in each morning to make sure no one is missing or needs a communication relay to another boat. VHF radio works via a line of sight, so a sailboat 50 miles away might come in loud and clear to a boat outside the harbor, but not to us inside Turtle Bay. They also put out a general call on the net to see if anyone needed something that another cruiser might be able to help with, such as spare parts or tools they can loan. Every cruiser loves to repeat the saying that "cruising is boat repair in exotic ports."

We hadn't had any boat maintenance issues other than our small dinghy outboard, a Colt 1.5-hp engine, which worked when it felt like it, much like the "Sea Cow" engine Steinbeck wrote about in *The Log from the Sea of Cortez*. I tried to be philosophical about it, but it was damn frustrating when we wanted to dinghy to shore and the outboard wouldn't start. Luckily, the Yamaha outboard, which was our boat's auxiliary power, had been a peach, moving *Watchfire* along at 4 or 5 knots of speed when we couldn't sail. We were keeping our fingers crossed it would stay that way; we could always row the

dinghy to shore, but we couldn't move the sailboat if the motor died *and* there was no wind.

Someone reported on the "net" that their dinghy engine had been stolen. The outboard was left locked to the dinghy at the local dock at night for a few hours, and someone cut the cable and took it. Everyone was clearly outraged at the thought of thieves stealing from us cruisers. Americans seem far more aware of theft if it happens in a foreign country; we don't consider how many cars and bikes get stolen every day back in the *Estados Unidos*. It's like everyone is supposed to be extra special nice to us when we cross a border, even if we do something dumb.

No one suggested that it might have been a fellow cruiser, automatically assuming it was a local fisherman. But most *pangueros* (the fishermen who fish from long sleek skiffs called *pangas*) use at least 25-hp engines to enable their vessels to "plane" above the water and thereby go much faster on their long trips to and from the offshore fishing grounds. Russel and I had our doubts about a local having stolen it. What would they do with a 5-hp engine? And where could they use it? A cruiser could hide it below and bring it out, or sell it, in another port down the way. We didn't voice our suspicions on the radio, seeing no reason to make people even more paranoid than they already were.

After the net, we got a VHF invite from Laurel and Kevin, who'd invited some Canadian friends to join the four of us. The couple had two teenagers onboard, so they suggested we four come over to their bigger sailboat. It was always fun to go to someone else's boat and see how things were done, and I never turned down a meal someone else cooked, though we all brought side dishes.

The husband gave us a tour of their boat. He had only one arm, which I didn't notice right away, since he had a prosthetic hand, until he started joking about being "a true *single-hander*," which is what captains who sail solo are commonly called.

The two teenagers turned out to be friendly and talkative, even more outgoing than their parents. The eight of us had a delicious dinner and a lively chat about the next destinations down the peninsula. It was nice to know we'd be in good company during the next leg of the voyage.

A Good Investment

WHILE WE WERE IN SANTA Maria Bay, our next anchorage, another cruising sailboat came in. Flying a British flag, the boat anchored much too close to us, though the bay is wide, with plenty of other good spots. Russel was a little pissed off but also excited to meet a crew who'd sailed here from overseas. I was definitely in the latter camp because I loved their boat name, *Imagine*.

A little background on us two Anglophiles:

Russel spent time in England during the Vietnam War, while his mom and a UCLA lawyer argued with the draft board that "Rusty" had not been given his full college deferment. He'd supposedly taken too few units the previous semester and been called up for a physical. Despite every trick, including eating a dozen raw eggs in Hershey's syrup to send his blood sugar skyrocketing, he was accepted and given an induction date. The UCLA lawyer would argue that he belonged in school, not boot camp, but following the progress of his case from afar seemed smart. Luckily, his screenwriting teacher was a renowned British writer who offered him a gig writing dialogue for a BBC series, so off he went. He took time off to see the UK by bike, from London to Edinburgh and everything in between. A huge Thomas Hardy fan, he even bicycled through Dorset.

My first trip was much shorter, when I was much shorter. I turned nine in London, when my family was backpacking around

Europe in 1970 (more on that, later). My second trip was when I was seventeen, attending United States International University for a summer at a campus that looked like a castle outside of London. The village of Bushy in Hertfordshire was charming, and the castle was the former Royal Masonic School for Boys. We students walked the streets of London every weekend, practiced our accents in local pubs, and saw West End plays, like the original production of *Evita*.

In short, Russel and I loved the English and couldn't wait to meet our new neighbors. They soon came by in their dinghy, with captain Stephen apologizing for anchoring so close to us. Chris, a petite blonde from England with an accent I'd have killed to master, invited us over for dinner. We happily agreed and brought a bottle of decent red wine from Ensenada.

Imagine was stunning—a custom Dutch creation, with built-in cabinets made of blonde wood and plenty of cunning hidden berths and hideaways. Stephen, an American, had lived in London since he followed Chris home from her Florida vacation when he was in the navy. They'd recently sailed across the Atlantic to the United States, with Chris thrust into the role of captain when Stephen broke his ankle and was stuck below.

This started me *imagine*-ing what I would do if Russel was suddenly incapacitated. I needed to be able to do everything required to sail our little boat to its next destination at any time, just in case.

As we said goodnight, we invited Chris and Stephen to have dinner on *Watchfire*. We'd already decided to stay one more day to celebrate our six-month anniversary in the lovely bay. It was time for some relaxation and beachcombing.

Something delicate crunched beneath my bare foot as I stepped onto the sand. Kneeling, I gathered up a double handful of sand with broken shards of a delicate shell, and one perfect sand dollar, looking like it was bought from a shell shop.

Looking around, I saw dozens of sand dollars scattered around me, small and large, whole and shattered. I squatted on my heels, piling a stack of the matte white empty shells on my open palm, sorting through them for the best-looking specimen.

"Look, honey!" I held it up. Russel was a few yards behind me, standing atop the last dune, shooting photos of etched drifts of wind-tossed sand. "Sand dollars!"

He walked toward me, squinting in the low morning sun. "Wow," he said, "look at those."

"It's incredible! I've never seen so many that were completely whole," I said, showing him the small pile I'd already collected.

"I always knew this trip was a good investment," he said, lifting his camera back up to his eye. "Money everywhere we turn."

"Have you ever seen the doves inside one of these?" I asked him. He shook his head, so I snapped one of the brittle white discs open and showed him how the intricate inner construction of the shell breaks into shards that resemble white birds in flight. He smiled as I tossed the shell-birds into the air while singing about a white dove who must sail many seas before she could sleep in the sand.

Russel hummed the refrain as he wandered off with his camera up to his eye. Laughing, I continued to sift through the sand for treasure.

I've always been fascinated by minutiae, and that day I found myself drawn to the microcosm, to the easily missed. In Baja California, with its constant visual drama of mountains and sea, it took some looking to see past the grandiose to what was relatively infinitesimal.

Up the beach where the tide line was marked by a sifting of small snail shells, I crouched on the warm sand and examined it closely.

I was astonished at the abundant remains of former living things, in a single handful of beach sand. I ran the round shapes through my hands like a miser's coins, focusing on the sensuous feel of them falling through my fingers. The hot and cold of a scoop of pebbles and shells tumbled from one hand to the other, and a few grains scattered at my feet.

Such a variety of colors and shapes within this meager palmful. A pearly white snail shell of the finest construction rested atop the pile. Its thinner-than-eggshell curves were translucent, revealing a cunning architecture of spirals and coils. Next to it gleamed a clamshell no bigger than a newborn baby's fingernail. All the colors of a tropical sunset had been distilled down to this tiny canvas and yet still glowed with an intensity that stunned me. My eye fell upon a brown-and-white olive shell, a calm respite from the clamshell's glory, but even there I found splendor; its curved surface was covered with an intricate pattern of lines and angles, like a Navajo blanket done in ten different natural shades of cream and beige wool. The complexity of the designs was awesome, and my simple human mind could only repeat: *How can this be?*

I reflected on the words of Emerson: "To see the universe in a grain of sand, and eternity in an hour." There was some visual connection to the infinite here, gazing on the intricate sculptures that were once home to myriad tiny ocean creatures.

But perhaps what Steinbeck wrote about looking up to the stars and then back to the tide pool again was more to the point. It is too easy to assign cosmic or theological meanings to nature; what's important is remembering to look back to the tide pool again, to appreciate life for what it is, not for anything we would have it represent.

Rather than feeling that there must be some great plan to have produced these marvels, I found myself amazed at nature's controlled chaos. There may be no accountant, and no accounting,

but nonstop natural perfection lives and dies and deteriorates daily, only to continue as some part of the whole.

I scooped another handful of tiny sea snail shells in every color. Caught unprepared when one began to move independently, I sat spellbound, watching it perambulate before lifting it up for closer study.

In my hand, the teensy hermit crab tucked itself so deeply into its shell that only the edge of one miniature folded claw showed. On San Benito, I'd returned from our beach walk with a pocketful of keepers and arranged them on the settee table as a centerpiece; at lunch, one small shell started inching its way toward the edge of the table—an unintentional stowaway that we quickly carried back to shore.

Smiling at the memory, I put today's unwilling passenger back down on the sand. The tiny crustacean took immediate action, moving quickly toward the sea.

Russel was calling to me from far up the beach. It was getting late. Time to head back to where our own delicate home bobbed in its sheltered cove. I stood up and brushed sand from my legs before trudging up the beach to join him. Hand in hand, we crossed back over the dunes.

Above us, seabirds looked down from their lofty height at the two specks of life moving side by side, beside a vast sea.

Wandering Souls
1970–1978

I N MARCH OF 1970, MY mom turned thirty and decided that we all needed to broaden our horizons. My father's airline job gave us huge discounts on travel, and she wanted to take us to Europe. Traveling with three kids under the age of twelve to a handful of foreign countries was an idea that was met with some alarm, but the young anti-establishment women who were her coworkers and our teachers saw it as educational and gave the idea their blessing. Mom quit her teachers-aide job, and we sold everything in the little canal house, including my beloved canopy bed. I begged my mom to let me stay with Nena, but she insisted I go along.

Dad's Pan Am employee miles meant we could fly dirt cheap only if we went "standby," and so we did, with my mom carrying a massive backpack that contained our sky-blue nylon tent, and we three each hefting a child-sized backpack. Each of us toted our own sleeping bag plus whatever clothing we'd brought. In other words, our traveling clan traveled even lighter than before. We spent spring and early summer searching for our destiny, or at least a cheap place to stay, from London to Paris to Rome, and on to a communal meditation enclave on the tiny Spanish island of Formentera, off Ibiza.

I discovered new versions of myself on that European journey, after having lost my bid to stay in Nena's pristine shag-carpeted LA apartment. The very first week, even though we were freezing under

duvets in a borrowed, unheated apartment in snowy Paris, I began to appreciate the appeal of travel; each location was a new setting for my ever-present fantasies of the future. Turning nine in London, a city that felt familiar from dozens of children's books, I happily took off with my brothers to ride the tube and explore the city for a day while my mom and a new beau had a one-day stand.

Finally, in June on Formentera, I became a searcher of sorts. After hearing so much about Transcendental Meditation (TM) from my mom and the others in the group, my brothers and I asked to be taught meditation. The acknowledged leader, a young guy who had recently studied with the Maharishi in India, pronounced us too young to be initiated into TM but bestowed upon each of us a "walking mantra," like a two-syllable set of training wheels. The next day, no doubt inspired by the talk of being fully in the now, I stood alone on the beach at sunset, mumbling my mantra, communing with the setting sun; the moment ended with me sprawled in the sand. The adults all called it a transcendental experience. I called it weird.

Back from Europe in late summer, and at loose ends until school started, we four joined my mom's friend Fran, who was driving her Renault 16 north from LA. We got as far as Healdsburg, a charming town full of hippies. Someone knew of a cheap rental, out in bucolic pasturelands far from town. Living there was a fun taste of country life for us, but as much as I liked the farm animals and dogs, my favorite gift that year was a pair of white go-go boots to go with my long white leather coat, a present from a friend in Paris.

My mom, as usual, gathered a group of young people around her. One of them, Mike Wright, was tall and handsome—a man of twenty who found my thirty-one-year-old mother attractive. Mr. Wright joined us, and our new family was off to see the world (starting with Oregon) in his old yellow Chevy pickup.

We never found the ideal spot in Oregon, and after a few months here and there, we headed south to Santa Cruz, where we settled into the School of the Earth Commune, situated on a few acres surrounded by the Big Basin wilderness. Mr. Wright and his friends built us a house of scrap wood and fresh timber, and we kids reveled in helping, to the detriment of our formal schooling. Getting to school involved getting an adult to drive us miles down the mostly dirt road in the Chevy truck to the school bus stop, and of course we kids rode in the open truck bed in all weather. Buses took my brothers to Santa Cruz for Junior High and me to nearby Davenport Elementary. I was the only kid in the sixth grade in the tiny school and dreadfully bored; my only thrill was getting to ring the school bell to signal recess.

My eldest brother Joe and I finally staged a rebellion. We wanted to go to a real school five days a week. Soon we were back in Venice, living in a small upstairs apartment on Howland Canal with my dad, who was driving a cab. Dad said I could take home a puppy from the free box at the food co-op one day. The tiny black pup was named Juniper, and she quickly grew into a big black lab mix I adored.

My mom and John had gone back to Healdsburg with Mr. Wright when our commune dream fell apart, and they soon trailed south behind us, when she and Mr. Wright split up. My mom finally accepted a handout from Nena and agreed to move to San Diego, then a staunchly conservative Navy town, where she and Grandpa had settled. We rented an apartment on a street that was much too busy for playing ball with a dog in the front yard, and Juniper was hit by a car and killed.

Heartsick and grieving, I started sixth grade again in San Diego. I had been in sixth grade in Davenport, but didn't retain much. Having skipped second grade long before, retaking sixth put me back with people my age. I was eleven but hadn't attended enough school in the last year to have any sense of how a preteen was supposed to act.

I always raised my hand when I knew the answer, and often blurted out answers if not called on. The kids soon took to calling me "Dicktionary" and "Computer Wore Desert Boots." I sported my brothers' hand-me-down shoes, OP shirts, and corduroy jeans when I wasn't wearing a black leotard and tie-dyed cotton skirts. Suffice to say, I did not fit in.

Making friends was a skill I had not practiced; my brothers had long been my built-in friends and frenemies, and my mom was more like a buddy. Getting girls my age to like me seemed impossible. Every overture was met with disdain. So, I did what any desperate eleven-year-old would do. I lied. I spent my lunch money on Hostess snacks on the way to school and told my classmates my dad worked at Hostess and brought the goodies home. Each day I would bring and share a different assortment. Soon a few girls began talking to me in exchange for Donettes, Ding-Dongs, and fruit pies. When my mom found out we qualified for free school lunches, due to living below the poverty line, she enrolled me in the program, and I stopped getting lunch money. There went the tempting treats, and there went all my new friends. Except one.

From a big Catholic family with deep local roots, Cathy Britt was tall, blond, green-eyed, and popular. I have no idea what she saw in me, but we became best friends, and remain close to this day. Because of Cathy, the others tolerated me, though many girls shunned us both. I cared not at all; one friend was all I needed, and we soon lived in each other's pocket, walking from school to her house or mine each afternoon. Her family accepted me easily—with eight kids, one more eating dinner made little difference. To me, their well-stocked cupboards and refrigerator were a culinary heaven where I ate forbidden-by-Mom-food like sugary cereal for the first time.

My mom had rented us an old barn of a house in the barrio of East San Diego. The 40th Street house had three bedrooms and

an unfinished attic, plus a big backyard with a two-room shed that would be converted into a room. The yard, in my eyes, meant another dog, and I soon had a Weimaraner puppy I named Nova, the new star.

Mom tried to make it as an Avon lady (yes, Avon is Nova backwards), but, as part of her agreement with Nena, she'd also gone back to school at City College in downtown San Diego, where she discovered her true people in a group of radio DJs and thespians. Many of them worked (for free) at Actors Quarter, the local community theater, and Mom got a small part in *Death of a Salesman*. My brothers and I were soon doing children's theater, riding the city bus downtown after school and on weekends. On our few free weekends, Cathy and I walked our dogs to Balboa Park, where I mooned around the Old Globe Theater and dreamed of being on stage there.

Surprisingly enough, my next role was in *Our Town* at the Old Globe, which in those days still had open calls for the public to audition. The cast quickly became like family, and I made my first theater friend, Helen, who picked me up each day so I didn't have to take the bus or cadge rides. Watching Jack O'Brien direct Craig Noel as the Stage Manager, and standing up on a ladder in a spotlight as Becky, the little sister of George Gibbs, I fell deeper in love with the world of acting.

Our Town was also where I met the handsome and charming Russel Redmond, who played the milkman, Howie. The play got great reviews, but one reviewer picked on Howie's accent, the only accurate New Hampshire one among us Californians struggling to sound Eastern (Russel had actually met the real milkman who Thornton Wilder had based the part of Howie on, and promised to audition for his part if he ever could). Russel was so embarrassed by the bad review that he took photographs of the whole cast and created a stunning pen and ink poster.

Russel was also in the next play I did at the Old Globe, *A Trip to Chinatown*. He had no interest in being an actor, but he had developed a hankering for a certain actress appearing in the play—not me, as I was only fourteen. Though I made no secret of my mad crush on Russel, he always kept it platonic, due to "common decency *and* the state law." He accepted my kisses, took my first headshots, nicknamed me "little snit" for my feisty attitude and ever-ready opinions, and took up with a talented, age-appropriate actress I admired and resented in equal measure.

As The Kid, an old-time newspaper boy, I watched the whole play from the wings during every performance. Luckily, the cast included the immensely talented Steve Gunderson, so I basically focused on him every night, able to watch and laugh as if for the first time. The Kid's big scene came at the close of the show, doing a little time-step in a spotlight on the empty stage after the rest of the cast had bowed out, a moment that was a visual metaphor of my inner life. I had found a place in the theater, not that particular theater, but all of The Theater, which would be a home to me for many years.

I also assisted Helen, the prop mistress, so we had to be at the theater by 6 p.m. and often didn't get home until midnight. Homework got done right after school; sleep was unimportant. I lived for rehearsals, performances, backstage shop talk, and cast parties. At one of those parties, Helen introduced me to a gorgeous actor friend of hers named Jimmy Hansen, who made me laugh uproariously and quickly became a friend.

At that year's Old Globe Atlas Awards I didn't win an award, but was thrilled to be in the running for best supporting actress. At the black-tie reception, Jack O'Brien himself took me aside to give me some advice as I listened wide-eyed.

"Obviously," he said, "you can rush off to Hollywood and cash in on your looks and talent." But he suggested I stay in San Diego and study my *craft* (a phrase I'd never heard before) so that when I finally

got roles, I'd have a foundation of *skills* and might be able to prolong my *moment in the sun*. I took his advice to heart.

Meanwhile, Russel's *Our Town* poster had become a hit, which prompted The Globe to hire him to illustrate posters for their renowned summer Shakespeare festival. That launched a new career for him, enabling him to leave television production (which he hated) and become a professional illustrator. I kept popping up in his life, asking him to shoot my new headshots and even showing up with Cathy at his house on Black's Beach, a clothing-optional haven in La Jolla, appropriately un-attired.

My mom and her friends had produced a few plays by then, including a magical *Alice in Wonderland*, which was a blast to act in, and my mom (I'd started calling her Diane when she legally changed her name) decided to start directing plays. Her first production was *The Diary of Anne Frank*, starring me. I researched diligently and tried to become Anne. Helen embodied Mrs. Frank totally convincingly, despite only being five years older than I. A friend in local radio recorded my voice reading Anne's words to play over the action in places, including her last journal entry about still believing that people are good at heart. When we put on the play at a former church, the actors who played Nazi soldiers would suddenly pound on the old wooden doors, making me and the audience jump in terror. Performing that role nightly had a profound effect on me.

My brother John passed the High School Proficiency Exam at sixteen, graduated from high school, and soon had a paying job. Turning sixteen, I followed his lead, and soon I was off to United States International University's (USIU) School of Performing Arts on an academic scholarship. At seventeen, I got a job with a San Diego theater troupe and dropped out to earn enough money to study at the USIU campus near London. That job brought my first real boyfriend, Ted, ten years my senior; skilled at a variety of arts,

he taught me the joys of consensual sex and entertained me with original songs.

I spent the summer of 1978 in England, studying Shakespeare; my job as a work-study student meant dusting stuffed owls, doing windows, and cleaning school toilets with my friend Roxanne while our wealthier friend Elissa hung out in Paris on the weekends. I came home at the end of summer to Ted and San Diego, though I wanted neither. In fall, my school friend Cathy joined me at USIU, and we became roommates, which made living on campus (just) bearable.

Cast in the school's production of *The Lower Depths* by Maxim Gorky, I was transported into the world of Russian theater. I loved the dark, angst-filled play and dreamed of playing Nina in *The Seagull*.

I never did play that part, but seagulls would end up playing a big part in my life.

Getting Legal

THE VOYAGE FROM SANTA MARIA to Cabo was a marvel. We had following seas at just the right angle to speed us along, but not toss us about so much. Russel and I traded watches all day and night, and managed a little sleep on our off hours. Overnight, my stomach finally settled, and by dawn I was fervently hoping I'd conquered my ongoing seasickness.

At noon, I came below to put together a gourmet meal of PB&J, since our fishing pole was being steadfastly ignored by every creature in the Pacific.

The VHF radio crackled. "*Watchfire, Watchfire, Watchfire* . . . this is *Imagine.*"

"*Imagine*, this is *Watchfire.*"

"Switch to 68?"

I repeated the channel and quickly switched off 16, the main hailing and emergency channel for boats, over to 68 to chat. Stephen said he was calling to ask if we could do him a favor.

"Of course," I answered, a bit anxiously. What could we possibly do for him while rocketing over the waves, so many miles offshore?

"I've caught a rather large fish, and I hope you can help us eat it."

I laughed in relief and called for Russel to come down. We formed a plan to bring our two boats as close together as possible for the handoff.

Back up on deck, we scanned the horizon for a sail. There they were, outside us a mile or so, racing south on a parallel course. We angled toward them as best as we could and settled in to wait to intersect.

When we got close enough to shout to them, Stephen threw us a line and we caught it, miraculously. Then he tied on a large bucket he had rigged with a line, and we pulled it over. The bucket was half full of dorado (mahi-mahi), its colorful skin still on.

"Hey, we caught a fish!" I said, giggling, and Russel laughed in agreement.

We sent the bucket back, along with our shouted thanks, then Russel fired up the barbecue and I started cutting up our "catch." One grilled fillet was quite enough for lunch and the rest went on the still-warm coals in the BBQ for slow cooking.

That afternoon, long smooth swells pushed us along under a bright sun. We poled out the big jib and fastened the jibe-preventer on the fully extended main, then ran like that, wing on wing, for hours. I was nervous, afraid to backwind the sail, something I'd done days before; filled with wind from the wrong side, the main sail had pulled the boom across the boat, where it crashed into the rigging, and *Watchfire* heeled so far I thought we might tip over. I'd burst into tears and Russel had run up and calmed my fears, saying, "The boat wants to stay upright, but try not to do that again."

So, holding the tiller gently, and keeping a close eye on both sails, I shifted the rudder slightly to compensate each time the stern slewed to port with the following seas.

The barbecued fish was done and nicely smoke-flavored by dinnertime.

Early on December 3rd, sunrise illuminated the rugged Baja coastline above Cabo. Almost at the end of my watch, I hoisted a cup of herbal tea to my oldest brother Joe, whose birthday would be celebrated in San Diego with his wife Teresa. My brother John's

birthday had been the week before. The first person I knew who loved sailing, John read every sailing memoir in our small local library, and would rhapsodize over these romantic tales and dream of going to sea. He'd grown up to be an arborist who owned his own business, plus he was married and had two children, so he probably hadn't missed my usual birthday call.

Later that morning we rounded Land's End, the furthest point of land on the Baja California peninsula, a famous arched point of rock known as Los Arcos, which graced nine out of ten Cabo postcards. The wind had built, and the powerful following seas were throwing a bit of spray as the boat sailed alongside the massive headland of rock. A few buildings, hotels mostly, could be glimpsed up on the bluffs. Finally, we were past the iconic point, and the low-lying city of Cabo San Lucas was revealed.

Once we were inside the headland, the scents of earth, fruit, and flowers enveloped the boat. It was warmer and a bit calmer as we turned up into the wide-open bay. We whooped and hugged, and I cried some tired-but-happy tears. We'd made it past the point we'd been aiming at for so many months. Including the miles that we'd logged getting into bays and anchorages, and those spent tacking away from our goal, we'd gone over a thousand nautical miles. Downwind, but still, we did it.

And I did it. I made it here. Me. A woman with absolutely no sailing experience helped to sail a boat over a thousand miles.

The Port Captain in Cabo San Lucas wore a pressed white uniform complete with braided gold epaulets and a row of gleaming medals across his chest, like a costume out of a Gilbert and Sullivan light opera. But this was no laughing matter. He was quite serious. The questions he asked—names, boat name, number of crew on

board—were all answered quite clearly on our check-in papers, which he held, but they were asked with a gravity that came from years of sniffing out fraud.

On our way in, we'd taken a wrong turn in the big municipal building and found ourselves looking into the storage room, stacked floor to ceiling with cardboard file boxes, each clearly labeled by year in black felt pen. We marveled at the mountains of paperwork before finding our way to the first of many offices we'd visit that day. After the receptionist and the secretary, we were interrogated by the assistant port captain, then we were ushered in to see the man himself.

We were all very polite, and bent over backwards. Us, trying to be very helpful, and the officials, trying to be very efficient. And they did it mainly in English, though we'd been warned that no one would speak the language, and therefore I'd taken great pains to learn the meaning of every word on the many forms in Spanish. Lots of nods and smiles helped bridge any lingual gaps.

Our port fees amounted to a few dollars, which we produced in pesos, having been warned not to offer dollars. We were required to carry our sheaf of official crew list and immigration forms, freshly stamped and autographed by the *capitan* himself, plus our passports, tourist visas, and fishing permit, from his office over to the customs office a few blocks away, then to the immigration office, and then circle back to his office, all so that the papers could be filed by one of the young assistants into a box that looked for all the world like the many identical boxes in the back room.

The day flew by in this pursuit. We'd agreed to meet up with the *Imagine* crew to have a meal, which I'd decided would be *carne asada*. After being a no-red-meat person for many years, I found myself craving beef. Russel was shocked and delighted to hear me say that, as he'd always claimed to feel guilty eating his favorite carne asada burritos in front of me.

Chris and Stephen had gotten to Cabo early enough the previous day to get their paperwork done and have dinner, and they recommended we eat lunch at the same place. The open-air restaurant had a palapa-style roof of thatched palm fronds but no walls, so we could people-watch while we ate and drank.

An hour later, sated and slightly buzzed on Pacificos, we said goodbye to our friends and stopped to buy a few provisions at a small tienda. Loading our packs, we wandered down to the dinghy dock and rowed out to *Watchfire*. The harbor was barely protected from the swells and wind that wraps around Cape San Lucas at Land's End, and the many anchored boats were all bouncing. Just before sunset, we headed back to shore to get fuel for the next leg. There were no taxis about, so we had to lug the full jerry jugs a long ten blocks before we could load them into the dinghy on the beach. Then it was back out to perform the acrobatic stunt of getting the jugs up onto the lifting and bouncing surface that was our boat at anchor.

That evening, the waves rolling into the anchorage got bigger. Pretty soon *Imagine*, anchored a couple hundred feet from us, was completely disappearing into the troughs between swells. I felt okay, oddly enough, but Russel looked a bit seasick.

Lying in our v-berth that night was like trying to sleep while underway, so the actual sleeping hours were few. I had been looking forward to reaching Cabo for a very long time, but by dawn I was eager to leave.

Bashing North

AFTER NEARLY A MONTH OF sailing south, beating our way north from Cabo San Lucas to La Paz was the next leg of our voyage. I knew it wouldn't be fun, since heading "uphill" against the wind is always tougher, but it was the only option if we wanted to reach the Sea of Cortez. And with the *Imagine* crew beside us, two hardy Brits who'd already crossed the daunting Atlantic, how could we go wrong?

That morning we were cheered to see yet another little sailboat motoring out of the harbor ahead of us. The neat lines of the vessel caught my eye and I pointed it out. Russel told me it was a Bristol Channel Cutter, one of the sturdiest small boats ever to sail. Next went *Imagine*. We were in good company, and off we went.

The first few miles were tolerable, though the wind and swells hit us smack on the bow from the beginning. Bouncing past the snug anchorage at nearby Hotel Palmilla, we wondered aloud if we'd be better off staying a few more days and waiting out the blow. But the weather reports made it clear there would be no letup in the north winds for over a week, and the conditions would deteriorate further, before getting better.

We decided we were going for it. I steered for the first leg of the trip, sure that I had the technique mastered. I was queasy but not nauseous at that point, and I focused on the horizon, trying to stay

ahead of the seasickness. The sun was shining, the sea was blue and frothy, and I was full of confidence.

Soon, *Watchfire* was struggling up each oncoming wave and plunging down the other side, only to head up again, moving forward but seemingly going nowhere. It was as if something unseen was pushing us backwards, like the house in the horror movie that says, "get out!"

Two very long hours into the eight-hour voyage, we saw a sailboat up ahead, heading toward us. It was hard to see it clearly, with the foam flying and the seas so churned up, but eventually Russel was able to make out the lines of the boat, with the help of the binoculars. He set down the bins and turned to me with an unfathomable look.

"What is it?" I asked.

"It's the Cutter," he said.

"What Cutter?"

"The Bristol Channel Cutter," he said. "They're heading back to Cabo."

My stomach plummeted, and I nearly sobbed aloud. If that sturdy boat was giving up on going north, and heading back to the barn, how could we go on?

We immediately radioed *Imagine* and were heartened to hear that Stephen thought the dropouts to be lacking in courage.

"It's only a bit of breeze," he said, with such deliberate understatement that we had to laugh. "The fellow's obviously not British."

Neither are we! I silently mouthed to Russel.

Stephen said the weather was bound to improve when we got around the first point, 20 miles ahead of us (about four hours, at best) and that they weren't willing to go back.

"We don't want to do this all again, now do we?" he asked.

Nothing sounded worse, at that point, than doing this leg over. We went on.

My stomach flipped and flopped as *Watchfire* battled her way over the waves, each seemingly trying to lift us onto its back and carry us south. Every drop down a wave made my stomach lurch and fall like I was dropping a few floors in a broken elevator. Each time was worse than the last. Eventually, the nausea caught up with me and I was forced to surrender and go below. Wedged into the settee, a bench-like couch, lying completely still with my eyes closed, I could tolerate the situation. I couldn't fall asleep, but I could *maintain*.

I took over the helm from Russel at midday, so he could try to sleep, but he had no more luck than I. He wasn't feeling sick; he was simply "too interested," as he put it. So, he came back up, took over the tiller, and advised me to go below again. My dreams of having licked the mal de mer were shattered, and I had thrown up repeatedly.

"I'll need you later," he said, "if we have to come in after dark." He'd plotted our course again, based on our actual speed, and it seemed a surety that we would not make Bahia Los Frailes before sundown.

We didn't. It was many hours later when we finally rounded the point that had seemed so tantalizingly close all day, and began to beat our way into a large bight that held the small, protected bay.

Again, I was mostly prostrate below as Russel steered us through the night to our goal, a tiny blue circle on the chart. Somewhere in those long hours below, I slept fitfully, having a nightmare that was like something out of *The Exorcist*, with me flying up to the ceiling and spinning around, possessed by demons. I woke to feel the boat lurching and flying through the waves and nearly wished myself back in the hideous dream.

It seemed the day would never end. But when we finally made it around the final *punta* (point) into the small *bahia* (bay), it was as if the weather had been switched off by some giant hand. Starlight shone down on flat black water, almost completely ringed by natural

stone walls with sand beaches, and the wind fell to a whisper, blocked by the low mountains behind the bay.

Having dropped the foresail, I stood up on the bow, trying to guide us in. Staring into the dark water, trying to avoid the dangerous rocky outcropping drawn in our chart book. Once safely past the danger, I stood there marveling as we glided across the smooth starlit water of the bay.

As Russel circled the bay, where *Imagine* already sat at anchor, I stepped down into the cockpit and sighed. My wry comment brought a tired chuckle from Russel, and soon made its way into our official list of life mottos.

"Sailing is like life. For every punta, there's a bahia."

Last Leg to Paradise

B AHIA LOS FRAILES LOOKED EVEN more stunning when we woke to a clear blue sky. The north wind was still blowing, and the seas racing south outside, but the bay was flat. We'd made a plan with *Imagine* to leave for the next stop up the coast at midnight, and we two decided to explore the beach, thinking it would tire us out enough to fall asleep right after dinner. We dinghied in to find pristine sand beaches set into coves of sandstone and rock. Walking inland on a narrow dirt cow path, we discovered small clumps of cacti and succulents like tiny xeriscape gardens growing in crevices in the rocky reddish earth.

I took far too many pictures on that first day ashore, and most of them show the same thing: deep blue sky, clear turquoise water, empty white beaches. I couldn't fathom why no one lived in such a naturally gorgeous place. There was definitely no fresh water, but still. It seemed an ideal vacation getaway for those who came prepared.

Chris still had smoked fish from the huge dorado that *Imagine* had caught on the way down to Cabo, so dinner was an easy meal, with plenty of side dishes. Here was perfection: delicious fish, fresh vegetables, good company, and stunning surroundings. We sat in the cockpit of *Imagine* with the sun setting behind us, as *Watchfire* bobbed in the tiny swells of the cove, and small waves crashed on the beaches of the Bay of Friars.

I woke at midnight to the sounds of Antonio Carlos Jobim. Russel had picked that cheery music to jolly us through our nighttime departure. Neither of us was ever happy to wake up and get going in the middle of the night—is anyone?—but we knew it had to be done, so we gutted it out and got ready to go. The weather seemed fine until we got well away from the bay, too far to even *think* about re-entering an unlit rocky bay in the black of a moonless night. And then we were pounding into the waves again, in a rerun of the trip from Cabo to Frailes, and heading for another unknown-to-us anchorage, around yet another punta, unseen in the darkness.

The trip to Bahia de Los Muertos was as bad as the trip to Los Frailes, but fortunately, it was a shorter run. Again, I spent most of the voyage below, too sick to be of much help, except when I was required to assist with the gas jugs. Again, Russel steered us safely through the night to our destination.

The Bay of the Dead is lovely, despite its bleak moniker, but we only went ashore for a very short hike and then returned to *Watchfire*. Our day there was too short, as we had to turn in early again, so we could wake again at the calmest time of day: midnight.

Once more, we underscored our waking with a samba or two, and again we took off in the wee hours. Fortunately, the wind was with us, and we sailed all night, arriving after dawn. I slept a good deal of the trip, sorry that Russel was again solo sailing but so glad not to be sick. Pretty well rested, I came up on deck to help us come into Bahia Balandra.

Our nautical charts of Baja were very detailed, and we also had a couple of books that had more specific information on the bays and inlets. One of these was *Charlie's Charts*, with its charming hand-drawn illustrations of the anchorages in the sea.

Coming into most well-protected bays is fairly straightforward, as you simply stay in the center of the opening, but Balandra has a long underwater reef that makes it necessary to stay far to one side

of the entrance channel. It was a bit odd to be so close to the shore, but the noon sun overhead made the situation ideal for what Russel called "Caribbean Navigation," meaning I stood on the bow looking into the water in front of the boat. It was easy to see the underwater rocks on both sides, making me confident enough to guide him in with hand signals.

We anchored in a lobe of the big, nearly enclosed bay, off a curve of white beach with water so clear we could see the anchor dug in below us in the sand, which made us feel quite secure. Once we settled in, I made us breakfast with the last eggs and bread.

"French Toast," Russel remarked with a grin, "Why Julia Gibbs!" (We often quoted *Our Town* even after all the years that had passed.) Despite his lack of sleep, he was as thrilled as I was to be so close to our ultimate year-end destination. We toasted each other with the last of the canned orange juice.

After breakfast, Russel hit the berth for a long morning nap, while I sat out in the cockpit with my journal and a cup of tea, writing and taking in the day.

Just a few miles from La Paz, Balandra is a picture-perfect bay. In fact, we'd seen postcards that featured the bay's iconic balancing rock landmark. From our boat, the view was breathtaking. White sand beaches wrapped around clear aquamarine water, all surrounded by rolling brown and green hills. People were on the farthest beach, near the dirt road. Another family was closer, at a small sand beach, wading into the shallow water in rolled-up pants and shirts, probably clamming.

I couldn't wait to learn how to find clams, the key ingredient for one of my favorite linguine dishes. Supposedly, there were scallops to be found in the rocky bays of the Sea of Cortez, too, and diving for them was yet another lesson waiting to be learned.

We got together that afternoon with Tim and Kay from *Harbinger*, another small sailboat we first saw in Turtle Bay, to celebrate having

conquered the seas from Cabo and made it to paradise (the crew of *Imagine* had opted to go on to La Paz). There was one bottle of champagne left in our storage locker, not exactly cold, but cool enough. We followed that with the last of our fresh provisions thrown together into a big salad to go with my spicy beans and rice. The early dinner flew by, full of sea stories, jokes, and even a song or two before they headed home to their boat.

We barely made it to sunset, but it was worth staying awake for. The hills had turned a deep violet, and the sky was illuminated with golds and deep reds, all reflected on dramatic cloud formations that spread across the cerulean sky in rose, gold, and hot pink billows and streaks. The water of the bay reflected all the colors on its glassy surface, mirroring the celestial glory. La Paz sunsets are justly famous, and though I am still partial to dawns, sunset would prove to be a high point of each day to come.

I watched the sun disappear, visualizing my mom watching the sunset from the pier in Ocean Beach. The same sun, the same earth, the same twilight. It would already be night in New York. I tried to picture the Manhattan skyline as seen from my old bedroom window. It seemed like another world from here.

Our schedule didn't allow us to linger. We were due in La Paz to meet up with our friend Joan's parents, who had been on vacation there, renting a small apartment. Joan had arranged for us to take the place over for a while if we met up with her parents before they left town. I was dreaming of a hot shower, perhaps even a *bath*. With no idea what the amenities would be, I knew that anything would beat rinsing off in a tepid solar shower in the breezy cockpit.

Russel and I hugged in the fading light of twilight over Balandra, its hills now inky silhouettes against a deep red sky. So much beauty to take in, and so little time to explore it. There was no doubt that we would be back.

The Garden of La Paz
December 1989

OUR FRIENDS RON AND JOAN had stayed at Marina de La Paz, the oldest marina in town, so we motored the boat directly there the first day. Mary and Mac Shroyer, the founders and proprietors of the marina, were long-time sailors from Northern California who'd moved to La Paz after first arriving on a trimaran in the late 1960s. They ran the marina with efficiency and kept their rates reasonable, plus the Club Cruceros (Cruiser's Club) was *the* spot for cruisers to do everything from receiving mail to exchanging paperbacks.

We'd bought two folding bikes in San Diego, and they became indispensable. La Paz lies alongside the long narrow harbor for miles, from the entrance of the big bay by the ferry terminal at Pichilingue, clear down to the newest construction, FidePaz, located way out on the road to the airport. Most of the business of day-to-day life could be done at shops and markets located in the Centro section of town, about ten blocks square, but we were required to visit the port captain and immigration, plus make copies, and visit banks, and it all had to happen on the first day you officially checked in.

With the boat safely tied up in a marina slip, and our paperwork handled, it was time to enjoy living ashore in the capital city of Baja California Sur.

How can I convey the joy of the simple everyday pleasures of apartment living after months of boat dwelling in the marina and then a month on a sailboat at sea?

The experience of my first shower was nearly unparalleled. All that water, running as hot as I pleased for as long as I liked. Being able to shave my legs and rinsing my clean hair in fresh water till it squeaked. Stepping out of the shower stall in a warm room, with a clean fluffy towel. Drying my curly hair at leisure, inside my own private apartment, instead of having the salty sea wind dry it into a broom-like brush.

And having a whole working kitchen was like being in *The Jetsons*. A flame that fired up with a turn of a dial, a vast oven, a microwave. The refrigerator seemed huge to me. And inside it was always cold, even at noon, not to mention it had a freezer that made actual ice cubes. There was even a cup-sized slot in the front of the fridge that dispensed cold water or ice, and it was a struggle to make myself stop playing with it.

This was heady stuff. It seemed like a lifetime since I'd wandered over to a fridge and opened the door to peruse the contents, wondering if I wanted to whip up a crisp salad from a bevy of ingredients, or nibble on some cold chicken.

Obviously, we had not been short of nutritious tasty meals and snacks aboard *Watchfire*. But the struggle of acquiring and storing our food was cut way down, though we were still shopping for food on foot or by bike.

The apartment house was named Jardin de la Paz, Garden of La Paz, and it lived up to the name, with a red-tiled courtyard full of lushly fronded palms and shiny green banana plants. I could step out and sit by the fountain and read in the early morning sun.

Exploring the city by bike was great fun. Aided by Mary Shroyer's advice and free city map, we discovered museums, auto shops that sold parts we could use for the outboard, two movie theaters, a few

small shopping centers, and even a department store, La Perla. That name is big in La Paz, due to the long-time pearl diving industry, and one of the biggest local hotels is called La Perla, too.

There's nothing like walking into a big, clean, air-conditioned department store if you've spent most of the last six weeks out on the ocean or on a beach. The number of attractive things displayed everywhere you turn can be a bit overwhelming. At first, I wanted everything I saw: summer dresses, colorful lipsticks, delicious smelling lotions, and glittering bottles of perfume. But because everything I considered would have to be put somewhere on the boat, and most of it seemed unnecessary by this point, I kept putting things back down. With the air conditioning chilling me, I gravitated toward the exit where I spotted Russel waiting, and we both ended up leaving empty-handed.

Outside the store was a street taco booth that featured shrimp and fish tacos that were the best I'd ever had. The tortillas were small, like Tijuana street tacos, but so soft and delicious that, along with the fresh tomato salsa, they would have been a meal in themselves. Russel tried one of each type, plus some octopus ceviche, and we washed it all down with the fresh fruit drinks known as *licuadas*.

The city's open-air market was a bit odd. First, it wasn't open at all, but covered, though the big wide barn doors were always open to the elements. There was no air-conditioning, so why not? Arranged within the circle of small shops featuring meat and seafood were tiny booths overflowing with fruits, veggies, and prepared foods.

I stared in horror at a hog's head in the *carnicería*'s display case. Flies buzzed around the trophy, crawling into the dead pig's eyes and nostrils. There were flies on the fish, too, but they sat on a bed of ice, with a fan blowing across their shiny scales.

Speaking Spanish to the man at the meat counter, I got quoted a lower price than Russel had been quoted minutes earlier.

Once I fumbled into Spanglish, I could see the man reassessing me as a tourist.

Unfortunately, I lacked the names for fruits and veggies. I knew *manzana* and *naranja* for apple and orange from somewhere in my past, but I had never heard *lechuga* for lettuce or *sandia* for watermelon. I hefted a huge green sandia, picturing myself eating it at the beach, the rinds scattered about, sprinkled with sand. Sandia would be easy to recall, with that mnemonic, but it was too heavy for this trip—we had a long walk home ahead of us and our net bags were already bulging.

"*Buenos dias*," I said to the lady behind one of the counters. She wiped her hands on her apron, gesturing to the stools in front of the counter. "*Dos burritos?*" I queried, not meaning to sound so unsure.

She rattled off a few options, from which I caught carne asada and *machaca*. Russel stuck with carne asada but I chose machaca. The dried shredded beef can be stringy and dry in tacos, but seemed like it might work great in a burrito. She nodded and moved away, and we tried not to drool as we watched her assemble and deliver our lunch. The burritos were almost as small as the rolled tacos in San Diego, but were the most delicious burritos I'd ever had.

"*Muy rico!*" I praised the food when the Machaca Lady returned with our sodas. At that, she smiled her first real smile, responding with a rush of Spanish that was incomprehensible to me. In answer, I took another bite. Russel tried my machaca, and then held up two fingers, asking for *dos mas*.

"Um, *tres* mas," I said.

She wrapped up more burritos as I tried out my broken Spanish, asking about her health and her family. She responded with questions of her own. I replied that we were from San Diego, were here on a sailboat (Russel had taught me how to say *barco de vela*, or boat of sail, one of his few Spanish phrases). We had gotten married in May,

so we were on our, "*como se dice* 'honeymoon'?" I smiled quizzically and hugged Russel as a sort of visual aid.

"*Luna de miel*," she said with a smile, before turning to a new customer.

"That's so great," I told Russel, "Honeymoon is luna de miel, literally moon of honey."

That became our phrase of the day. We bought some wine *because we were on our luna de miel.* I splurged on fresh strawberries *because we were on our luna de miel.*

When we left the market with a last wave at the Machaca Lady, I was already looking forward to coming back. If I came back on my own, and added some words to my limited Spanish, I might pay local, not *turista* prices. And I needed to do some shopping before our houseguest arrived.

Russel's mom, Alice, would be arriving while we were still at the apartment, which would enable us to show her a good time and limit the boating to a fun outing or two. Though very fit and nimble, she was in her seventies and not a boater.

Walking home, we discovered a Bing ice cream store. The shop was charming, with wrought iron chairs and tables outside for eating and watching the world go by. Of course, we stopped for dessert *because we were on our luna de miel!* It turned out to be rich, creamy ice cream, and my Bing cherry (what else?) was full of sweet fruit. We agreed we would splurge and take a quart home to our very own freezer.

Holiday Daze
December–January 1990

THE DAYS ASHORE FLEW BY, hurried along by Alice's visit, which entailed acting like cultured tourists. We visited museums, curio shops, and even a weaver's studio. Alice also insisted we tour La Paz by taxi, which turned out to be well worthwhile. Our garrulous driver showed us the history of the capital city, including an abandoned whorehouse which he said had been home to "the girls to play with."

We took Alice on an overnight sailing trip out to a nearby bay. Quite the determined angler, she caught a couple of Sierra mackerels that made very good eating. Russel had told me about her passion for fishing, but I was still surprised to see her so patiently bent over the rod for hours. Alice always dressed to the exacting standards of her heyday, attired in pressed slacks and blouses, nylons, and pumps, with her hair done and her face fully made up. I'd always felt she rather despaired of me, since I dressed in thrift shop clothes, seldom put on makeup or wore nylons. Eventually, as we spent time together and shared our love of certain authors, especially Willa Cather, she'd thawed a bit toward me, and though we were hardly what I'd call friends, we got along.

The Christmas holidays swept us up in parties and potlucks with our friends on *Imagine* and some new cruising friends as well. We were treated to quite a Feliz Navidad, with plenty of holiday cheer.

Alice was a great sport about it all, including going out to *Imagine* by dinghy, and we were sad to see her go.

New Year's Eve was upon us before we knew it, and there wasn't a seat to be had in any restaurant. It turned out that many places in La Paz closed for New Year's Eve, so the pickings were slim and had been booked well in advance. Russel was handsome and dashing in a blazer and slacks, and I wobbled along on high heels in my only fancy dress. With nowhere to go, we walked and people-watched on the brightly lit *malecon* (embarcadero) for an hour until we got hungry enough to settle for hotel food.

We ate a terrible club sandwich at the Hotel Perla, and when they closed before midnight, which seemed very odd, we strolled down to the Hotel Los Arcos for a drink on their upstairs patio, looking out at the boats bobbling in the harbor. And then we came back to the apartment to "consummate our marital bliss" as Russel put it so well. After sharing our space for a while with Alice, we were hungry for each other and had been taking every chance to make up for lost time.

We found out later where everyone went for the big New Year's party—the small bar in the alley behind our apartment house. The noisy revelry continued until it was nearly light. We didn't get much sleep and had to move our things by noon but, luckily, we hadn't had much to drink, so we were tired but not hungover.

I packed all morning while Russel ferried things down the street by bike and out to the boat by dinghy. He took the last load out to the boat while I cleaned the two rooms and then we rode our bikes to the Bismark Restaurant. Though the decor, a wall-sized mural of a sinking battleship, was a bit odd, the *chiles rellenos* were the ideal lunch. We happily stuffed ourselves before cycling slowly through the empty streets to Marina de La Paz, making it back to our boat's v-berth for *siesta*.

The next few days were crammed full of boat jobs, including fixing our busted water pump, repairing the head, and generally getting the boat squared away. A fellow cruiser who'd heard us discussing our water pump issue on the VHF net offered us his spare repair kit, saying he'd upgraded to a larger model, but often a task was put off as we searched for a tool or part.

We'd scoffed at the concept of blue and pink jobs, which was how we'd seen the male and female jobs divided in various sailing articles. Instead, we figured out who was best suited to the task, and the other person either stayed out of the way or played the part of the operating room nurse, handing the doctor tools as needed.

One shopping trip turned into a long day, trying to find a twelve-volt bulb, starting with the local auto parts store. I'd been told a small light bulb was called some name no one there had ever heard, so they sent us to another tienda, and the guy there sent us to another, until someone finally told us that the small bulb was in fact called a *bombilla*. After visiting five stores, we were finally asking for the thing by the correct name, and found one back at the Pep Boys where we'd started.

The next day, we took a bag of paperbacks to the Club Cruceros to exchange for new reading material. Knowing that Mary Shroyer liked literary fiction, I took the cream of the crop to the office and handed it to her. Our conversation about recent favorite reads lasted until lunchtime, when Mary suggested we try the cart in front of the marina. The cart's sole offering was tamales, she said, and they sometimes sold out in an hour.

The tamales were excellent, coming in a close second to my grandpa's. (Nena's second husband, Grandpa Jim, was a Midwestern transplant who learned to prepare tamales and chiles verde better than many Mexican *abuelos*.) We had two each and then had another for dessert. Neither of us had ever come across tamales with a whole green olive stuck in them before, and we quickly learned to beware of the traditional olive pit.

That afternoon on the boat, we wrote an illustrated New Year newsletter to send to our friends and family. The words were a joint effort, but Russel designed and drew it. It was so satisfying to be part of a creative team, even if the job was purely for fun.

I rode to the post office the next morning, bought some wonderfully colorful stamps, and got a stack of our newsletters off. There's something so satisfying about mailing out correspondence. Despite not finding the other two things on my shopping list, including lamp oil, an actual necessity, I had accomplished something major.

Anchored off the marina, we'd become familiar with the La Paz Waltz, the haphazard dance of anchored boats across the bay each day as the wind and tides shifted. On our first "ask-i-versary" (one year since the day he asked me to marry him) a cold front came in, bringing 25–35 knots of north wind. Russel was up and down all night checking our anchor, and had fallen back asleep around four. A bell ringing brought me peeking out of the hatch to see a big powerboat coming toward us, sideways. Cursing, I ran up on deck in my sleeping shirt, with Russel right behind me.

There was nothing for either of us to do as the runaway vessel missed us by a few feet, but the adrenalin rush took a while to wear off. The boat had dragged its anchor, and ended up on the beach after striking a nearby catamaran a glancing blow. Later on that day, at maximum high tide, we got into our dinghy and helped a small group of cruisers pull the powerboat off. At sunset the wind finally died, and we had a nice celebratory dinner, though Russel was nearly nodding off.

After another two days of laundry, provisioning, and boat jobs, we were ready to sail north again. I couldn't wait to be out at sea once more, exploring the gorgeous nearby islands we had so far only glimpsed.

Farewell, *Imagine*
January 9–14, 1990

OUR FIRST FOUR DAYS BACK at sea were spent at Islas Espiritu Santo and Partida, two large linked islands which are visible from some balconies in the city of La Paz on a clear day. The water was clear, but still a bit cool, so we stuck to hiking and beachcombing and relaxing on the boat at anchor. January 11th was the two-month anniversary of the day we left San Diego, or 60 days on the boat, less the few days we'd spent at the apartment.

On the fifth day, we woke up early and sailed north. The wind was just right to make San Evaristo, which promised better protection from the west wind, so we passed by lovely Isla San Francisco, promising ourselves we'd stop at the long curve of white sand on our way back.

Off Evaristo, we tried hailing *Imagine* on VHF and were pleased to hear them come back to us. They were off Santa Catalina, sailing south, so we decided to go further north, meet in the middle, and have dinner together on *Watchfire*. They were heading back to the States, so this might be the last time we would see them.

We pulled into the anchorage a bit later than hoped for, but seeing our friends' boat come in and tuck into the little point beside us was so joyful I couldn't be sorry about having invited them over. I set about concocting a dinner of pasta with the last of our fresh chicken

and some veggies. We'd shopped well in La Paz, but only so much fresh food would fit in the ice chest when it was full of ice, so I was limited as to how much meat and cheese I could buy. Of the veggies, only lettuce and tomatoes went in the ice chest, the rest, along with bananas and apples, filled the bulging mesh fruit hammocks that lined our little galley and extended into the main salon.

Everyone talks about not drinking the water in Mexico, but we'd found the water in Baja to be no problem at all (that rule applies to the old cities on the mainland, we later learned, where many a city's municipal water pipes date back to not long after the revolution of 1910). Many people advised washing all fruits and vegetables, but we gave up on that too, preferring to add a few drops of bleach to our boat's tap water (brought to the galley sink via foot pump), so that everything we rinsed got a quick cleaning. We had not suffered any intestinal distress, and vegetarian dishes with rice, beans or pasta were mainstays of our diet, along with fish we caught or bought.

We'd been warned back in San Diego to not bring any cardboard from the Mexican stores onto the boat, as they might have insect eggs or larvae in them, which would turn into crawly bugs or moths. Despite us opening and putting everything in plastic bags before bringing it aboard, somehow the teeny critters always slipped in.

The first time I opened up a bag of pasta and found weevils in the semolina, I'd tossed the entire bagful overboard as fast as I could, double bagging the empty bag to make sure that the wormy little rascals didn't infest any more of our onboard stores. The second time, when we were farther from a shopping trip, I spent hours sifting and separating the tiny larvae from the pasta before I (over) cooked it, rationalizing that they hadn't eaten much.

That night in the unnamed cove, with my dinner guests minutes away, I dumped everything straight from the bag into the boiling water, pasta, weevils, and all, then skimmed the critters out with

a slotted spoon as they gave up the ghost and floated to the top. I had to share this with Russel, and he told Chris and Stephen, after pouring them a cocktail, and pretty soon we were all laughing about what the next step would be—perhaps featuring the weevils as the meat course?

I shared a story I'd recently read in James Michener's *Covenant*, about South Africa: the indigenous people of Cape Town would barter with English sea captains for as many pounds of their ship's weevil-ridden hardtack as they could spare. The English sailors laughed, saying that the indigenous people were too ignorant to know how little they were getting in exchange for precious stones and gems, but the locals laughed even harder at the stupid Englishmen who would practically give away such a handy source of solid protein.

We had a lovely time over dinner, but we agreed to make it an early night as we all had miles to go the next day.

Much later, Russel and I were woken up by the sound of something bumping against the hull outside of our v-berth where our feet tangled cozily under the covers. Russel popped up and peered out the big hatch above our bed, and soon I was looking out as well. Our friends' dinghy, tied to the stern of *Imagine*, was so close its transom was tapping our bow. Quite a bit heavier, their vessel had swung one way, and our light little *Watchfire* another, and now our little worlds were in danger of colliding.

Calling "air-hair-lair" to them brought a blond head popping up and calling out in surprise to find us mere feet away. Soon Stephen looked out and we shared a laugh. We moved the boats apart, and not too many hours later, got up to say our farewells. They were nice enough to take a photo with our camera of us aboard *Watchfire*, with the early morning light on the cliffs behind us. The photo appeared on our holiday card almost a year later, and we still treasure it.

A Captive Audience

THE NEXT DAY WE WERE both in the cockpit, basking in the weak winter sun as we sailed north. The wind was light, but not so light as to make us want to motor. The seas were calm, and we were gliding along over the swells with minimal pitch and roll. We'd had lunch, read a bit, taken turns resting, and were listening to Jerry Goldsmith's "Islands in the Stream" while chatting.

"God, I miss theater," I said.

"I don't think we're going to find any up ahead," Russel said with a smile.

"You don't think there's a Mulegé Moliere festival?"

"No. And I think the Sea of Cortez Shakespeare Company is on hiatus."

This exchange led us to a best-show-I-ever-saw comparison. He extolled the performances at ACT and the Old Globe, and I recounted the multi-media Broadway stage production of *Execution of Justice* about Harvey Milk.

"I saw it on opening night in 1986. Jimmy and I were completely blown away by it, and it closed ten days later. What a crime."

"It is called show *business*. Guess they didn't sell enough tickets."

"But it was amazing! The only production that held a candle to it was *Orphans*. I sobbed like a baby after that play ended, along with half the audience."

A silence followed. The film score was over. Someone had to go below and pick something to play. I lamented that our music library lacked any true musical theater options. When Russel asked what cast album I'd pick to listen to right then, I hesitated.

"*Godspell,* maybe. No, I think *A Chorus Line.* It has some really rousing sing-along songs. Hard to beat that score."

"Huh. Never saw it," he said dismissively.

I was flabbergasted. "You never saw *A Chorus Line?* Seriously?"

"I don't think so."

"You would know if you had. It all takes place during an audition, and was based on . . ."

I went on to tell him the story of how the play had been written and gave him a brief synopsis, stressing that it lacked any power without the music and lyrics. I recalled for him the day our friend Steve had first played the cast album for me and Helen. We had been so touched that we all ended up on his couch, in the middle of the day, in tears. Knowing Steve's great taste in music, Russel was impressed.

"Sounds like I missed out," he said. "I'd like to hear it."

"It starts out like this," I said, humming the opening bars. I stopped with a laugh. "I did listen to it an awful lot, and probably know it by heart."

He sat back and encouraged me to proceed, so I launched into it, describing what the dancers were doing at the beginning and humming as much of the orchestra sounds as I could—bada-ba-bada-ba-bada-*bump*-ba.

As we sailed along, surrounded by sea and sky, with the arid desert landscape a low barrier to the west, I performed the entire musical, singing all the parts and explaining as much of the action as I could recall from seeing the touring production.

Russel was an attentive audience, smiling at the silly jokes in "Tits and Ass," "Sing," and "Nothing," and looking suitably moved by my rendition of "What I Did for Love."

I was in my element, belting out the choruses, hamming it up with the funny cracks, and even trying to carry off the final rendition of "One" where half of the cast members sing different lyrics in perfect syncopation.

When I took a bow, he gave me a standing ovation.

"That was amazing! Brava!"

Even though I'd been acting since kindergarten, and had done a number of good roles to some pretty nice acclaim, that was my all-time favorite performance. I killed it.

But it was not my last on-board performance.

Almost exactly a year before, in early 1989, Russel and I had taken a train from NYC up to Boston to visit his old friend Robert Morgan, a renowned costume designer who was currently the dean of the Boston University theater school. An hour into the trip, I asked what Bob knew about me; I'd never met him at the Globe, as his reign started after I moved to LA. Russel shrugged, saying he'd said only that he was marrying an actress from New York. When I said that Bob must know we met at the Globe, Russel said he was sure that it had not come up that his new fiancée was a Californian.

"So, he don't know I'm from New York?" I chimed in, as Angela, a very over-the-top character I'd invented. "Yo, youse think I could get a job with him? I done all the Shakespeare roles, ya know, Lady Mack-bet, Or-Feelia, and Juli-Et. I can do some Lady Mack-bet for him, right?" I went on and on, improvising a bit of monologue, complete with "out damn spot an shit."

Russel, teary-eyed with laughter, said that Angela might be too much for Bob and, unprepared for my alternative persona, the poor man might have a heart attack. We ended up telling Bob the story once we were settled in his comfortable office, and he and Russel were all caught up. He was aghast that we might have sprung Angela on him as Russel's soon-to-be-wife.

Long story short, Russel had met Angela, and knew I could "freestyle" as that character pretty effortlessly. So, a day or two after my performance of *Chorus Line*, I was staring out at the rocky coast south of Bahia Agua Verde when I started talking as Angela.

"Where's the beach? I ain't seen no real beach. Youse told me Mexico was white sand beaches and palm trees and whatever, but this here is all rocks and shit."

"We'll see plenty of beaches, Angela," Russel immediately replied. "In the meantime, aren't the rocky cliffs sort of pretty?"

"Yeah, sure, they are okay, but not what you promised me. You said beaches and palm trees, right?"

Russel laughed and bantered easily with Angela as we sailed on. But he eventually started to look a bit worried when I wouldn't drop the character.

I kept saying, "What do you mean, stop talking like that? This is how I talk."

Soon, clearly worrying about my mental state, he was begging me to stop.

Finally, I went back to my real voice and Russel almost cried with relief. He eventually saw the humor in it, but he pleaded with me to "Never do that again. I was afraid you got stuck and I was going to be married to Angela."

Man, oh man, being an actor can be fun. Even if your stage is a few thousand miles from the Big Apple.

Diving Right In

ON OUR FIRST MORNING IN Agua Verde the sky was clear. To the east, the famous tall white rock that marks the bay was visible from our anchorage. To the west, figures of people scurried around on the beach. Men got into pangas and zoomed off into the sea. Groups of women shepherded both kinds of kids, human and goat, along the beach to the small scrubby fields that enveloped the cove.

I stood up on the bow, watching it all. After a year of anticipation, ever since Russel first showed me Puerto Escondido on a map, suddenly we were in no rush to travel the 20 miles north to the hidden harbor.

By noon the air was warmish, and I opted for a swim. The water was cool, but there's something about stripping off all your clothes and jumping into clear blue water that is irresistible. The combination of cold and the slight frisson of fear—you are off the boat, after all, out in the ocean on your own—made for an exhilarating experience. Even when we turned our short off-boat swims into baths, it was still fun.

We tried, like good scouts, to maximize cleanliness and minimize the use of our fresh water. I'd bring up a bucket of salt water and douse myself. The water was slightly cool, but usually welcome, if I bathed in the afternoon. Then I'd follow with the salt water shampoo, from head to toe. Once I was fully frothed, I stepped carefully to the side

of the boat and jumped into the sea. A quick rinse was all it took to complete my toilette. Soon I was back aboard, clean but shivering, a beach towel wrapped around me, a bath towel wrapped around my hair. My thick shoulder-length hair required a sunny day to dry, or it stayed damp for hours.

Doing small amounts of laundry during each bath came naturally. A pair of panties or a lightweight shirt could easily be part of a bath-day dip, then get hung over the lifelines to dry. Our bath towels were too thick for the ever-present humidity, and those that were dampened by salt water seldom ever relinquished that state. They could hang over the boom for a day in the sun, without ever getting fully dry.

After a day of sailing in light air, which entailed mostly sitting, I adored the freedom and weightlessness of being in the water. I could hold my breath like a seal, and often dove down into the cool depths of that day's anchorage to check that the anchor was sufficiently dug in, and to see how deep I could get. Water was nearly as familiar to me as air. My mom had introduced me to a backyard pool as a baby, having read that infants take to water naturally. I did.

One of my favorite shows as a small child was *Sea Hunt*. I was so jealous of the Bridges boys who got to snorkel along colorful reefs, dive off the boat backwards, and explore an underwater world I could only glimpse in our short trips to the beach.

By the time we moved to Venice, I was a two-legged fish, equally at home paddling over waves and diving under the surface. Years later, when we lived in San Diego, Nena moved into an apartment house with a pool not far from our house and we leapt those ten blocks daily, like salmon swimming upstream. We raced each other and played Marco Polo until our eyes were red and our skin exuded chlorine in the hot sun.

The one thing I could not do was to float. My mom showed me how a hundred times, but my legs always sunk like stones,

and soon I'd be thrashing about, gulping salt water and gasping for air.

Underwater, it was a different story. I slipped down through the green depths like a seal and surfaced like a dolphin. Whatever insecurities I might have about my body, my grace or lack of it, underwater I was as swift and sleek as a frigate bird in flight.

In New York City, my swimming was limited to yearly dips at the strangely quiet private stretches of Jones Beach, or a day spent splashing in the lame waves at Fire Island. All those years I ached for Venice, my haven and escape, the ideal place for brooding on the pier, bodysurfing powerful waves, wandering the tide line, and jumping across the wet rocks of the jetty.

Here in Baja, everything came together. Sunshine, astounding water clarity, and the gorgeous empty beaches meant that any chance to spend time in the water was precious, an opportunity not to be wasted. It was time to don my mask and snorkel, to explore the reefs and rocky points in every direction. I wanted to dive deep in the murky depths, to finally experience *Sea Hunt* first hand.

* * *

Puerto Escondido, a few miles south of Loreto, is a nearly landlocked bay considered to be the only hurricane hole, or totally safe anchorage in Baja.

Finally arriving, we dropped anchor in the small outer harbor, called The Waiting Room. The entrance to the big inner harbor is straightforward, if a bit narrow, but we were tired and it had been a long day.

The Waiting Room was full of other cruising boats, something that is always obvious to another cruiser, and some looked like they hadn't moved in years. One of those was called *Sand Dollar II*, and we met the owners Harry and Bea when we dinghied by the next morning.

They recommended taking a hike up to the clifftop far above us and we headed into shore to take their advice.

The Waiting Room is surrounded by mangroves and their long knobby roots, but there was a small beach where we were able to land and pull our dinghy up above the tideline and out of the way.

The trail was as easy to find as our new friends had said, and it led us quickly through the mangrove thicket and into the rocky heart of the land. We headed uphill at a slow pace, stepping gingerly between cacti and boulders, occasionally turning to glimpse the pool of blue water below us. The track grew faint and then disappeared. We leapt up onto large slabs of stone laid atop one another, eroded by wind and weather; devoid of vegetation, they looked like sculptures in some modern rock garden. Here and there we found embedded seashells, hinting at the area's fairly recent (in geological terms) changes in sea level. We stopped to study them, drank some water, and continued climbing up the small mountain. Finally, we reached the top.

The view from atop the narrow ridge was quite heady. High above the anchorage and everything else as well, there was nothing at eye level but acres and acres of clear blue sky. The Sea of Cortez stretched before us with only the islands of Carmen and Danzante marring its silvery surface. It was sunny where we stood, but the horizon was a thin line of clouds in the distance, and even those nearby islands were misty and indistinct.

Looking down from the edge of the sheer cliffs we seemed to be floating, the waves crashing into lacy edging below us. The salty air filled my lungs like helium, subtly encouraging the desire to fly. I took Russel's hand, my way of resisting that urge.

From such a vantage point our world is revealed as a place of beauty, strength, and grace. I was privileged to receive such a gift. It enabled me to believe that every inch of this planet was not yet spoiled and trammeled by us humans, and that there were a million glories yet to see.

I took a deep breath of the clean salty air. Russel looked over, saw my wide smile and grinned back.

* * *

We moved *Watchfire* into the main harbor the next day and found a spot to anchor out at one of the breaks in the rocky walls, called "windows" by the locals. Other than these, the popular bay is completely enclosed, except for the narrow entrance channel. The cruiser fleet was in, mostly, being that the northers were still blowing off and on. That meant a bay filled with boats from all over the west coast, as far away as Canada and Alaska. Most were sailboats, from those our size up to three-masted schooners. And a few powerboats as well.

Harry and Bea had introduced us to Keith on *Shangri-La IV*, a smallish powerboat. A charter captain who hung out in Puerto Escondido when he wasn't on a job, Keith took it upon himself to show us the ropes. In his early thirties, he was a wiry guy from New Jersey who worked, played, and drank hard. The self-appointed mayor of the local cruisers, he groused about how many boaters failed to "show respect" to the local officials. I enjoyed hearing his accent and cracked up when he showed surprise at our ignorance of something by saying, "Get outta town!"

The first time we were invited to *Shangri-La IV*, Keith greeted us with rum cocktails and opened some fresh *chocolate* clams for appetizers. He and Russel dug into the clams and I took a big gulp of my drink. I'd never had a raw clam before, but was game to try. Keith opened one in seconds with a scary-looking knife, handed me the shell loaded with shellfish and squeezed a *limon* over it. The pink-and-beige muscle contracted on the shell and Keith said, "Now." I scooped the clam into my mouth, chewed a bit, tasted the heavenly combination of sweet, briny, citrusy fishiness, and swallowed. I was in love.

Over dinner, Keith said he could give us a ride to town in his van to check in with the port captain and also promised to take me clamming for chocolates at a nearby bay sometime. I followed up on the clams with him the very next day as we ate lunch in Loreto. I was hungry for more of those amazing morsels and needed to know how to get my own. It took more than a few reminders and a bit of prodding to get Keith to take us out on his boat, but eventually he did.

He anchored *Shangri-La IV* in a wide, shallow bay. Clams live in many sandy bays, but they prefer a certain type of angle to the wind and seas, so experienced clam-hunters like Keith look for their prey in bays that are oriented just so. Standing in the knee-deep water, he showed me how to spot the tell-tale signs of a clam in the sand, and how to dig under it. Russel went with us that first time, but he soon turned the clamming over to me. His prescription sunglasses made it hard for him to see clam-sign under the water, and he could tell I loved my new role of hunter-gatherer.

It was true. I had discovered some blood lust in my make-love-not-war hippie-girl heart. I was thrilled to find a dozen clams on my own the next time we went hunting, and kept them fresh in a bucket of seawater until it was time for dinner. Then I created my own version of linguine with red clam sauce that is still one of my favorites, and we learned to enjoy the cooked clams as much as the fresh ones.

Keith also taught me how to find rock scallops and harvest them. I was soon gathering my implements—a screwdriver, a sharp knife, and a mesh bag—and diving in to search for these hard-to-spot creatures any time we anchored near any deep rocky points. I had grown up swimming in the Pacific Ocean, so the cooler water didn't bug me, but I was happy to score a short wetsuit on the VHF net, which made the water much more tolerable for long dives.

I challenged myself by holding my breath longer and longer each time I dove, as the scallops tended to be at or below 20 feet, and I soon was diving to 30 feet without a problem.

Later in the spring, anchored at a nearby bay, we entertained some local friends with fresh seafood and cocktails in the cockpit. One of our friends dropped their new sunglasses and they sank to the bottom of the bay. I got up and looked over the side. We were in about 40 feet. That was doable. I peeled off my cover-up, walked up to the bow in my bikini, and dove in.

The trip down was easy, pulling myself along the anchor line to save energy and breath and holding onto the chain while I cleared my ears a couple of times. Down in the dim green depths, I quickly spotted the dark glasses resting on the sandy bottom. I could never have done it without all that scallop diving. And, of course, the anchor line.

After the Storm

THERE WAS A PATTERN TO our days aboard the boat. We woke early and addressed whatever needed fixing or tending to on the boat, or we went out for supplies. One day we might catch a ride to the supermarkets of Loreto, another day might bring a series of dinghy trips to get water at the dock, or a leisurely walk to the market up at the trailer park. In the afternoons we retreated to the v-berth for a couple of hours, during which time we might doze, read, or just be naked in bed together.

Like all couples, we had arguments along the way, about which way to go on the road, which plan to enact for the day, even what to have for dinner. But like most arguments between newlyweds—and yes, we were still newlyweds—the difference of opinion was just that. Russel's outlook was often, but not always, more practical, and especially as it pertained to the boat, usually won out. My way of doing things was more instinctive, but I had a lot more experience in shopping for ingredients and cooking (I didn't work in restaurants for twelve years with my eyes and ears closed, after all), so when it came to food and provisions, my opinion carried more weight.

Where we ran into trouble was in our way of looking at life, and at the world. Russel assumes that most people are out for themselves, so each new person he meets begins from a position of being suspect, or at least on parole. He might like them right away,

but they are still *unproven*. I assume that everyone is generous and kind at heart, and that a stranger and I simply need to chat a little to achieve consensus, find common ground, and become friends.

It came as quite a shock to find that most of the people living in Baja on their boats were not what I expected. They were not hippies living a back-to-nature lifestyle as an expression of their love of nature and desire to embrace a simple spirituality. Many of the people we met could not have been more different. From right-wing paranoiacs who feared or hated the government, to libertarians who hated most laws and all taxes, the cast of characters was far more conservative than expected. And there were eccentric oddballs who'd never fit in anywhere, who had taken off to find their place in the world.

We were somewhere in the middle. Rather fiscally conservative and *definitely* socially liberal, we both grew up believing that the federal government was basically there to help people. The big difference is that Russel's parents were well-to-do and older; his father was already retired, and his mom was thirty-six when Russel was born, quite unusual in 1948. My parents were young societal dropouts in the 1960s, so I'd been raised to both question authority *and* trust in the universe.

When a small argument evolved into a showdown about how we viewed the world, things could get pretty hot. Russel tended to throw around words like "cosmic" and "hippie-groovy" when discussing my upbringing, and I might characterize his childhood as being "square" and "middle-class." These terms might not seem like fighting words, but as anyone who's ever been married can attest, all it takes is a great deal of love between two people to enable them to sling barbs most effectively.

We were anchored all alone in a small cove at sunset, when an argument broke out about what we were going to do once we got back to New York. Russel was talking about starting up his illustration business out in Long Island, where we had visited some

charming little towns. He would make a living doing illustrations and try to sell his paintings.

"I'll happily go back to waiting tables while I try to get back to acting, but I can't do that out in Long Island."

"I thought you liked Long Island? You were the one who said—"

"But not for *theater*. Theaters are in Manhattan. I'd spend my life on a train!"

Things heated up, and soon our voices were raised, and I was near tears. No. I'm never *near* tears for very long, so I was crying.

Russel started complaining about that, as in, "Can't you tell me what you're upset about without *crying*?"

That pushed me right over the edge.

"Obviously, if you really loved me, you would want to know *why* I'm crying, not spend your time yelling at me to stop."

"You're always *crying* about something!" he yelled.

"You're always *yelling* about something!"

"You're too sensitive about everything I say."

"That's because you yell about everything!"

"Why can't you calm down, Jenny?"

"Me calm down? You started yelling!"

"Jesus!" he barked. "You're acting like a baby!"

"You're acting like an asshole!"

I stomped out of the cabin and looked around wildly for a means of escape. Our boat sat at anchor about 200 yards from shore. The dinghy was pulled alongside, but where would I go? Speeding in circles in an inflatable in the dark is not like driving down the highway in a car at night with the heater on, blasting classic rock and roll. And my nearest friend's house was over a thousand miles away.

I plopped down on the hard wooden slats of the cockpit as far as I could get from the cabin door, frustrated and stymied.

Hearing movement inside, I peeked into the salon and saw Russel had gone up in the v-berth. He'd retreated, too, as far from

me as he could get on a 26-foot boat. Clearly, he, too, was nursing his wounded pride.

I sat fuming out in the cockpit until it was too cold to keep my mind on my imagined slights. I'd already forgotten why I was arguing against his plans to begin with. All I remembered was that he'd made me cry and then made fun of me for it.

But perhaps he'd been hurt, too. Or maybe he was waiting for my return in order to apologize for hurting my feelings. After all, I was the one who had walked out of the boat in the middle of our fight, and I knew he hated that. He might think I was still mad about whatever it was that we'd been so damn mad about.

I stepped down into the salon, waiting for him to comment cynically on my return, prepared to inform him haughtily that I would be sleeping out on the settee. But there was no sound at all.

He said nothing. I said nothing.

I stepped closer to the v-berth. And closer still, until I stood beside the quiet bunk in the near darkness, tuning out the plash of water against the creaking hull, listening with every fiber for his soft voice, welcoming me back into his arms.

Then I did hear something—a quiet buzz of breath and a gentle snuffle. My husband, the one I'd imagined listening as hard as I was to every move I made, my poor, soul-bruised, heartbroken husband, was fast asleep.

I undressed and climbed into the bed, grumbling to myself.

He reached for me, instantly awake. "I'm sorry, honey."

"I know. I'm sorry, too."

He pulled me close, and I melted into him.

"I love you so much," I said, with a sniffle.

"I love you more."

"No, I love *you* more. And women know more about love, so stop arguing."

He did.

Solo Meditations

WHEN WE FIRST SAILED OFF on *Watchfire*, spending the majority of my time with Russel sounded great, but what I hadn't anticipated was the dearth of alone time. I'd been living alone (or with roommates who worked long hours) for a while before getting married, and I'd grown accustomed to having plenty of time on my own. Even while I was living with my ex-boyfriend, my daily commute meant walking to and from subways, and zipping from Long Island City to work, class, and auditions. And though often in the company of other pedestrians, I was alone with my thoughts.

Though I'm a social animal, solo time has always been important to me. While living in a fledgling commune in the Santa Cruz Mountains, ten-year-old me snuck off alone into the woods on a daily basis to climb trees and boulders, peer into caves, and slip through dense blackberry thickets to find hidden meadows where deer grazed. My secret spot, tucked in a thicket of pines where a fallen tree made a tiny clearing, was just big enough for one. The log was covered with mossy growth and lichen, and a host of tiny flowers had bloomed in the rays of sun that snuck through the canopy. Fascinated by the miniature scene, I spent hours there spinning out fantasies.

My adventure stories always starred me, naturally. Sometimes as a wild animal, and sometimes the friend of one, such as the mustang I tamed and rode through the Badlands. I'd invented an imaginary

animal friend long before, a combination of polar bear and alligator I named Gypsy. Along with Gypsy the paligator, I fought coyotes and tigers, saving trapped mice and bunnies. Sometimes sketching animals or scribbling stories in my little notebook, most often I simply dreamed.

As a teenager, my daydreams became a bit more possible, but they were always rather grand: me as a Broadway actress, winning a Tony Award, or flying to Paris to film a movie. Living in Los Angeles, freedom was owning a car, and soon I was driving miles out of the city to Angeles National Forest or up to Malibu on a whim. In New York, Central Park became my haven, and I spent hours wandering its paths, around the Lake and through the Ramble. The sights and sounds of nature resonated with me, brought me back to my authentic being, and awoke my animal self.

After years of trying to meditate, using tools from TM to tapes and yoga, I'd seldom achieved any inner quiet. My body was often restless, which gurus blamed on lack of focus or concentration, but my physical needs were more real to me than the pursuit of inner calm while sitting uncomfortably still.

I'd learned from Warren Robertson, my New York acting teacher, that it was enough to simply be in the moment. Whether I achieved that over my morning cup of tea or walking through Central Park didn't matter, and sitting in a lotus position in an ashram didn't determine one's centeredness. He said he'd spent thousands of dollars pursuing enlightenment and he'd help us save time and money.

"Just *be* here, right now!" he'd say, punctuating the word "be" with a loud clap. He said that we usually existed in our heads, in the past or the future, and if a cab nearly ran one of us down in a crosswalk we should thank the driver, since it was the first time all day that we had actually *been* in the moment we were living in.

My inner stillness was usually found in motion. In my twenties, I ran. Afternoons or mornings I would take off, pounding hard-

packed beach sand, pavement, or later running trails through parks. On tour with a theater group, I ran long stretches of Florida byways and citrus groves. The downside of running was pain, not during the run but for days after, and finally weaning myself from the runner's high made complete sense.

Sailing in the Sea of Cortez, I enjoyed the solo watches, and my afternoons swimming or diving, but I truly came to love my walks ashore. Walking purposefully took me to that place of mental quiet. When I meandered along a dusty desert path alone, my mind shut off, and my body took over. Other than a whisper of wind, the only sound was my breathing. I simply existed. I was.

One day, after strolling on a quiet Baja beach, I began arranging pieces of shell and rock, idly creating patterns on the creamy canvas of sand. A mosaic image emerged and drew me into adjusting the play of light and shadow with different textures and shapes. Selecting a curved fragment of pink shell I paused, breath held, weighing where best to place it for maximum effect. Time stood still as I reached for another tiny bit of color and hue, arranged it with the others, then slowly selected and added one more. The process was purposeful but thoughtless, unexamined creation. The vague shape evolved into an impressionistic image and the shell mosaic became a dragon.

The next day, it was a peacock.

The high tide would wash each shell portrait away, but sometimes, the pictograph was still there the next morning when we walked the beach. Russel took photos of a few, like the running horse, but the end result was not at all the point in the moment. What I sought was the meditative pause, the stillness, the shutting off (as the Zen masters say) one's *monkey mind*, the chattering voice that constantly speaks to us inside our heads—solving problems, or creating them—every minute of every day.

On the right day, the process of creating one of these shell and rock mosaics could take me out of myself and grace me with an interlude of inner silence, a gift to myself that I came to treasure.

Cross-Country Flight
1980–1982

I MOVED FROM SAN DIEGO TO LA at nineteen and soon got a job at Zucky's, a deli in Santa Monica. There were not many shifts open for the new girl, but my old friend Nancy (my dad's cool ex-girlfriend who'd sort of adopted me) wasn't charging me much rent, so my free time could be spent pursuing acting jobs.

My weekly routine was to scour the three acting trade papers, auditioning for every role I could possibly envision myself playing. Though my agent sent me out for a few roles on soaps, and I generated tepid interest, including a call-back for a lead on *General Hospital*, the only jobs I booked were small roles in advertising, including a Shiseido commercial at Will Rogers Park, along with a hundred other girls in identical pink outfits, marching around the polo fields like a well-made-up army.

After one film audition for an ingenue role, my agent heard back from the casting director that I was not sexy enough and had to lose weight. By then, I'd been dieting for years, and that was the last thing I wanted to hear. When pressed about my odds for leading lady roles in film, my agent agreed that my still-curvy size six figure needed to be at most a size three.

"Or," he said, "you can gain ten pounds and play the fat friend."

Shocked, I juice-fasted for days, exercised to the point of exhaustion, binged and purged, and otherwise pursued an insane goal.

Lucky for me, I had friends like Nancy, Roxanne, and Elissa to give me regular reality checks; a much better job waiting tables at a kosher deli also helped me hang on in LA. As one of only two young waitresses, I made friends with the other, Allie, who would be my next roommate. Together we applied to a new Beverly Hills dinner spot called Cafe B-Minor, with me faking my way into a job as sommelier, running the wine bar. There were also a variety of day-jobs, including being a nanny to a grandchild of Hollywood royalty and babysitting for an agency that catered to the wealthy in Bel Air.

When the Riches (not their real name) offered me a trip to New York as a nanny to their toddler, the chance was too good to pass up. My job at Cafe B-Minor meant getting home in the wee hours, and I had to be up by eight for my weekday babysitting job. More importantly, there hadn't been an audition for me in weeks. My dream had always been to be a stage actress, and opportunities for theater roles were sparse in LA. At least this way I could *visit* Broadway, if not make the leap to acting there.

The Riches did everything top-notch, so I wasn't too surprised to find myself staying in a Park Avenue hotel. Each day for three weeks, Mrs. Rich handed me a wad of cash and headed off to the flower shop her hubby's company owned, where she'd pretend to work. The Little One and I would go to Central Park, visit the zoo and the boat pond, then we'd cab somewhere fun to eat lunch. With no bank account, I lived on the cash per diem and saved up my paychecks, planning to return to LA with enough to tide me over awhile. Allie phoned to say that Cafe B-Minor was closing, and on my referral, Mr. Rich hired her as receptionist at his new LA start-up; with businesses all over the country, he was very seldom in New York. When Mrs. Rich asked me to find us a long-term hotel suite, I chose an atmospheric boutique hotel in a brick building that housed a French cafe off Madison in the Sixties.

When Mrs. Rich decided to fly home with her daughter to celebrate Thanksgiving with her parents in Palm Springs, she offered to let me stay in the suite. The flower shop would be open, and the staff could use my help as they were short-handed and busy with holiday orders. With excellent room service available, I didn't worry about making a couple of twenties last me the week, and cheerfully waved mother and daughter off in a limo to La Guardia.

I never saw them again.

The flower shop's assistant designer David had already become my friend, now he became my savior. He and the head designer Roy, a flamboyant man we referred to as Her Majesty, were both gay, but not a couple. The two of them helped me keep the shop open the Tuesday before Thanksgiving when our paychecks all bounced, and Mrs. Rich wouldn't answer my calls. The SEC had subpoenaed Mr. Rich and froze all his accounts—turned out his companies were fakes, the flower shop being the only actual location in their shell-game enterprise. My paychecks were useless paper, and hotel management was beginning to doubt that my bosses were good for the money owed them.

The next morning, the hotel manager rang on the house phone and informed me that a deputy was there to see me. I dressed hurriedly, tamping down my panic with an inner monologue. *I haven't done anything wrong. The Riches did this.*

The deputy gave me the third-degree, certain I was in cahoots with the Riches. Secure in my innocence, I answered truthfully but could give him no more than he already had, which was the number to Mrs. Riches parents' house in Palm Desert.

"I'm on my way to the shop now," he finally said. "It will be locked up today, and all business will have to cease. There's a matter of unpaid taxes."

I did a quick mental calculation and went for it.

"Surely you can't close it without notice. My father is a lawyer in Beverly Hills, and he says that a legal writ is needed before law enforcement can close a business." The word "writ" was straight out of *True Grit*, but this bit of chutzpah convinced the deputy to leave the shop alone that day. Due to the holidays, we would stay open.

What was left of the staff—me, David, and Roy—promptly split the paltry register cash between us and the delivery driver. The driver took his share, then quit. Neither David nor Her Majesty had a license. I learned how to drive a panel van the day the last few clients' designer Christmas trees, centerpieces, and wreaths were due to be delivered all over the city.

That night, we three divided the cash profits. My share went to paying a week in advance at a much cheaper hotel in Midtown. Thankfully, the Upper East Side hotel bill had been paid by Mrs. Riches' father, so my overstuffed suitcase was released, along with her long camel-hair overcoat, which came nowhere close to what I was owed.

Not wanting to leave the city feeling like a victim, I was determined to stay in New York, find a job and an apartment, and start taking acting classes. My mom understood, and she and my brother Joe drove up and moved my stuff out of my LA apartment. Thankfully, Allie understood and forgave me for leaving, and for the awful job situation I'd put her in with Mr. Rich.

Needing to make money fast, I spent every morning pounding the Manhattan pavements, looking for work. In the afternoons, David showed me the city. A font of local history and insider tips, he took me to a Park Avenue corner where a string quartet played carols from a rooftop as the snow fell. We visited every one of Greenwich Village's renowned gay clubs and piano bars, took the 25-cent ferry to Staten Island, and rode the subway out to Coney Island for an original Nathan's hot dog.

My first real job, checking coats at Paddy's Pub on First Avenue, was won by affecting an Irish accent and telling a few tall tales. David scored me a week's stay in a tiny West Village studio from a friend off to visit his parents, since David was going to Puerto Rico over Christmas. Entertaining myself with baths and singing along to cast albums on the turntable, I lived on instant coffee, free work meals, and diner bagels.

Unfortunately, David's friend returned a day early. He let me leave my big suitcase there, but I dragged my massive tote with me through the snowy streets as night fell. David wouldn't be back until the next day, and I had nowhere to sleep. After a couple of warm hours in a friendly piano bar, I tipped my last dollar and schlepped my bag along Christopher Street to a quiet phone booth. There, with no one to call, I fell asleep. A cop woke me and said to move along. Tearful and humiliated, I used a precious subway token to get to a job interview, where they quickly admitted they only hired male waiters. I spent my last dime to call Brooklyn.

David brought me home later that day to his family's brownstone in Bay Ridge. I stayed three months, rent-free, and soon found a job slinging ribs and martinis in newly hip Tribeca. With money in my pocket, it was time to start dreaming my dream again.

I auditioned for Warren Robertson's Theater Workshop, one of the top programs for stage actors, and was accepted. The classes were weekly, plus we all met up on our own time to work on scenes. A room in a classmate's Chelsea apartment for a price too low to refuse meant my return to Manhattan, though David was still my standing date for Sunday tea dances in the Village. Working a few days a week at a theatrical agency, weeding through the slush piles of résumés for minimum wage, I hoped to find out about auditions in advance of the hordes of other aspiring ingenues.

In Warren's class, absorbing every word, I was surprised to hear him speaking my language. His holistic method of teaching acting

challenged me, since both my college teachers had been British and took a more old-school technical approach. Called out by Warren for simulating emotions instead of truly feeling them, I dug deeper and it paid off in my scenes. His lessons in being fully *present* would continue to yield benefits for many years, not only in my roles but in my life.

While I loved Warren's classes, I was increasingly homesick for my family and friends. When my roommate decided to move back to Texas, and David made plans for a summer rental on Fire Island with friends, my decision to retreat to San Diego and regroup became an easy one. Unsure if my long-term plans would unfold in Los Angeles or New York, my mom's house in San Diego was undoubtedly the right place to be for the summer of 1983.

A Flair for Drama

AFTER BREAKFAST, I HANDED RUSSEL a story about my New York acting class that I'd finished only that morning.

He replied with a posh British accent, "Thank you, I'll read it," a quote from *A Man for All Seasons*, but then set it aside before he went out to the cockpit.

Always happy to give me feedback on my stories, Russel preferred me to read them aloud, as I'd been doing for the books we shared. He especially loved listening while he worked.

He was painting that day, working outside on the easel he'd fashioned with no back legs that sat on one side of the cockpit. He never spoke of it as anything but "drawing the pictures," pronounced "peek-sures," and never referred to himself or any other painter as an artist, but always, wryly, as an "artiste."

Russel had become a successful illustrator in the years since *Our Town*, working in such a variety of techniques that he'd given himself the moniker "Dial-a-Style." On the boat, his medium was acrylics; their plasticity meant that a completed canvas could be rolled up once it dried, and he could also clean his palette and brushes with seawater.

After reading him the story and making a few hurried notes of his thoughtful input in the margins of my notebook, it was time for a chapter of our latest book. Always happy to be performing, I had

started reading the first volume of Tolkien's *Lord of the Rings* trilogy like a radio play, playing all the parts with gusto.

Russel mentioned being hungry around eleven.

"We had oatmeal for breakfast."

"But we haven't had *second* breakfast!" he cried in a Hobbit-like voice. He had me there, so we broke our short fast with Bimbo-brand wheat bread and peanut butter.

After our snack it was time for more *cinema*, which when Russel says it, can mean anything entertaining, and in this case meant me reading more Tolkien aloud.

When work on his current painting was done for the day, the Russel-isms continued. Seeing me start preparations for dinner, he responded with, "I am filled with anticipatory glee. Perhaps I will indulge in a Light Beer by Miller before our dining experience."

Our Miller Lite was long gone by then, but Light Beer by Pacifico didn't have the same ring to it.

On our way to bed—we slept in what he called "the pointy pit"—he stopped to brush his tusks in the head or pee-pee-a-ria. After shedding our clothes, our shirts and pants got put away in the locker or pantaloon-aterium. It was too late for a shower, always called "a dance in the laughing waters."

"Hey, Pookie," Russel called the next morning from up on the bow. "There's some wind coming up. Time to sail Mr. Boat."

"Okay, Boots, I'm coming!"

First, we started Mr. Yamaha, and picked up Mr. CQR (the anchor). Then we headed the pointy part out of the harbor, while looking up at the whirligig and the monkey business on the mast top to check the wind speed and direction, and checking to see that the dingus was tied properly behind the flat end.

Once out in the open waters, Mr. Sulu (our autopilot 1000) handled the navigation, and while still headed into the wind, we hoisted Mrs. Main, the main sail. It was my job to keep an eye out

while Russel went below to pick out a headsail. He considered the biggest genoa, known as the Hulking Bastard after one of Grandpa's unrepeatable jokes, but since the wind was light, he hanked on the huge colorful reacher-drifter we called the "solar windbag."

Winching in the jib sheet and cleating it off, I replaced Mr. Sulu at the helm, seeing that Mrs. Main was flapping a bit. Falling off more looked like it would balance the sails out, but Mrs. Main was having none of it. Eventually, the right heading was found and both sails were pulling. I looked up at Mrs. Main's full belly, recalling her recent flair for drama, and tried to take on her persona.

"I am *Mrs.* Norman Maine."

Russel laughed at my *Star is Born* reference. "Good one, Pook."

With Mr. Sulu back at the helm, and the wind finally coming from the right quarter, there was nothing that needed doing, so I joined Captain C. Boots up on deck for a brief moment of relaxation.

He was staring at the rigging. "I better tighten that shroud," he said, heading below for the toolbox.

Helping out was challenging, since his tool names could be hard to decipher. Most were referred to as a thingamajig or a DeVilbiss. He confused me this time by requesting a monkey wrench with the phrase, "I need the Expando-Matics." Endeavoring to interpret from context, this time I brought the wrong one.

But it all worked out since, as Russel said, "Every tool is a hammer, except a screwdriver, which is also a chisel."

* * *

We sailed over to a small bay with a promising rocky point. Russel was becoming handy with his speargun, so after anchoring we headed out separately, me to dive down along the rocks for scallops, him to scout the inner section of reef for a likely dinner fish.

The point proved to be a bust, with not a scallop in sight, but the underwater scenery was delightful. A school of glittering sergeant majors flowed by me, then wheeled about for a few feet, looking for who knows what, then reversed again, their blue and silver sides flashing in the dappled sunlight. I bubbled out a laugh, poked around a bit more, then turned back toward the boat. Kicking and stroking slowly along on the surface, my face in the water, breathing through my snorkel, I admired the wavy lines drawn by tidal shifts on the white sand bottom.

Movement caught my eye, and I was startled to see two large sharks swimming side-by-side above the white sand, 20 feet below me. They weren't huge, but they were each easily 5 feet long. I swam on, carefully keeping my arms and legs underwater so there were no splashes to attract their attention.

Just then, Russel called out to me. He was in the water a couple hundred feet away, holding up the spear from the speargun in one hand as he paddled in place. "Hey, look what I caught!" he shouted. On the spear thrashed a good-sized cabrilla, shot through and bleeding into the water.

Oh, shit.

I pulled myself further up out of the water with my arms in a sort of breaststroke, spit out my snorkel's mouthpiece and called, "Shark!"

He didn't react.

He didn't hear me.

"Shark!" I yelled, loudly and clearly.

"What?" he shouted back, thrashing one arm to hold himself in place, bloody spear still dripping into the water. "Can't hear you!"

I glanced down to see the sharks speeding toward his side of the bay.

Damn it.

I took a deep breath and bellowed, "SHARK!"

He heard me that time. Swimming rapidly to the boat, kicking up quite a bit of white water on his way, he quickly made it up the ladder and onto the deck.

Knowing there was blood in the water, I swam on as calmly as possible, while trying to catch a glimpse of the sharks. They'd turned back and were heading my way again, swimming much closer to the surface. I tried to move fast but not stir up the water at all, which was nearly impossible.

The boat was 30 feet away, then 20, then 10. Completely ecstatic to feel my feet on the bottom rung of the boat's ladder, I scrambled up it.

I complimented Russel on how fast he'd gotten to the boat and boarded. He claimed to have walked atop the water, and it was easy to believe him.

The cabrilla was delicious.

Sexual Navigation

I T'S ABOUT TIME WE TALKED about sex. After all, this trip was our honeymoon.

Our first date, in 1983, began when I showed up at Russel's studio in downtown San Diego, wearing a short red strapless dress and red high heels. Looking intrigued, he asked my age, heard twenty-two, and asked me to lunch. The meal was served at a cliffside bistro south of Tijuana. Yes, we went to Mexico for lunch on our first date and stayed there for dinner, then parked atop a cliff at a seaside overlook in Mister Bus. We kissed for an hour or more, ending up in the bed in the back. After years of anticipation, we finally, as Russel put it, "consummated our friendship."

The consummation was well worth the wait, and we were unfazed when Mister Bus failed to start hours later. Back in bed, we had a great deal of fun, got a couple hours of sleep, and at first light we got out and pushed the van down the road to an offramp to jumpstart it. It stalled a few more times, memorably in downtown Tijuana, and we pushed it a block or two each time. I made quite a picture, still in my red dress and heels.

We were together for a passionate six months, culminating with the emotional rollercoaster of my getting pregnant and our resolving to terminate that pregnancy. Russel was supportive and loving through it all, but a few weeks later, he took me to lunch—this time

in La Jolla—to inform me that he needed to concentrate less on our budding romance and more on his burgeoning art career. He was transitioning from an illustrator into a fine artist, which required him to focus all his energies for a while.

I'd been afraid all along that he was going to be unable to commit to a real relationship, much less marriage. This was my worst nightmare come true. Wounded to the core, I was also furious. He knew in his heart what an amazing match we were, and he was walking away from our future. A few quick phone calls resulted in a sublet in NYC, and a couple of weeks later, I was gone.

Fast forward five years to when we got engaged; we leapt into bed and spent a great deal of our time there for months.

Russel maintained that he wanted us to have a child at some point in the future. Though I wasn't completely sure about having a baby with someone who'd agreed to the idea as a condition of winning me over, I definitely wanted to keep our options open, so getting my tubes tied was out of the question.

I'd already tried multiple types of contraception that had failed, including the aforementioned diaphragm and the trendy sponge, which brought on a scary allergic reaction. Unwilling to give up sex, I finally opted to take birth control pills. After five years, I was ready to give up the pills and wanted something more natural. Neither of us was excited about using rubbers every time we had sex or inserting devices or whatever else was available. In short, most contraceptives were a hassle, messy, or downright dangerous. And since it was clear that we were going to have sex—a lot of sex—we needed a better form of birth control.

A little research led me to NFP, or natural family planning. It seemed like a very empowering way to prevent pregnancy by not turning the whole process over to doctors or pharmacists. Plus, it was free, less the cost of a basal thermometer and a graph-paper notebook. What was required was time, discipline, and the ability

to pay close attention to one's body, specifically one's vagina and its secretions.

Basically, a woman secretes clear, slick, and stretchy mucus when she is fertile; her mucus is completely different when she *isn't* fertile. If you avoid any "genital to genital" contact on your fertile-mucus days, with a couple of days to either side for safety, you don't get pregnant. NFP advises women to take their temperature with a basal thermometer daily, before getting out of bed, to recognize the very slight but clear rise in temperature that occurs during ovulation. The system sounded complicated but had a great track record if done properly.

I told Russel about it, and he was very enthusiastic. Of course, we both knew about the old rhythm method, a system of only having sex on certain days of the month, long popularized by the Catholic Church; its poor results were made famous by the old joke: What do you call people who use the rhythm method? *Parents*.

If we were going to do this, we needed to be serious about it. The good news was that it didn't mean we couldn't have sex for those ten days, only that we could not have genital-to-genital contact. The many other options for achieving an orgasm, or multiple orgasms, even simultaneous orgasms, were myriad, and exploring them sounded pretty erotic. We dove right in, shall we say, "head" first. Our explorations included mutual masturbation and taking erotic massage to a new level. We also refined our techniques for oral pleasuring, whether one at a time or simultaneously. By forcing us to avoid intercourse during those ten days each month, NFP made our sex life much more fun, varied, and creative.

Our past relationships were something we discussed very frankly. We exchanged our first-time stories and our most erotic stories. I told him the embarrassing story of my first date with a gorgeous male model, whom I finally found myself alone with, and how I went home because I was too embarrassed to have him see the

red impressions my tight designer jeans had made on my belly and thighs—it was the 1980s, what can I say? Hearing this, Russel laughed with me, not at me.

There was also the actress I'd had a steamy fling with. She and I had mutually decided against pursuing a relationship after spending a dozen passionate nights together. The story shocked Russel, but he soon got over it. I'm not sure who said it first, but we agreed that everything we'd experienced with other lovers had brought us to where we were, together, so we had no reason to resent or regret any of it.

We kept going deeper, no pun intended. Serious stuff. No-holds-barred talk. Everything. He shared secrets with me, and I listened with no judgment. He did the same. I told him about being molested as a young child and how that had affected my sex life. It was difficult to admit how often I had faked orgasms over the years and how hard it was for me to achieve an orgasm solely from intercourse. Not at all daunted, he got inspired and *very* creative.

In Mexico, whether anchored out in a lonely bay, or off a bustling town, we explored a new country in every way. Spending hours with no clothes on, sailing, swimming, and basking, we grew to be as comfortable with each other's nude bodies as with our own. Together in that small space day and night, we cuddled and petted and teased each other with anticipation. We enjoyed taking long siestas, even when the heat made our bodies slick with sweat, and we learned to tolerate the many jokes made by other cruisers we met about "The Honeymooners" and their perpetually rocking boat.

One afternoon, while sailing slowly between islands, with Mr. Sulu at the helm and no boats around (as was usually the case), I lay nude on the slatted teak bench seat in the weak sun. When Russel came up from putting on some music, he offered to put sunscreen on my back and shoulders. Massage led to kisses, which led to a new, somewhat acrobatic sexual position. Afterwards, we sat

up and wiped the sweat off our bodies with the towel. Still breathing hard, I said, "So *that's* why they call it a cockpit."

Back in Puerto Escondido, we ran into a new cruiser at the dinghy dock and casually exchanged the usual questions and answers. When the guy asked what instruments we used to find our position, Russel told him we did celestial navigation. The guy looked shocked; it turned out that he had heard the words "sexual navigation," and that's what we always called it after that.

Howling Winds

I N PUERTO ESCONDIDO, WE HAD a comfortable anchorage
that was fairly safe, even in the fierce local storms known as
chubascos, and a small market about a mile away. It was such an
easy place to hang out that the days flew by. But it was time to get
moving. There was so much more to see. We didn't have a plan for
how far north to go, but we had heard from Chris and Stephen
that there was a great anchorage at the far end of Isla Carmen, the
long island that lies a few miles east of Loreto. Oddly enough, this
anchorage is called Balandra, like the bay outside of La Paz (there
are dozens of repeated place names on the peninsula, including San
Francisco, Todos Santos, and Santa Maria).

We sailed up one day very late in January and found the bay as
lovely as promised. Anchoring in the protected north end ended up
being a good move because the north wind never stopped blowing
the whole time we were there. The VHF net weather report said the
Groundhog indicated six more weeks of winter were in store for us,
as that day brought a chilly wind blowing 25–35 knots, with a few
50 knot blasts.

We'd stocked up a bit at the small market at the RV park, but
we needed to sail over to Loreto for a few essentials, like eggs, fresh
vegetables, and fruit. It didn't seem likely that the wind would keep
blowing, but blow it did, day and night.

By Sunday, our fourth day in Balandra, we were down to the culinary basics, aka rice and beans, and almost out of rum. Egad.

We readied the boat for sailing and went to bed early, prepared to head out the next morning for the crossing and our big shopping day. We were worn out from being woken so many times each night by the keening and howling wind. I got up Monday morning, noted that the wind was down to a very manageable 8–10 knots, and started the coffee. Listening to the VHF net, we quickly learned it was a holiday called Cinco de Febrero, and the markets that sold food, as well as the outlets for gas, ice, and propane, might be closed. We shrugged, turned off the radio, and went back to bed.

Later that day, we jumped in the water to clean the boat bottom. The wind had died down to a stiff breeze, and we figured it would be nice to clean up for our big trip to town. As usual, we each took one side of the boat to work on. The process is fairly straightforward: First, you use a plastic putty knife to scrape off the small barnacles that cover the bottom paint. Then, you rub the whole bottom with a rough pad to get the rest of the weird, clingy, gooey stuff off the hull and waterline. We used snorkels and masks, but lots of breath-holding made cleaning the keel especially tiring.

It was pretty cold in the water, and we were both shivering by the time we were done. The solar shower we'd hung up in the sun was filled with fairly warm water, but as soon as the water ran out, the brisk wind cooled us right off. Always adaptable, we went straight from drying off to diving back into bed. We'd perfected a technique for warming both of us up at the same time, and it didn't even require getting dressed.

That night I dug out some miscellaneous food boxes from the bottom of the storage area under the settee we called the pantry, and we feasted on instant mashed potatoes and felafel, with a thick gravy of Campbell's Cream of Mushroom soup.

Tuesday dawned clear and calm enough to depart, and soon we were sailing into Loreto. In winter, the wide-open roadstead anchorage off the town is only tenable before the early afternoon winds come up, so we quickly got in the dinghy and went to shore. It was time to divide and conquer. I walked to the store and the tortilleria, and took a taxi back with my bags, while Russel took the jerry jug to the petrol station and hauled it back out to the boat. By the time he'd returned to pick me up at the beach and we had gotten all our purchases back to the boat, the wind was picking up, and we were tempted to blow off the final stops, for ice and propane.

The first time we'd come into Loreto, weeks earlier, we looked and looked for a store called Casa Verde, where we'd heard we could buy propane. Finally, having been directed down a residential street, we realized *casa verde* was an actual green house that sold refills of cooking gas to residents from their back yard. They were happy to fill our *pequeno* aluminum container, and the woman apologized for charging me $1.50, half of what I'd paid in La Paz. That same day we also found a new set of replacement oarlocks for our dinghy. Where? At the locksmith's, naturally.

We gobbled half a dozen fresh corn tortillas in lieu of lunch and took the dinghy back to the beach, where we spotted Connie, a friend from the RV Park, driving by in her truck. She pulled over and gave us a ride to both locations, saving us an hour or more and a great deal of ice, which often melted quite a bit by the time we got it to the beach by foot. The ride back to the boat in our dinghy was a bit wet, and we nearly lost the slippery barra de hielo during the dinghy to boat transfer, but we got everything stowed, pulled up anchor, and sailed the short hop to Isla Coronado.

The norther wasn't done blowing, but we managed to sail close enough to the wind to make it another 28 miles to San Juanico the next day. The large scenic bay was much talked about by other cruisers, who said we *must* make it at least that far north to claim that we'd truly *done* the Sea of Cortez.

Time Out of Time

S OME PLACES ON EARTH ARE simply too beautiful for words. Bahia de San Juanico is one of them.

We'd hardly been able to take in the full splendor of the location as we motored in after a day of bashing into north winds and choppy seas. Anchoring in the protected bay was a sorely needed respite, and we barely took time to eat before heading for the v-berth. The next morning, we stepped out to admire the view, just after dawn. Tall granite and sandstone cliffs nearly enclosed the large anchorage, revealing a vertical slice of dark green sea to the east. The closest coves had white sand beaches, and the water was the clearest, brightest blue we'd seen since La Paz, all set off by the pastel colors of towering rock pinnacles that looked like those drippy sandcastles kids make.

We dinghied to shore and wandered north along the shoreline toward the head of the bay. The pool of water formed by that small rocky cove was azure, edged with aquamarine. And the shelf that surrounded it—the ground we were walking on—was an amalgam of sandstone and shells and pebbles that had clearly been pounded flat by seawater and swept smooth by wind into a serendipitously artistic mosaic of rock.

"A floor like this would cost you a fortune in the States," Russel said. It *was* like something you'd see in a pool and hot tub contractor's showroom.

I couldn't resist. After shedding my clothes, I jumped in and splashed a bit while Russel shot a few photos and stayed dry. The water was not really *cold*, but he has a very different idea of what is enjoyable as far as water temperatures go. I didn't stay in very long, and soon we were hiking the path that wound up the nearest sloping cliff face.

At first, I thought the rocks alongside the trail were a natural outcome of multiple feet pushing larger stones aside as they trod the path, but it was soon clear that humans had made improvements. Larger and larger stones lined each turn until we were walking in ruts completely banked by rocks of gray, tan, rust, beige, and every other hue of desert mineral, interspersed intentionally like paint on a palette.

Around the final turn, we stepped into a sort of open-sided dry grotto. A spindly acacia tree arched overhead, shading the eclectic display that was arranged around a small natural rock patio. There were wooden plaques, dangling mobiles with pendants of shell, God's Eyes made of yarn and sticks, with each piece sporting a word emblazoned in some way upon them, using paint, pens, string, and crayon. The words were clearly boat names. We spotted *Scout*, *Imagine*, *Harbinger*, and *Gypsy*, but there were dozens more we didn't know. This was the San Juanico Cruiser's Shrine that we'd heard boaters speak of, and, clearly, we had our work cut out for us to match the shrine's artistic level.

That week in San Juanico still glows in my mind's eye like a dream. Writing and painting on the boat, swimming, trolling, and diving for the rock scallops or fish that we ate each night, walking the beaches and hiking up the steep cliffs, sitting in the cockpit each evening as the fading light painted the cliffs in deep pink hues and turned the sky to honey and papaya.

There were other cruising boats that came and went from the magical bay, too. We met up by dinghy one by one, and then all

gathered one evening for a BBQ on the beach, eating just-caught sushi one boater had prepared while we roasted fresh lobster tails the scuba divers had brought. After dinner, we shared sea stories, told silly jokes, and sang rousing ballads to the plunking of a beat-up guitar.

We met a French-Canadian couple on another Columbia 26 who were heading south to La Paz. *Islay* was going to be trucked north to the States, but they wanted to enjoy a bit of sailing first. Michel was a handsome character, and his girlfriend obviously found him charming. Sailing down from Conception Bay, they hadn't been able to get to a store, so the potluck repast was a welcome break from rice and beans. We hosted them on *Watchfire* the next morning, and they were surprised to see me serving pancakes topped with butter and maple syrup. I explained it was from a just-add-water mix, but their admiration was not diminished.

Russel lost his prescription sunglasses on the way home from fishing in the dinghy the next afternoon, which was a real loss. He is pretty much blind without his glasses, and they were the only pair he had. It was too late to search for them in the fading light, but we gathered with a few other cruisers the next morning, and lo and behold, we found them, thanks to the underwater defoliation one ex-firefighter had performed in the small weedy cove. The guy smiled and shrugged off our effusive thanks, saying, "No problem, that's what we do, we help each other out."

Some days were cloudy at that time of the year, and every afternoon was windy. We stayed hunkered down on the boat for two days straight, waiting out a major rainstorm. Still, the time in that bay was idyllic. We stayed in bed late, worked rather intermittently, and enjoyed each other and the breathtaking vistas immensely.

Our time there had a bittersweet quality. This was as far north as we'd be going in the sea. The northerly weather made going further too much work, since the trip up to Conception Bay from there was

a long one, relieved only intermittently by marginal anchorages, none of them tenable in a true, howling norther.

On our final day in the enchanted bay, we brought our piece of memorabilia into the shore, fastening a creative amalgam of shells glued to a chunk of driftwood painted with the word *Watchfire* to the Cruiser's Shrine. A few tears may have been shed by me, but they were as much from joy and gratitude as regret.

We both hated to leave the sea, but it was time to continue our journey south and eventually east, toward New York City and our new life. At least, that was our plan at the time.

Whimsical Ambassadors

WE'D STARTED REFERRING TO THE Sea of Cortez as The Sea of Madness since it often blew right on our nose until we'd turn and try to run with it, when lo and behold the wind would shift 180 degrees. A friend on a power boat summed it up by saying, "There's never any wind here, unless it's contrary." So we had sailed close-hauled, or nearly straight into the wind, quite a bit by that point.

Sailing downwind is a wondrous thing. We hadn't done it since we reached Cabo, and I'd forgotten how exhilarating it was. On the way south from San Juanico to Isla Coronado we had following seas, and the brisk northerly wind from the stern had us surfing down the waves at times.

Almost overpowered, we had only the big headsail up, so our little boat tended to slew around a bit at the end of each slope it slid down. We took turns at the tiller, because Mr. Sulu couldn't steer with the strain of all that wind and wave power behind us. At the tiller, I had to balance the thrill of it while keeping an eye on how far we could surf without burying the bow in the water. The boat would probably have suffered nothing worse than a wet deck, but I was trying to learn to steer safely, not to court danger.

At one point *Watchfire* topped 7 knots, an unheard of speed for us up to that point. Luckily, *Islay* was sailing alongside us, so we took

pictures of them, and they us, and we swapped the photos later on in La Paz.

The Canadians went on the few miles to Loreto that afternoon for supplies, but we stopped in Isla Coronado. Pulling into the southern anchorage, a wide-open scoop of white sand beach that faces the towering Sierra Giganta behind Loreto, we dropped the anchor in 20 feet of strangely tinted water. As soon as we'd stowed our sailing things a bit, I stripped off my clothes and grabbed my snorkel. It wasn't exactly hot, but the wind had settled into a mild 10 knots or so, and the sun was warm enough in the lee of the island. The greenish water didn't look very enticing—nothing like the usual clear water of the sea—but I wasn't planning on more than a quick dip.

As I walked to the ladder, I spotted a pod of dolphins headed into the bay. I jumped straight into the water, and soon the dolphins were streaming past me, each one appearing out of the murky water for a split second as they zoomed by. One reappeared almost immediately, as if to say, "Hey, was that a naked lady wearing a snorkel?"

It was an unworldly encounter, with the dolphins and I suspended together in murky green liquid. I couldn't spot a dolphin flying toward me until they were so close that I could have touched their sleek sides, and each one disappeared into the green water a split second later. It was impossible for me to discern the sandy bottom 15 feet below the boat; I couldn't even see my feet. There was no visible connection to the earth, nothing tangible in sight but these whimsical ambassadors of the ocean. I stayed below until the last dolphin swam away, then resurfaced, shivering and grinning, tears mixing with the salty sea.

That night we were awed to see phosphorescent seawater lapping at our anchor line and lighting up the edge of the shore beside us. I'd seen the eerie light shows of ocean phosphorescence back in Venice as a kid, but I had never seen it quite so colorful.

Each small wavelet that hit the beach was rimmed with a neon line of ice blue.

The following afternoon we stopped a few miles off Puerto Escondido at neighboring Isla Danzante to savor one last night before returning to the herd in the big bay. Not long after sunset, we were lingering in the cockpit when Russel looked down into the water and gasped in awe. He called to me, and I ran over and flung myself into the gap between the lifelines.

Gazing down into the dark water, I glimpsed what looked like a small comet hurtling past the hull underwater. It was followed by another spectral form, and then another—an entire pod of dolphins, as phosphorescently blue-white as Beluga Whales, their forms star-bright against the dark water. Unlike the choppy waves that accompanied the glowing dolphin show we'd seen off Turtle Bay a few months earlier, the sea was nearly flat, so each blue-white figure was perfectly clear.

And to top it off, all that night we were serenaded by fin whales underwater as they passed by us, hunting their dinner. Each loud huffing breath woke us, and we'd giggle and murmur together as the sounds grew fainter. Every time, we'd drop back off to sleep, but eventually one of the two whales would circle back and swim alongside or under us again, their exhalations bringing us back from sleep and into a half-awake state of wonder.

The next morning, Russel rowed out to pick up our stern anchor, passing a kayaker out for a paddle. Soon they were joined by the two whales. One was a full-sized fin whale, about 65 feet long, and one was clearly a juvenile. Mama whale circled, clearly watching Russel closely to make sure he was not endangering her baby, finally passing within feet of him sitting in the dinghy. Meanwhile, I watched from the boat, photographing the scene with delight and some anxiety.

When Russel came back to the boat with the stern anchor and rode, he asked if I'd managed to get a shot. I thought I'd gotten a couple of good ones, but we were pleased when the kayaker came by to ask for our address. Eventually, the print arrived in the mail at his mom's house and was forwarded to us in La Paz. The photograph is astoundingly clear, shot with a telephoto lens from behind our dinghy, and shows Russel sitting calmly just a few feet from the long shining back of the massive sea mammal.

Whale watching is quite something, and when the whale is watching you, it's magical.

Two by Two

TWO NEW SAILBOATS CAME INTO Puerto Escondido and anchored. When we heard them hailing each other on the VHF, we followed them off the hailing channel to the one they had agreed upon. This is something nearly every cruiser does—it's a good way to find out what new people are like and whether one wants to get to know them.

This conversation was all one-sided and mostly all complaints. The captain of one of the new boats aired his displeasure at what he had been led to expect in Mexico versus what he was seeing all around him.

"Where are the palm trees and beaches?" he asked his friend. "It is nothing but rocks, everywhere I look."

His refrain was like an encore from Angela, the unhappy New Yorker I had channeled a few weeks earlier.

We all have preconceived notions about what a landscape should look like, whether we realize it or not. Most of us grew up drawing bushy green trees that cast shade and leaves below them, but a tall, spare cactus is as lovely a plant as any tree. If we grew up running through grassy meadows or parks, we may have trouble recognizing the stark beauty of a desert; the sharp contrasts can be forbidding at first glance, but every natural space has its own inherent beauty.

One of the benefits of going through life "two by two," as Thornton Wilder put it, is that you learn to see the world through another person's eyes. When that other person is an artist, that new perspective can be quite revealing.

Learning to appreciate composition and balance in everyday scenes always brought up a myriad of other esthetic questions, and we had many an impassioned discussion over the question of what makes a particular vista beautiful. Is it merely color and form, symmetry—or the lack of it—or does our idea of beauty depend more on where and how we were brought up? Most challenging of all, if I think this is beautiful and you disagree, who is right?

Seeing the simple planes and angles Russel sketched in pencil on white canvas come to life with color and contrast each day, I saw beauty that I'd missed before, looking at the same landscape.

When I explored solo on foot, I learned to take more time with each view that emerged, to stay open to finding a work of art in nature. Returning to the boat one morning after a long walk, I tried to capture my thoughts and feelings on paper:

> The road goes by beneath my feet, one step at a time. Dirt, rocks, pieces of shell, the occasional overly ambitious sprout of desert growth, and tracks. Hoof prints of horses, cows, deer, the paw prints of dogs, possibly coyotes, the many tiny birdlike feet of mice. A long, thick squiggle left by a fat rattlesnake that crossed last night. The strange pattern of a mouse-snake that is a lizard's legacy in the soft dirt. My sneakers fall to puffs of red dust, like the silent applause of an unseen audience. After walking the roads of this part of Baja almost daily, I never tire of the experience.
>
> Dirt roads are a part of my childhood memories, but most are hidden under asphalt now. After years in cities,

I feared unpaved roads were a lost art, and discovering the myriad twin treads winding across this peninsula was like finding water in the desert. A road made of dirt has a kind of character that a paved one, no matter how scenic, does not. Characterless roads are what's required when you simply want to get where you're going, but most every trip will be the same as the last. Driving on a dirt road makes each trip unpredictable, a challenge, even without added hazards, like mud or dust.

Walking dirt roads is a whole other thing. I watch where I'm putting my feet because there's always something going on down there. Tracks, certainly, but also dusty treasures—pieces of rusted hardware, old coins, bottles, seashells, fossils. The history of the road is there, but last night is jumbled together with five million years ago, like fallen pieces of a puzzle. The road cuts revealed layers, sagas of prehistory, with their striations of sandstone, mixed rock, and limestone. The variations of color are like symphonies played in hues from black to dark brown, from rust red to sunset pink, from sand to light cream—dozens of shades and tones, all on a theme of earth.

When a smooth patch is reached on the path, or when I decide to let my feet find their way like wise old burros, my eyes can stray to the mountains nearby, to the clouds, or to the crooked black lines of frigate birds in the sky. The underscoring is usually the steady buzz and hum of bees and other industrious insects, with the rare interjection of a warbler's song or a gull's laugh. My own progress is almost silent, and I sometimes startle long-eared rabbits or families of quail into frantic flight.

The hill I hiked was not very high, but even a hundred feet of elevation changes the scene into a prospect. A thin line of highway, almost buried in green from the recent rains, snaked

away around the feet of the Sierra Giganta, and the roadside
pueblo sent up plumes of smoke from cooking fires. Unseen
dogs barked briefly, the sound drifting skyward with the smoke
and trailing off, lost in the faint buzz of a faraway outboard
motor. Turning, I took in the full circle of foothills, beaches,
and sea. The twin wakes of two fishing pangas plowed thin
furrows across a plain of blue, the islands were golden in the
early sunlight, and a wisp of white sail was barely visible on
the horizon.

Unseen across the expanse of sea was a worn mirror of rocky
coast that once, millions of years past, merged with this one.
Below, small waves kneaded and pulled at the shoreline like cat
paws, slowly wearing it away. Above, the sun shone golden in
the blue Mexican sky.

Becoming Mexican

THIS REEL STARTS IN BLACK and white. My grandmother Nena, christened Edmee, left Mexico as a child in the 1920s. Her father, Ulyses César Silva—a philosopher and writer who'd already traveled to New York and had his poetry published there before returning to his beloved Mexico to marry—brought his family north in search of artistic and political freedom. He didn't last long in Los Angeles and either died by suicide or was killed while being treated in, or while escaping from, a mental hospital; either version could have been a cover story. He was a proud Mexican in America, which was not popular at that time.

Nena always typified her mother's second husband as "an Okie," and she and her siblings were raised to speak English. When Nena went to the movies or to dances as a girl, it was always in the company of her aunts (she had three). That might seem like the young women were chaperoning her, but she told me that she was the chaperone, as no one would "get fresh" with her aunts if their "little sister" was around. She loved dancing and movie musicals, a love she passed on to my mother. Only 5 feet tall, Nena was an energetic and graceful dancer particularly suited to jitterbug and Charleston once she was old enough to go to the dance halls. She met the tall, handsome Ray Chafe, fell in love, and married him.

My mom was born in the far-flung part of Mexico now known as East LA. Her father went off to war in England when my mom was only three. Her little sister was born while he was overseas. Ray's family and Nena's family were close, until he returned from the war and the two divorced. He married a second cousin of Nena's and chose to focus on his new bride and their future children over his original family.

Nena soon remarried and that man, Jim Forshey, a cowboy turned truck driver turned crane operator, became my mom's stepfather and my grandfather. Work kept him and Nena traveling, and they had half a dozen homes over the years, but the family ties in LA were strong.

When my mom turned seventeen and married an older neighbor boy from Pasadena, against Nena's wishes, she effectively cut herself off from the extended family. Nena visited us, but there were no longer any of the big family dinners. Perhaps Nena had been happy to escape all that as well; I'll never know. She despaired of the places my parents rented in Venice, seeing the dirt and disrepair rather than the Bohemian lifestyle they envisaged.

One summer day, the Mexican aunts and uncles and cousins all came down to Venice, and we had a huge beach party. I recall mostly the throng of people I didn't know, and how much they all laughed. They also sang songs and played fun games. We didn't sing or play games with my dad's parents, whom we only saw on Easter, Thanksgiving, and Christmas. I can't picture either of them singing or playing, though I didn't know them very well.

My brothers and I loved Nena, who sometimes sang us songs in Spanish, called us *pobrecito* when we skinned a knee, and taught us how to make quesadillas before they were a staple of every Mexican restaurant and taco shop. She tried to pass her father's fierce cultural pride down to us grandkids; when anyone spoke of things that were Spanish, she would say, "We're from *Mexico*, we're not Spaniards, we're *Mexican*."

In middle school, I moved to East San Diego and encountered Chicanas for the first time; the Mexican girls were my age but seemed older with their elaborate eye makeup and hairdos. Their daily outfits included black velvet loafers and fancy leather jackets over lacy tops. I was still wearing my brothers' hand-me-downs, along with a few cool thrift store finds, but Cathy and my few new friends were tomboys and "horse girls," so I fit right in.

I couldn't understand Spanish beyond the few words I'd learned on the street or from Nena. My mom never spoke *en espanol*; she'd never learned it. Like most children of immigrants, the sound of her family elders speaking a foreign language was heard as white noise, and she never bothered to tune it in. Her cousins all spoke English and so did her school friends. What was the big deal?

Nena wanted me to take Spanish, but I had unknowingly absorbed my mom's rejection of all things East LA, including the Spanish language. I followed in my brothers' footsteps and opted for French. Unfortunately, the French teacher was a sweet Mexican lady who spoke (and taught) fluent Spanish and spoke French with a Spanish accent. I attempted to decipher the blended language but, admittedly, not very hard.

For some reason, two of the Chicanas at Wilson Junior High hated me on sight, perhaps sensing my racial cluelessness. They bullied me, and I rose to the bait. Soon I was trading them smirks for their glares, which one day escalated into an exchange of words. I was the kind of smart-mouth kid who, when the bully said, "Do you think that's funny?" always said, "Yeah, I do."

The next words out of her mouth were the dreaded, "Meet me out by the flagpole after school."

Out by the flagpole. Everyone knew this was code for *I'm going to kick your ass.*

Cathy was usually happy to back up my stupidity, but this time she recommended leaving school early. I couldn't see taking that

tack, since the result would be hiding out forever. So I went to the flagpole and waited. Cathy came with me, dear soul, and tried to look mean. No one showed, and, as soon as we'd convinced ourselves that we'd waited long enough, we took off. Nothing was ever said about that missed after-school rendezvous; the two Chicanas never spoke to me again.

I never did learn how to be a Chicana, or even a Mexican-American, though my dark eyes and tanned olive skin usually allowed me to pass for *whatever*. In my restaurant jobs, I'd been assumed to be Jewish, then Italian, Irish, and even French. I thought this might work in my favor, casting-wise, but instead it dropped me into a chasm between types. On calls for movies in LA, they said I looked "too ethnic" to play a typical American girl, but the Japanese director on a Shiseido commercial I shot kept bringing me to the front of the girls, saying I was "All American."

Perceptions are only opinions, and nowhere are people more opinionated than in New York. In two different auditions on the same day, I was told that I looked too young to play twenty and too old to play eighteen.

The thing that shocked me the most about New York was how much people referred to race. I wasn't there more than a few days when I heard someone referred to as a "PR." My friend David told me it meant Puerto Rican, which he was. He also told me that growing up in Puerto Rico, his family members came in every shade, from pale and red-haired with blue eyes, like him, to his dark-skinned cousins with afros. Once he moved to Brooklyn, he learned to call people by racial epithets and only hang out with people who spoke Spanish. Eventually, David figured out he was gay and started socializing with a diverse group of people in the West Village, the very friends he introduced me to in gay clubs and piano bars.

When David took me home to Bay Ridge to meet his mother, a short, round woman who didn't speak English despite living for a

quarter century in Brooklyn, she immediately asked me where I was from. San Diego, I said, but added in my broken Spanish that *mi abuela* was from Mexico City. She embraced me, beaming, and I was smilingly instructed to sit at the dining table, where she introduced me to the wonders of fried plantains served with honey and washed down with sweet *cafe con leche*. From that point on, I was referred to by her, and the whole extended Hernandez family, as "that Mexican girl from California," which made me smile every time I heard it.

Gigantic Steps

PUERTO ESCONDIDO IS GUARDED BY a giant gorilla. At least that's what the locals say. The highest point of the towering mountains, the aptly named Sierra Giganta, resembles an immense stone gorilla with one arm wrapped around the mountain beside him, clinging King Kong-like to the peak.

Each morning from our anchorage in Puerto Escondido, I looked west to the mountaintop as the sky lightened and the peaks turned gold and then pink. There was the Gorilla, always on watch, protecting us from the high winds that assailed the Pacific coast only a hundred miles to the west, and the hurricanes that sometimes raced through Cabo and up across the peninsula. It had been a century since a hurricane struck Loreto, so the big ape was doing a good job.

We were taking a hike with some new cruiser friends. I filled a small pack, adding two light long-sleeved shirts, a couple of granola bars, and a small thermos of water. As Russel said, "we are far from medical aid," so being prepared was key to survival.

A mile west of Tripui Trailer Park, there was a dirt road that led us toward the mountains. It was not yet hot as we walked around the muddy flats where the wide desert dwindles to a canyon between the hills, the deep wind-carved arroyo where we began climbing. Among the huge boulders were thorny bushes, scrawny trees, and cacti. Gray lizards scurried from underfoot, scaling rocks and trying to blend in,

their tiny red sides heaving from gasps of effort or relief. The hike began easily, but soon the riverbed narrowed, and ascending became more challenging.

We climbed higher and higher in the arroyo, picking our way through thorny brush and wobbly rocks. At one point we stopped to look back, admiring the jewel-like setting of blue sea framed by golden canyon walls.

When we rounded the next bend, those tall canyon walls closed in around us, turning the shadows blue in the corners and crevices where palm trees grew in clumps. The trail led upward, and our conversation lagged as we focused on breathing.

In half an hour, we reached some drying pools. Though they each contained barely a cup of water, their shapes suggested how they would brim and overflow after heavy rains. The rocks above them were worn into pitchers and pour-spouts from the streams that had flowed over them, slowly decreasing into rivulets and eventually drips before drying up completely. Spindly trees arched over these phantom ponds, where wasps fought for the mossy yellow dregs. Boulders, carved into smooth slides by years of rushing water, stood parched, waiting for its return.

Lacking rainwater, we stopped instead in pools of shadow to refresh ourselves as the climb got steeper and sunnier. We stopped for a bottled water break on a massive rock that tilted down into the arroyo, talking about the rain and how one wouldn't want to be caught up there on a stormy day. Russel quoted our friend Mort, who he'd nicknamed Bull Dorado, "These are the words of Bull Dorado, don't park your car in a swollen *vado*." Laughing, we went on, still eager for the climb.

The way was decidedly tricky now, and we often paused to try to figure out the next step before advancing. At one point we had to climb up an abrupt cliff face using tiny footholds and sidestep along them to get through. The highest point was only about 10 feet

above the ground, but it was enough to bring out momentary jitters. The most difficult section came next, a tall, narrow crevice between sheer rocks that had to be shinnied up, followed by a rock tunnel that required us to crawl through it for a few feet. In the dark spaces I imagined all sorts of creepy critters hiding, hopefully terrified into submission by our invasion.

All around us, small succulents and other plants grew close together, as if in a nursery, all the way up the steep slope. It was hot now, and the last few yards were as intense as the highest level on a stair machine.

It was all worthwhile when we reached the first cold, clear pool. We splashed liberal handfuls onto our hot skin. Not far up was another pool, large enough to swim in, with a tiny waterfall above it, a clean sand bottom, and a sloping edge. Our friends were eyeing it longingly, and we told them they were welcome to wait there for us to come back. They agreed gratefully.

Russel and I continued climbing, scrambling up a couple of nearly sheer rock faces, to what proved to be the loveliest spot yet.

Surrounded by big mossy rocks, the small pool had a fall above and below it, and the center lobe was shallow, sandy, and clear. Slipping off our shoes and socks, we bathed our legs in the cold water, chatting about the beauty of the spot, then lapsed into a comfortable silence. Russel reclined with his eyes closed. I gazed around at the lengthening shadows, then leaned back and looked up at the deep blue sky. In that instant, I was more alive than ever, and, also in that instant, I recognized my own mortality.

I will die some day.

I'd known this theoretically, but suddenly knew it viscerally. After a moment, I looked over at Russel. He was older than me by twelve years. I would probably outlive him, perhaps even watch him die. That was awful to imagine.

And there was my dear friend Jimmy, far away in New York, battling against a frightening, deadly disease. Jimmy would die, too; he would most likely be gone before either one of us.

Stunned, I breathed in and out, trying to sit calmly with this knowledge.

Just then, voices rang out. Our friends were calling up to us that it was getting late, and we still had to hike back down.

"It's time to go!" one of them called.

That is so like life. You never get any notice. One moment it's simply *your time to go*. I sat up and shouted back that we were coming. Then we put our shoes on and went back down the mountain.

Different Strokes

HAVING BRUNCH WITH FRIENDS SEEMED like a reasonable way to spend a Sunday morning. Keith had invited us to join him and Harry and Bea at the restaurant in the nearby trailer park, and so we two strolled up the road a bit early to give ourselves a bit of exercise before eating.

Tripui, like many a tourist hangout in Baja, was a strange oasis of Americana in the middle of the Mexican desert. The rows of RVs and trailers each sported a *palapa* of palm fronds arranged over a wire structure to shade the space closest to the door. These patios were festooned with awnings and flags in every shade of dyed canvas fabric and were decorated with everything from the stars and stripes and bumper stickers to sprawling cactus gardens decorated with driftwood and seashells.

Russel and I strolled around the park, admiring the odd—sometimes charming, sometimes repulsive—knick-knacks the neighbors had chosen to decorate with, and finally ended up back at the clubhouse as our friends drove up. Keith didn't walk anywhere, being fully acclimated to Mexico, where you only walk if you don't own a car.

The lunch buffet was deep and, though not varied, was full of good choices, from eggs and bacon to *huevos Mexicana con frijoles*, plus heaps of salsas and fruit. Russel and I piled our plates high, having not sampled restaurant cooking in many weeks.

No sooner did we sit down than the table was discussing tennis and asking if we wanted to join them for a game after brunch. I was up for it, but Russel demurred, maybe because the guys sounded more competitive than he was interested in, maybe because he wanted to spend the afternoon painting.

Perfect. With Bea we'd be a foursome. Mixed doubles, it was. But first, there were some other doubles to mix. Brunch came with Bloody Marys, and someone kept filling the tall glasses of ice with the chilly, tangy concoction. When someone pours me a tasty cocktail, I drink it.

An hour later, the four of us were on the court, me wielding their loaner racquet, clad in shorts, t-shirt, and sneakers, the others wearing some version of white clothes and holding fancy aluminum rackets. *Uh-oh*.

Keith and I had offered to partner up, but Harry said he and Bea had to separate or they'd argue all day. I laughingly agreed to be Harry's partner, and soon he was returning a high percentage of their volleys. I waved at a few balls as they flew by but opted to stick close to the net and try to stay out of Harry's way. Apparently, I didn't try hard enough, because when I backpedaled to get a high lob that was clearly coming right down at me, Harry swung at the ball and brought his metal racquet down on my uplifted face.

There was a crash of sound in my head, followed by a flash of pain, and I was lying on the court, blood gushing from my split lip. I tried to speak, and spit out blood plus a glimmer of white. Still on the ground, with everyone jabbering around me, I touched my mouth and discovered that hurt even more. I picked up the sliver of white that had been the bottom corner of one of my front teeth.

The game was over. My split lip was iced. I was advised of the proper dentist to go to in Loreto and given a lift home, complete with a fast dinghy ride out to the boat. I was fine until I saw Russel peering over at me as I awkwardly clambered up the stairs onto the boat.

Keith explained from his dinghy as I sat down hard in the cockpit, holding the ice pack to my mouth, suddenly teary.

When Keith left, I started crying and couldn't stop. Russel urged me to go lie down below and brought me a cold glass of water. Still, I sniffled and kept my mouth closed, mumbling about my injury to the point that Russel grew worried. He finally asked to see exactly what was wrong. My tears still flowing, I smiled in a trembly fashion so he could see my broken tooth.

He looked a bit shocked, but smiled reassuringly.

"It's not that bad," he said.

"It is, too, I look twelve. Like a twelve-year-old Becky Thatcher!"

I did in fact look much younger with my badly chipped tooth. As an old friend once said of his own chipped front tooth, it took away ten years and fifty IQ points.

But it was Sunday, and at best I would not be seeing a dentist for a day or two. In the meantime, I could rest and read, keeping my mouth shut or at least my lips closed. That was fine, because I definitely didn't have anything to smile about.

* * *

I was in the office of "the best dentist in town." He may have been the only dentist in town, as I didn't ask for clarification on that point; probably he was not, in a town of seven thousand souls that had three well-stocked candy stores. The previous day, when he had quickly fixed my broken front tooth, the dentist had poked another tooth far back in my mouth, and I jumped in pain. I needed a filling.

He had the face of a saint. Kind, gentle, forgiving, but one that looked like it had seen plenty and heard it all before. He had, no doubt, perhaps even right there in his office. He might have been the unofficial confessor of the town as well as the man in charge of dental hygiene. He nodded toward the plastic cup of water. "Rinse," he said.

I had been 30 minutes late, unforgivable in my past experiences with dentists. But he greeted me at the gate of his home next door with the first of many understanding smiles and gestured to his office door. Inside his front room window, I spotted a grand piano and pictured him playing as he waited for me. I went into the office, and he followed me at an unhurried pace. Clearly, none of what came before this was important. Now I was here, and that was what mattered.

The office was small, one chair for me, one for him, a window, a nice seascape in oils on the wall. I sat in the big chair after divesting myself of backpack and jacket, trying to get comfortable and relax. He arranged his tools methodically, then turned on the bright light over my head and examined my mouth. He found the tooth again without any of the instructions I was going to give, prodded it gently, shook his head.

"It is bad," he said sadly. "The old filling is broken. It will be one hour today, maybe more . . . Then in four or five days, you must come back."

He looked sympathetic to my plight.

The shot of Novocain was totally painless, also a first for me. My confidence soared, and I hardly flinched as the work started. As the drilling began, I looked heavenward, but my eyes were arrested by the white waves of stucco on the ceiling. It looked like a frosted cake in a glossy magazine advertisement.

Above the paper mask, the doctor's deep, dark brown eyes thoughtfully regarded my mouth as he excavated with the drill. No one had ever given my teeth the amount of concentration they were now getting. There was no assistant, no line of people in the waiting room, no receptionist answering calls, no buzzers, no other chairs full of patients in adjoining rooms. There was only this problem: my tooth, my mouth.

A little later, the drill infringed upon the nerve and that familiar jangling went off in my head. The urge to flee or fight was almost overwhelming. A great many dentists must get slugged in the jaw every year. As the discomfort increased, his brow furrowed. He'd noticed the infinitesimal winces I couldn't control.

"I realize this is sensitive," he said with an expressive shrug. "I am sorry."

He paused to show me an acupressure spot on my hand and instructed me to pinch it hard with the fingers of my other hand. This helped immensely, or perhaps it was doing something that took my mind off the pain.

The dentist smiled, and the drilling resumed. It was not really *pain*, but it was certainly more than *sensitivity*.

I tried to distract myself further by thinking of real pain, real suffering. It wasn't like having to sail in freezing weather with howling, biting wind all the way across a frozen sea like Shackleton and his buddies did. It wasn't even as bad as being cold, wet, and seasick, like I was on that trip up from Cabo to Los Frailes.

I'd already forgotten how miserable I was, though it'd only been a few months. That was the longest day of my life, to date. Time had stood still, as the boat did the exact opposite.

The whining in my ear ceased, and the dentist said, "Rinse."

Settling back again into the chair, I assured myself that I could take anything for an hour. It was half over already. Twenty more minutes. A piece of cake. The dentist's eyes crinkled with what must have been an encouraging smile, and he began again.

The drill stopped and I rinsed again before the gentle hands began to pack the hole in my tooth. The space, explored with my tongue as he prepared the temporary filling, was huge, cavernous, jagged—somehow bigger than my whole tooth.

The saintly dentist hummed behind his mask as he packed each tiny parcel of filling into the tooth, fitting them in some

prescribed manner, like doing a jigsaw puzzle whose finished picture is known only to a chosen few. It was almost over.

"This is temporary," he said when he was finished, tapping his own tooth to demonstrate. "In a few days, you can come back?"

I did the math as I gathered my things and stood. Next Monday.

"*Lunes?*" I asked, speaking softly as I tried out my new bite.

"*Si.* Very good."

He waved away my money, saying we would attend to that the next time. The appointment and repair of my front tooth had come to 30 dollars, total, so I was not worried about the cost. He instructed me not to chew anything on that side of my mouth for a few hours. His strong but gentle hand was on my shoulder, guiding me to the door, patting my arm in farewell as he followed me out of the room.

As we left the office, I saw that a young man was waiting in the vestibule. He slowly got up as I said goodbye to the dentist and headed out the front door. When I glanced back, the two men were shaking hands, smiling and talking. Probably the dentist had known this fellow since he cut his first tooth. Their conversation was warm and unhurried. Now the young man and his concerns—his mouth, his teeth—were the only thing concerning the saintly Loreto dentist. It was not me getting some special tourist treatment, this is the way he treated everyone. And it was unlike anything I had ever experienced in seeing dentists my whole life.

They went into the office, the patient first, the doctor following. The door closed slowly behind them.

Naked Truths

THERE'S A SAYING AMONG CRUISERS that the most dangerous thing on a boat is a *plan*. People new to sailing tend to focus so much on the fact that they told someone they'd be back in port on a certain day, that they ignore important factors like weather and sea conditions.

That having been said, we'd had a sort of plan. We'd spend a couple of months in the Sea of Cortez, then sail over to the mainland of Mexico, continue down the coast to Central America, and go through the Panama Canal. We had spent enough time here, and it was time to go south.

One last trip to Loreto to check out with the port captain and do a little more shopping. Sadly, the two stores could often be as low on supplies as my pantry. There was no peanut butter on that particular day. They did have romaine lettuce, which was quite an unexpected treat, so I got a couple of heads for our boat neighbors, along with a few more *existencias* (supplies).

We sailed out of Puerto Escondido and over to Isla Danzante for a farewell stay in Honeymoon Cove. One of our favorite spots, the narrow rocky slot was the right size for *Watchfire* to anchor in bow-and-stern style, and a spectacular place to skindive. The water was as clear as glass, and I spent more than an hour swimming before finally getting chilled. We watched an incredible sunset, and

our spirits sank along with the sun. Hard to believe we wouldn't be visiting again.

The next few days we continued along the coast south, stopping at Agua Verde, Punta Marcial, and Los Gatos, saying goodbye to all the places we'd come to love. The wind kept blowing from the south, right where we were headed. We sighed and shook our heads, laughing about how we'd turned around at San Juanico due to the wind. Where was all that north wind now?

The same local fishermen who had sold us fish the last time we were in Gatos came by in a panga and sold us a huge grouper for five dollars. An ideal fish to barbecue, grouper has a steaky texture and pairs nicely with grilled squash. The pangueros told us they call this month *Febrero Loco*, Crazy February, and predicted more favorable winds in March. (No doubt, once we were in La Paz and didn't need the north wind, it would blow.) When the fishermen left, we were completely alone.

It was clear that we needed some extra time in Los Gatos, with its stunning fiery color palette. The cliffs are all some shade of brick, from deep red to weathered pink. Against the red rocks and the white sand beach, the bay is bright aqua and clear as blue glass. Russel shot quite a few photos, hoping to create a painting to do it justice (he did).

On the deserted beach, we stripped to swim and sun naked. When Russel pointed his Nikon at me, I immediately tensed up, feeling constrained and awkward. Being *photographed* nude is not like being looked at, and, despite all our swimming and hiking, my body didn't match up with my mental picture of my ideal self.

He took in my brown eyes, sun-streaked brunette hair, and tanned skin. "Look at you. You're a symphony in brown."

Suddenly, I was able to see myself through Russel's eyes. The love and desire in his eyes allowed me to feel—no, to *be* beautiful and sexy.

Soon I was relaxed and posing voluptuously as he took arty black and white shots of me.

Basking naked on that beach was like being at a private resort, or on our own desert island. I made Russel laugh by suggesting that everything we humans strive for is working toward the goal of swimming in the nude. Want a walled backyard pool and Jacuzzi or a house on a private beach? I knew why. The five-star resort vibe was amplified by another dinner of fish and the last of the lettuce, cucumber, and tomatoes. From this point on, it would be canned veggies.

We sailed south through the narrow pass that Russel had dubbed "Heaven's Gate," waving goodbye to our cruising heaven as we headed to Isla San Francisco. This island is picture-postcard perfect, with mountainous cliffs and a long white curve of beach along its blue bay. A power boat was already anchored there, but since it's a big bay, that was no problem. We were hailed right away by the captain of the charter boat, who turned out to be Keith from *Shangri-la IV*. He was going to La Paz in the morning, so we got together, and he brought us a care package that included baked clams, enchiladas, and some avocados. Ideal timing.

We followed the charter boat toward La Paz, but opted to stop at Isla Espiritu Santo since the wind had died and we didn't want to motor all afternoon. The next morning the wind had come up and was blowing hard, directly from La Paz, so we settled in to wait for it to shift. Ah, the Sea of Madness. I hoped we wouldn't be stuck too long as the only supplies left were beans, rice, lentils, popcorn, and hot sauce.

We had popcorn for dinner with rum drinks as the sun went down, and then our sunset chat turned into a talk about our relationship. We managed to talk about our future with neither of us getting touchy, which was a miracle. I tried not to push my agenda about having a child, since it was clearly not the right moment in

time to start a family, but it would have been nice to hear him say that he really *wanted* to have a baby with me someday.

We segued into talking about art and then writing. I mentioned *Islands in the Stream* which I was reading. I'd never seen the film, but Russel jumped up to put on Jerry Goldsmith's score, which is as lively, dramatic, and moody as the sea itself. We talked about Hemingway's writing, how unafraid he was to reveal himself—or his main character, who seems to me to be a lot like him—as deeply flawed.

In a momentary flash, I got something about my own writing. Regardless of the type of short stories I write, the characters tend to be very different from me. Maybe it was time to start listening to all the professionals and "write what I know." But that might reveal things to me about me that I didn't want to know or share with the world.

What was it that I wanted to say? And who was I, anyway?

* * *

Back in La Paz, I was able to get in touch with the outside world again, in a very slow way, through the odd adventure of going to the town's telephone exchange.

Once inside, and after paying a few pesos, you were assigned an old rotary phone in a tiny wooden cubicle. Then, the operator sitting nearby found you a dial tone. Once the call connected, you could talk as long as you could afford to. I couldn't get a hold of my mom, but I did reach Nena. She said she'd call Mom and tell her that we were fine. Before I knew it, the telephone lady was waving, and we got disconnected a few seconds later. No matter how hard I tried, I was always cut off mid-sentence.

Later, we dinghied from our boat over to Keith's to bring him a beer as a thank you for his emergency provisions out on the island.

He ended up taking us out for tacos at a local spot that didn't open until 9 pm. It looked like a used car lot with strings of lights around an empty lot, but there was a BBQ set up in one corner and the lines of people told us how good it would be. It lived up to the hype. The carne asada tacos were to die for, and the toppings were even better: grilled onions and fresh cilantro, tomatoes and all the rest. Keith demonstrated how to garnish a taco sparingly, like a local, and not pile everything on it *like a tourist*. We may never truly absorb that lesson.

I had a bit too much to drink, which, back at the boat, led to a dumb argument about me being an actress in NYC once we arrived. I hadn't learned not to open that can of worms. It wasn't that Russel didn't want me to act, but he hated the idea of me being intimate with other men (even on stage), which was understandable, since he'd had some bad experiences with actresses in his past.

Lying sleepless in bed, I went over it all in my head again. There was nothing that either of us did wrong. The problem was trying to make life plans while being ignorant of how exactly they could or might work out. Clearly, I needed to let whatever was next in my career happen when it happened and stop trying to figure it out in advance.

That sounded like a good recipe for my whole life.

The next morning, we were walking on eggshells. I had to go call Mom to find out when she was coming to visit, and getting off the boat for a while was good timing. The Johnson outboard was running again, and I got to run it by myself for the first time, which was the perfect metaphor—zooming away from it all. At the telephone exchange, I reached my mom on the first try, and we covered a lot. Both of us talked at the same time, questions and answers flying through the phone lines as rapidly as we could speak and hear, and lots of kisses were sent and received.

By the time I came back, excited about my mom's impending visit and loaded down with bags of groceries, Russel was happy to see me and a little bit contrite, and we both apologized for getting "het up," and all was well again. We were both wiped out from the combination of too much rum and lack of sleep, so we went back to bed and made up for a couple of hours.

Networking in Paradise

RUSSEL AND I WERE IN agreement. We wanted to spend more time in La Paz. But staying in a city–any city–is expensive. We pondered how Russel could get some work or if we could find a free place to stay, and I decided we should go into shore one morning and *network*. Russel laughed when I said that, but it turned out to be fairly accurate.

We started at the cafe at Jardin de La Paz, where we'd rented the apartment in December and where my mom would be staying when she visited. We'd seen the cafe under construction but never had the chance to visit it before we left to go north. It was open for business when we walked up, so we had a delicious and inexpensive breakfast. The couple who owned the place were friendly, and we explained our dilemma to them. Turned out, they had a local real estate agent friend, Miguel.

We met Miguel, and he was *muy simpatico*, which means just what it sounds like. He also spoke excellent English, which was helpful since my Spanish never seemed to improve and Russel's was still limited to a few phrases. Miguel gave us the number of some friends of his who might be looking for a house sitter for their place, located outside of town on the road to the airport.

We called Mort and Jane, who said they already had someone lined up but wanted to see us anyway, since we might be able to

house-sit for them the next time they left La Paz. It was a treat meeting a new couple who were not boaters (I did like our fellow sailors, but after months of talking about engines, anchors, and boat repair, it was fun to discuss other things). They'd been active in the audio-visual world—Mort said he'd done the sound for the Monterey Pops Festival, and we were properly awed—but were retired. Jane spoke excellent Spanish and even wrote for a local rag. She also read voraciously, so we shared titles we had both loved. Is there anything better than connecting over books? It quickly reveals a true kinship or a terrible mismatch.

The two of them had lived for many years in Sausalito, a place Russel and I both love, so we had much in common besides books; it turned out that Mort had a very cool, larger-than-usual version of the Baja panga, so he and Russel did end up talking about boats and engines.

In short, we communed and became fast friends. They called us a couple of days later, asking if we could house-sit for them as the other person's plans had fallen through.

We were so excited to have the opportunity to live on land for a short time without going broke that we didn't really care that we might have lost the other people their gig. Mort and Jane promised to invite us out to see their house very soon.

The next day on the beach at the Annual La Paz Dinghy Regatta we met another unusual couple. Mike and Karen Riley were completing a circumnavigation . . . on a *24-foot Columbia*. Yes, they had the same kind of boat as us, and it was even smaller than ours. And their sailboat had no engine. Their eighteen-month-old boy, Falcon, was napping out on the boat when we met them ashore. After about half an hour Karen looked up and said, "He's up," and I saw a tiny figure waving from their anchored sailboat. The two of them drifted out by dinghy to get the toddler, using an umbrella for propulsion.

They returned with Falcon, who was dry-eyed and cheerful and played happily on the beach after nursing. We chatted for an hour or more and found them to be bright and funny. They had more blue-water sailing experience than anyone we'd met, but even more important than that, they were so darned creative in how they approached sailing. I knew we would be seeing more of them and felt a bit smug about La Paz offering us opportunities to network.

We were also finding time to write and paint; I had written a story about the day that Russel and I got back together after our years apart. It was hard to write about it honestly, but it was a good creative challenge. I polished it up over a few days and then read it to Russel, and he liked it. Whew.

My mom's visit came at just the right time. The weather was sunny all week, enabling a lovely day-sail to Balandra and ideal conditions to show her the underwater beauty. Though she'd always been a strong swimmer, Diane hadn't snorkeled much before and was stunned by the shimmering clouds of small silver fishes that surrounded us in the crystal-clear water. Our gleeful laughter sent clouds of tiny bubbles all around us, scattering the schools of fish. Taking a break on the white sand beach, we chatted about beaches we'd loved—a few on rivers, but most on the ocean—and I told her about swimming nude with the dolphins.

We swam back to *Watchfire* and soon picked up the conversation with Russel. Diane told Russel about the first time she took me and my brothers to a nude beach in the late 1960s. She was scared to disrobe but didn't want to pass on to us her anxiety about being naked, so she acted nonchalant about it all.

"And it worked!" she said with a laugh.

When she mentioned missing La Jolla's clothing optional beach, a place my family had often visited over the years, Russel said she should go. She shook her head, saying she'd feel too self-conscious about her Rubenesque body, and he said, "I learned something

important in my years at Black's Beach. As far as attractiveness, *attitude* is everything."

After a dinner of fresh fish and a quiet night at anchor, we sailed back to La Paz. What luck we'd had. Russel and I had such different moms, but they were both strong women who could fit in anywhere, and who could literally *fit in* to our small boat and adapt to our life, if only for a couple of days.

Back in La Paz we again visited museums, shopped, ate out, hung out at Diane's rented apartment and generally acted like tourists. My mom and I went shopping and she bought me a bikini, since my current suit was looking beat up from so much salt water and sun. Mort and Jane's house had a pool, which was shared by the other homes in their complex. Diane and I laughingly agreed that it would definitely not be a place for swimming nude.

Mort and Jane had invited all three of us to dinner at their home, another fun not-on-a-boat experience. They immediately clicked with Diane—no surprise—and the conversation ranged from rock and roll to acid trips. Mort and Jane told us they'd decided to stay in town until the end of April, so we would have time to race our boat out to the nearby islands and enjoy our first La Paz Race Week festivities.

The day Diane left (early, in a cab to the airport) Russel and I biked over to the empty apartment to get the case of beer we'd left in her fridge.

In the bright tiled kitchen was a note, saying how much she'd enjoyed being with us and how glad she was that we'd found each other again. My mom, a fine writer who never traveled far without her notebook, included a short poem about how well we were "steering our relation-*ship*."

Off to the Races

WE GOT UP EARLY THE day of the race. I was nervous about being in a race, even though not a single boat in the motley fleet was really a racer; we were all cruisers, so our boats were loaded down with people, gear, and provisions. Race boats are traditionally sleek empty shells with big sails designed to carry a crew to a specific point very fast. I'd never thought about sailing fast, purely of getting there (to wherever we were headed) before dark. Though Russel always says that any two boats within sight of each other are automatically racing, he's not much of a racer, either. He claims that anyone who is really interested in speed should get into aviation, not yachting.

Anyway, we headed for the start line at 6 a.m., though no one started sailing right away, because there was no wind. Finally, we all got under way and, like a ragtag flock of ducks, we slowly threaded our way out of La Paz harbor. In the outer waters of the big bay, the islands of Espiritu Santo and Partida shimmered on the horizon, and the vast expanse of water was blooming with boats and spinnakers of every color.

For hours, the VHF radio crackled with messages of encouragement as well as snide comments from vessel to vessel. I had gotten as comfortable on a VHF as on a telephone by this point, so I was keeping in touch with our racing rivals.

By late afternoon, the fleet was spread out like a broken strand of pearls across the blue water, with almost everyone ahead of us. *Watchfire* was valiantly trying to keep up with the pack, but our overloaded little cruiser was hard-pressed to go more than 4 knots even in that breeze. Some of the bigger boats, 50 and even 60 feet long, made good time getting to the island and were within a few miles of the entrance to Caleta Partida, a long narrow bay between the two islands that marked the official finish line.

Then the wind died down, and the big boats were not going anywhere. So, one by one, they dropped their sails and motored in. We continued to sail, being much more accustomed to sailing slowly and also much more capable of going a decent speed in such light winds. The sea went flat, as if to help us along, but our speed dropped to 3 knots, then 2, and then, even with only our big lightweight reacher-drifter up, we were only going a little over a knot toward our goal.

I stood up on the bow, slowly turning to take in the lovely panorama. The hulking silhouette of Espiritu Santo loomed beside us to starboard, La Paz was a sprinkle of white buildings far astern, and the glassy sea spread out beyond and between, glowing golden in the low rays of sun. Except for a squadron of pelicans flying low over the water, we were alone, silently creeping across the surface of the sea like a snail on a glass tabletop.

Russel looked surprised when I said we shouldn't quit—we were still sailing, after all, and quite safe.

"But we'll be out here for *hours*," he said. "It'll be dark by the time we get in."

"What are we going to do once we're anchored?" I asked. "Have dinner and a cocktail and watch the sun go down, right? We can do that out here." I gestured around our boat. "After all, we live here."

We kept going. The sunset was gorgeous, as nearly every sunset was in La Paz. The cold rum drinks were tasty, and the dinner wasn't half bad either.

The *Coromuel*, as the locals call the evening wind, came up eventually, and we sailed into the entrance at about nine, full and content, and anchored in the deep bay not long after. We counted the race as a major success, even if it took us fifteen hours, because we finished what we started. And we had another important phrase to ink into our ship's log: *We live here*.

The next day we took the boat out for another race, but didn't come close to placing. We did finish, but long after most of the boats. I discovered that I did not enjoy racing and opted to sail with Karen on *Tola* for the final run. Mike and Russel took *Watchfire* out for that race, and I got to hang out with Karen and two other friends.

We four spent the day trying to sail little *Tola* from the farthest shallows of the long anchorage, and finally succeeded in crossing the start/finish line as the rest of the fleet came into sight on their return trip. We wheeled around and broke out the tequila, claiming to be first across the finish line.

The days ran together, full of silly games and dinghy races, potlucks and beach BBQs, and a sandcastle-building contest that was a blast. On the final day, Mort and Jane even came out on their speedy super-panga, though they had boohooed all the silliness of Race Week.

The week ended with a party for the fleet back in La Paz at Marina Palmyra, the closest marina to the entrance of the bay, with awards for all the boats who placed in their classes. Amazingly, we came in third overall in our class, mostly due to finishing the first race all alone. Got a bottle of rum for that, and another bottle for our third-place win, and one for the massive sandcastle lobster we helped to sculpt.

With the bottles safely tucked in our backpack, Russel and I strolled home to *Watchfire*—tired, sandy, and ready to move ashore.

A Change of Plans

W E SAILED *WATCHFIRE* DEEP INTO the bay of La Paz, past the furthest southern point we had been to before, following the channel all the way to a marina-in-progress called FidePaz. There was not much there but an empty hotel and a turning basin for boats that was open for anchoring.

It was a bit scary to come in the narrow, sandy channel, Russel watching the depth sounder and me up on the bow, checking for any visible underwater obstructions. We got a sounding of 4.5 feet as we went over the shallow sandbar that had accumulated at the harbor entrance, which means our 5-foot keel was moving through a few inches of the soft sand that had piled up. I was so relieved when we passed into the deeper water at the far end of the channel. The little harbor of FidePaz, that would someday hold a small marina, was almost a perfect circle, enclosed by cement and brickwork walls. We were the only boat inside, floating right in the middle of the basin. The water was about 9 feet deep, and the tidal shift was not enough to cause any concern for our keel and rudder.

It was a handy spot for *Watchfire*, since we could walk over easily to check on the boat from Mort and Jane's house. And the empty harbor was completely protected from any wind chop or swell, no matter how hard the wind blew. Mac Shroyer, the knowledgeable boatwright and owner of Marina de La Paz had pointed out the tiny

bay on a chart and told us how to get there; we'd never have found it on our own.

The adrenaline rush of the morning's short but anxious sailing journey subsided and we collapsed, in a good way, spending the rest of the day supine—mostly reading.

The next morning we tidied up the boat and wandered over to see Mort and Jane, who treated us to a nice midday *comida* as we learned about the workings of the house, and how to care for the dog, cat, and garden. There was a plethora of potted plants inside and out, so I would have my work cut out for me to keep them all watered and shaded at the appropriate times. The sun had already gotten very hot and bright a few times, and it was only April.

There was also a TV with a VHS player, and Jane said there was a place not far away where we could rent films. Russel and I took a walk over to the nearest shopping district, and indeed there was a video rental store, though it was closed for siesta. We peered into the shop windows, and it looked like we would have quite a few choices for catching up on "cinemas" as Russel would say.

Just a block further up was a place that specialized in carnitas tacos as well as *chicharrones* (fried pork cracklings). I love chicharrones but had never had fresh ones. They were a bit greasy, but I liked them; Russel was grossed out and demurred. Each of the small taco shops and carts in town was open at a different time of day, and each one specialized in a different sort of meat. Ceviche and shrimp tacos from the cart near La Perla department store downtown. Carne asada tacos from the shop on Cinco de Febrero, and breakfast tacos *de pierna* (leg of beef) on Cinco de Mayo.

The big *supermercado* was close to FidePaz, so we could easily bike over there for groceries, but Jane had stocked the house with foodstuffs, so we'd be well fed. She said since they were not paying us to house-sit, it was the least she could do.

The first morning, after Mort and Jane left for the Estados Unidos in an overloaded Jeep SUV, we unlocked their front door and stepped out of the bright sun and into the cool tiled hallway. We looked at each other, grinning, and then dashed inside, whooping with joy.

The house was charming, with a guest room below ground level that stayed very cool, and the master bedroom up a flight, with enough windows to catch every stray breeze. There were ceiling fans in all three rooms, including the big airy living room, with its vaulted ceiling. The tiled kitchen was big enough for two people to work in comfortably (the kitchen in my NYC apartment would fit in there at least twice). The many windows made the place light enough to read in any chair in the daytime, but the thick adobe-like walls and smooth floor tiles kept it cool and dim enough to feel like a refuge.

* * *

One of the first things we did the next day was to get out a notebook and work out our budget. In the first five months of cruising, we had only spent about $500 a month, but we never intended to stay more than a few months in Baja before heading south, and the packets of traveler's checks we'd brought with us were running out. We had a little income from the interest on Russel's savings account, and if we could find a way to get up to the bank during the summer, that small infusion might keep pace with our spending.

"We can take a bus up to the United Snakes when the weather is right for leaving Mr. Boat on anchor. I'm sure they have buses from Mulegé or Bahia de Los Angeles."

"That'd be cool. I'd like to see LA Bay."

"Going south to the Canal right now feels wrong," Russel said, "I want to see *more* of Baja, not leave. We'll probably never be in such an ideal sailing spot again."

"I would hate to leave Baja now, we've barely scratched the surface!"

"But I don't want us to start spending my savings, either."

"I'll get a job as soon as we get back to the United Snakes. God, now you have me saying it!"

He laughed, then turned serious. "And hopefully I can actually sell some of my paintings."

"You will, but you have to find a gallery that likes expressionist paintings of Mexico. Mexpressionist paintings."

"Good one, Pook. I like that. I'm a Mexpressionist."

"But you can't sell paintings unless you have time to paint them, so we should definitely stay up in the sea for the summer."

His face lit up. "The sea is my muse. No, you are my muse, but—"

"Yeah, yeah. Stop buttering me up. We can stay."

"You aren't saying that because you know I desperately want you to, are you?"

"No! I love it here, too, and why should we hurry to New York? We'd never get there before summer and New York in the summer is horrible. I wouldn't even try to get a job. Summer is when people *fire* waiters."

"So?" He looked like he was holding his breath. "Can we do this?"

"I think so, as long as we don't have any unexpected expenses," I said, looking back down at the paper. "We know our food budget stays about the same month to month, and we might catch more fish further up in the sea."

"And more clams, and more scallops." He licked his lips with a loud slurp.

"Hopefully," I said with a laugh, "but we can't count on that."

"Another plus," he said, "is that we won't have to worry about hurricanes if we go south in October or November."

"Right. And we'll move south faster once we get to the mainland, because we won't be able to afford to stay in places like Puerto Vallarta and Acapulco."

"It's like I always say, everything's a trade-off!"

"It is," I agreed. "And it's worth skimping a bit later to see more here now. Deal?"

"Deal."

We hugged, both of us giggling with excitement.

Russel was clearly ecstatic. He'd been somewhat blue since we passed through Heaven's Gate on our way to La Paz, and now he was a new man.

It was thrilling. More islands to explore, more reefs to snorkel, more trails to hike. Maybe with the whole summer to write, I could get some stories or articles completed.

Meanwhile, it was fun for us to be able to catch up on a little culture. We watched a movie every evening, sometimes two. We were surprised to find classics like *A Man for All Seasons* and *A Clockwork Orange* at the tiny local video store, plus a few action films and silly comedies.

We'd had no way to watch films at home since we left our little San Diego apartment and moved on to the boat. The two of us love nothing more than rhapsodizing over the merits of a great film, unless it is dissecting and analyzing a terrible film. I'm always much more critical about the acting and the direction, and Russel is obsessed with the score and cinematography. And many a night ended with us talking in improvised bad movie dialogue:

"Remember when we met, darling, when you were an international spy based in Washington and I was still a go-go dancer at that strip joint in Georgetown, while studying to be a forensic anthropologist?"

Russel loves foreign films from the 1960s and 70s. He studied them at UCLA, but more importantly, he loves *pure cinema*. We watched *Death in Venice, Day for Night* and *8 1/2*. I used to see foreign films in New York, but sometimes watching a classic movie lacks a bit of something without someone to explain the context of who-what-when. He could easily write essays for cinema aficionados, but for the moment I had the film curator to myself, as he was busy being an artist.

He'd taken advantage of having a separate studio in the downstairs guest bedroom and had been sketching out his next few paintings on canvas, including one of San Juanico and one of Los Gatos. Those two were only a foot across, but a few were going to be 36 inches by 30 inches, determined by measuring the spot where he stored the finished paintings rolled in a tube; that was the largest size canvas we could fit on the boat. He was running out of raw materials, so we went in search of unstretched canvas in La Paz. No surprise, it was not to be found. Russel would work on the six big paintings he'd already sketched and try to get more canvas in San Diego when we went up by bus.

Mort and Jane's dog was a light brown Baja mix, pretty and sleek with a black face and feet, like a Siamese cat. Very quick and alert, with such an intelligent gaze that Jane nicknamed her "Maggie the dog person." Russel had worried aloud at each new anchorage that I was going to latch onto one of the stray dogs I befriended everywhere we stopped, and his worries increased when we started taking care of Maggie. It was true that I'd forgotten how fun it was to share walks and playtime with a dog.

The pool was another nice addition to our days. Nearly every afternoon found us slipping into the water to swim a few laps and cool off. No one else in the small complex of homes ever seemed to use the communal pool and patio, probably since every

home had its own lovely, shaded lanai with plenty of ceiling fans throughout.

It was fast becoming clear that the weather in summer would be unpleasantly warm up in the sea. I commented on the hot weather to a neighbor one day and she smiled and said, "This is nothing. Wait until August."

Thinking of August in New York City, I shuddered.

Big City Dreams
1984–86

MY SECOND TRIP TO NEW York wasn't anything like my first. Though I didn't have a job lined up, I did have an apartment in Queens. An old boyfriend who was filming in Europe wanted a roommate to live there full time, while he paid half the rent whether he was there or not. It sounded like an ideal situation.

I soon found a job as a counter girl in a fancy French pastry shop on the Upper East Side. The clientele was high-end (Jackie O, Andy Warhol, and the like) and the food was delicious, which was key since I was flat broke. The first of the month had come, with no rent from the supposed roommate, and no answer to my pricey overseas calls. The rent was only $400 a month, but it took every cent I'd saved to cover it. Luckily, I was soon making $5 an hour and working forty hours a week.

I ate two meals a day at work and took home extra brioche and a mini quiche or two when I left each day. In those days, many diners like the one on my corner sported a breakfast deal of coffee plus a bagel with a *schmear* for a buck, and a new sandwich place called Subway featured a foot-long tuna sub that I could make two meals out of. And I knew all my mom's tricks for making cheap and filling brown rice dishes and hearty lentil soups, made from whatever was in the cupboards. Skimping on meals was fine, but not swimming the East River on the way to work, so payday sent me straight to the

closest subway station for a roll of 75-cent tokens to last me until the next paycheck.

Saving every spare penny meant I could afford Warren's class again. I also signed on with a couple of modeling agencies: the petite model agency had me down as five-foot-three and the regular modeling agency as five-four. No one ever checked. One memorable job came through the petite agency—a shoot at AT&T headquarters in Connecticut, playing a magician's assistant, based on my ability to fit into only half of the big wooden trunk for the old sword-through-the-box trick.

One audition in summer of 1984 was for a hotel in the Poconos, so we—four girls and four guys—got bus fare from NYC to go up there for a weekend. It was fun to play at being a tourist, though our rooms didn't offer the heart-shaped tubs the place was famous for. All three of the guys were single and I was the only girl who was unattached, so I got quite a bit of flirting in, especially with a guy named Phil. The eight of us were shadowed all weekend by a photographer who snapped us playing mini golf and basking by the pool, but it turned out that the owner also spied on us through a mirrored glass wall at the restaurant. The bigoted fool pronounced me *too ethnic*. Tall, blond Phil was chosen for the job, along with the other blondes and redheads. I was not, but instead of leaving on the next bus with my expense money, as instructed, I stayed on in Phil's room, and we got to know each other. The Poconos was the ideal place for a new romance to flourish.

Not many months later, Phil moved to Long Island City to become my second roommate. My cousin Maya, a dancer, had been rooming with me since July—her first day ended up with us on my rooftop watching fireworks lighting up the night over the skyline of Manhattan—and she was eager to get her own place. I got her a job at the French pastry shop, and even Phil took on a few shifts over the busy summer and fall. The French woman who ran the place, who

no one ever called anything but "Madame," was tight-fisted but fair and accepted all my recommendations.

Eventually, fed up with working so hard for no tips, I applied at Maxwell's Plum, the Tiffany-glass-filled eatery on First Avenue that attracted high rollers as well as tourists who had heard it was a must-see location. That led to getting a lot more fine-dining experience and gave me the courage to apply at Bud's, up-and-coming chef Jonathan Waxman's soon-to-open restaurant on the Upper West Side.

By then, my old friend Jimmy Hansen had returned from a modeling gig in Europe with his lover, Michael. Their apartment was near Bud's, so I told Jimmy about the new job opening. We were both hired and got paid minimum wage to help get the place ready to open.

Bud's was a medium-rare success, attracting some entertainment folk, like the musicians from Letterman. Jimmy and I commiserated our way through long hectic shifts and then talked into the wee hours with Neil, a handsome and witty bartender who became a dear friend—we are still laughing about the patron who tried to impress a young lady at the bar by telling her he loved reading classic authors like "Somerset Magnum." Each long night concluded with a cab ride home over the sparkling river to Long Island City, unless I stayed over at Jimmy and Michael's.

A particular joy was spending time with Jimmy, the best kind of best friend; he always encouraged me but also urged me out of my comfort zone. He wrote a hysterical one-woman one-act that featured me as a bizarre Long Island matron, and put it on in various venues around town. His talent was world-class, and his intellect incisive, so I thrived on his regard. He and Phil never really clicked, so Jimmy and I hung out with Michael or Neil, but more often alone. We saw weird films, went to racy clubs, and took big bites of the Big Apple.

Before work, I met with acting scene partners, or went on auditions. Jimmy and Michael had both done some day work on soaps, and they introduced me to a casting director who cast me as Nurse Nancy on *Another World*. The part was an under-five (a day player with less than five lines) on a national soap. I was going places!

Then my old friend Steve from the Old Globe called and asked if I wanted to audition for a children's theater group he was in. Of course I did. By the next week, I had the job. My singing wasn't as strong as my acting, but I was experienced. Performing musical plays for children had been my first professional theater job, after all. Most importantly, I was full of enthusiasm and energy. That was crucial, since we traveled by subway and elevated train throughout the five boroughs, performing at every school, library, and rec center that could afford us, from Brooklyn to the Bronx.

We acted, sang songs, horsed around, danced, and the focus of the show was the importance of reading. From poems to stories, through laughter and song, we reminded those kids that whole new worlds lay waiting for them in books. I was surprised to see that the kids in the fancy expensive school were often not very good audiences, and sometimes even walked on stage or acted out in some other way during our show.

But when we did our show at a library out in Far Rockaway, for kids who lived in the sprawling acres of squalid run-down tenements, they sat silently with big eyes and big smiles, taking in every moment.

One little girl followed me offstage after a library show and hugged me, saying that no one from TV had ever come to see them before. Instead of bursting into tears, I sat down with her and asked what books she liked and what she wanted to do when she grew up. She cocked her pigtails up at me, starry-eyed and wistful.

"I want to do what you do," she said in a small voice.

"You want to act?"

"Yeah." Voice tiny now, eyes downcast.

"You absolutely can, if you really want to."

I told her to aim for the High School of Performing Arts, and not to settle for less. The two of us picked out some books for her to read, and I sent her home with a head full of big dreams. In neighborhoods like that, where hopelessness seemed endemic, it was easy to see that our little company was making some small difference.

The Way to San Jose

ON MAY 9TH, 1990—180 DAYS since we left San Diego—we sailed out of La Paz harbor loaded down with provisions and heading for the islands on our way north.

Roxanne, a friend from college, was set to fly in and visit us up in Loreto, so we needed to get up there before the 23rd. I couldn't wait to show off our Baja to her and hoped she wouldn't mind the close quarters on our tiny boat. She would have our stuffed seal mascot, Mister Seal, for company, at least until Keith showed up. He heard I was inviting a girlfriend down and got quite insistent that he be introduced to her, actually more like set up with her. We would see how that worked out.

Our first stop was Caleta Partida, site of the recent Race Week, but now deserted. I had already forgotten how stunning the anchorages were, with their red rocks and cliffs dotted with green cacti and small plants, the brilliant aqua color of the big bay and, alongside it all, a long expanse of white sand beach. The water was crystal clear and the weather hot and still, making it the right time and place to clean our boat's neglected bottom.

My new dive mask, an early-birthday-and-anniversary present, had glass so clear it was like snorkeling for the first time. The underwater scenery was as good as footage from a National Geographic film, which made looking around while scrubbing the

hull pretty entertaining. And the water was in the high seventies, much warmer than before.

We headed out early, bound for Isla San Francisco, but gave up when the wind didn't show. The water was too choppy to sail comfortably or efficiently in the light breeze, so we motored into the next anchorage up the island, known as Ensenada Grande. We'd been trolling a lure and as I started to pull it in, preparing to anchor—you don't want a fishing line out when you back down on your anchor, for obvious reasons—I saw the top of the rod was bending. I grabbed it and reeled in a small bonita. We anchored the boat, barbecued the fish, and ate it, all within the hour.

When the afternoon wind came up, we took off and sailed up to San Francisco Island. The sunset was spectacular, and the clear starry night was made even better when a full moon rose. The 18-mile sailing trip took us about five hours, and we got in at 10:30 p.m. There are not too many places we'd feel so comfortable coming into after dark, but that commodious sandy bay is so free of obstacles that it was no problem at all. It helped that we'd been there a couple of times before and knew the lay of the land, as it were. The bright-as-day moonlight was the cherry on top.

Altair, a boat we had run into back up in Turtle Bay, showed up; John, a solo sailor, soon invited us over for a beer and we caught up on all of our travels. He was heading to Isla San Jose, which we'd not yet visited. There was supposed to be a stunning fresh-water lagoon and an abundant variety of bird life. Our dinghy motor was not dependable enough to go so far from the boat, but John said his dinghy had a motor big enough to tow us over. Sounded like a grand adventure, so we agreed to join him and explore a new island.

We checked out *Charlie's Charts* and our other guidebooks and the only caveat about San Jose was that, due to the lagoon, there were supposed to be many flies there, which meant there could be mosquitos. Russel, the sweet thing, is every mosquito's favorite meal,

so we normally eschewed any place with even a hint of bugs, but we planned to stay far enough off San Jose island to avoid being eaten up.

It was a fast sail over to San Jose, and soon we were off for a day of exploring the lagoon. John towed us in and then we rowed around in our little dinghy, following the winding fresh-water channel deep into the island's interior, watching the herons and egrets watch us, clearly unafraid of humans. Bird calls were the only sound in the hot, still air. We made it clear out to the far end of the island, where a narrow line of bright white pebbles made a long, thin spit of land between the edge of the lagoon and the ocean. The only life to be seen was one tiny, gnarled tree; the ideal setting for a production of *Waiting for Godot*.

Before sunset, we dinghied back through the waterway and easily rowed and drifted out to *Watchfire*, far off the island at anchor.

Russel was taking pictures all day for future paintings. I was inspired too, but to do what? I'd written a few stories and essays, but they always languished, unfinished and un-submitted. My inner critic was sure that they were not good enough to let someone else read them, other than Russel. I wrote in my journal:

> *Perhaps being inspired is to be appreciated for its own sake. But I feel the need to complete a job, play a role, or perform a feat of derring-do. Derring-doodle-doodle-do.*

We were anchored quite far out to sea that night, but so were the bugs. It turned out that San Jose was a breeding ground for no-see-ums, or, as they are called locally, "he-he-nes," because they fly away saying "he-he," as Keith explained. These gnat-sized buggers climbed in through any gaps around the mosquito netting and even through the tiny holes in the netting itself. The night was hellish, with very little sleep in between attacks on us by them, and on them by us,

wielding magazines, papers, and fingers. They bit us up pretty good, and as soon as it was light, we moved farther out to sea. Luckily the wind came up, too, so we were able to catch up on sleep a bit before starting our workday.

That night, the boat rolled and rocked all night, since we were far out on the channel with hardly any protection. Also, the bites from the night before started to really make us nuts. There was much itching and even more bitching. At midnight, we were taking turns lowering ourselves down the ladder to get some relief from the cool ocean water, while hanging on for dear life as the boat pitched and yawed. The cruising life does have its ups and downs.

Dos Encounters

THANK GOODNESS FOR SAN EVARISTO. We sailed there from San Jose and finally got a good night's sleep after our three days of bug bites and itches. Russel was working on a new painting out in the cockpit as I puttered and prepared lunch and thought about what to make for dinner. Mike and Karen from *Tola* were anchored in the bay, so we'd invited them to dinner on *Watchfire*. They'd had us over to their three-year anniversary dinner on *Tola* before we left La Paz, so we owed them a nice meal.

As Russel set up for a painting day, I rowed the dinghy to shore to check out the tiny store at the fish camp. There was no one around, and the store looked empty too, though the front door was open. I looked in, called "Hola!" and eventually a young woman walked in through the back door, revealing a residence behind the tiny building that housed the store.

The word *store* is a bit generous, as it was basically a room with a counter and a huge ice chest full of sodas. The shelves were mostly bare, but I found some Pan Tostada, a strange food brought to you by the Bimbo bread company. It was toasted white bread, basically, which is nice when the package is fresh, but the toast can often be stale, and there is no way of knowing until you open it. We had eaten plenty of it, stale or not, since bread is such a convenient delivery system for peanut butter, as Russel put it.

There was a single jar of mayonnaise, quite dusty, but unopened, so I bought that, as well as a small package of cookies for dessert. We seldom ate dessert when we were on our own, being more likely to make a meal out of ice cream when we found it, but it felt necessary to provide dessert when one had people over.

The young woman, Maria, had a dozen questions for me about our life on the boat and I answered them as best I could. In turn, she gave me a tour of her home, and introduced me to her two young children. On the boat, I still had one of the coloring books that I'd found in La Paz, so I told them they should come out to visit. Maria closed the door to the shop, and she and the kids followed me down the beach, very excited to get in the dinghy. I pushed us out onto the water. The little ones splashed us plenty when they tried to help row, and we were all laughing when we got to the boat.

Russel stopped work and moved his easel aside to welcome the family aboard and soon had the kids amazed by his quickly sketched drawings of airplanes and boats. Their visit aboard was short as Maria quickly began to look a bit green when the boat rocked in the gentle swells. I gave the kids the coloring book and some gum, and then rowed the family back to the beach. All smiles, we exchanged hugs and farewells, and Maria told me to come in the next day after her supply truck came and she would give me some ice.

Back at the boat, I finally put away my purchases, made our bed a bit more neatly, and tried to put the rest of the boat in order. As Russel cleaned up the cockpit, I chopped up veggies for a pasta salad. I'd been working on a system of combining salt water with fresh for boiling pasta, since it is customary to add salt to the water, anyway. Once it was too heavy on the seawater, and the pasta turned out too salty, the next time I went too far the other way, and the pasta tasted bland. This day, I'd added a pint of salt water to the pot and it turned out fine, so I put the pasta salad in the nearly empty ice chest to cool.

Russel dove in the water and shampooed his hair, and it looked so refreshing that I followed suit. We dried off in the cockpit in the nude, as we were too far from the shore to be seen. The sun was hot and we were dry in minutes. Basking led to flirting and kissing, which led to fondling, and that led us up to the newly made v-berth to make love. We'd barely finished and were still breathing hard when a voice called, "ahoy."

Our guests had arrived early.

We called out that we'd be right out as we scurried around grabbing clothes. Mike and Karen were pulled up alongside in their dinghy with Falcon standing in the bow, ready to come aboard.

One look at our disheveled appearance and Mike started to chuckle while Karen said, "I told you we should radio first!"

The laughter continued all evening. Mike had brought a new rum drink made from a sort of Mexican Tang that comes in mango, so we spent some time coming up with drink names, like Spaced Out Rum and Mango Tango.

Mike told us the story of sailing solo to Hawaii and back on his first small sailboat *Time Out*, then taking off from San Diego to circumnavigate in his engine-less 24-foot sloop, *Tola*. Russel asked Mike what *Tola* meant and he told us to guess.

I blurted, "Time Out Lives Again."

He stared at me, very surprised, and I laughed.

"Words are my thing, man."

Mike and Karen's story was amazing. Mike had been sailing solo around the world when he stopped in New Guinea to work and build up his cruising kitty for the next leg to New Zealand. Karen was in New Guinea teaching school and came along with a friend one day to join in some impromptu yacht races. Mike and Karen ended up paired on *Tola* for the race that day and had been together ever since. They got married along the way west, and pregnant a bit farther west than that, and eventually had Falcon in Malta

(yes, he was an actual Maltese Falcon). Falcon had lived on *Tola* all his life and was as bright and self-sufficient a toddler as I had ever seen.

He was also, at twenty months old, quite a handful. *Watchfire* had never been baby-proofed, so he was into everything from the first minute he stepped on board. Karen tried to keep him busy with toys and books she'd brought, but nothing captured his attention until he found our stuffed mascot. Poor Mr. Seal ended up a bit the worse for wear by the end of the night, including being wet from being made to swim in a small bucket, and a bit sticky from having peanut butter and jelly rubbed into his face while he ate, but it was worth it for the few minutes of peace we were granted while Falcon played with his new friend. Finally, he took a nap with Mr. Seal and was nearly asleep when we all said goodnight.

Russel thought Falcon was cute, but it was clear he didn't enjoy little kids. I adored them, and my favorite acting jobs were the times I spent doing children's theater in San Diego, New York, and Florida. Growing up around people who all had young children, I saw having kids as a part of life; whatever you do, the child comes with you, as my brothers and I did on my gypsy mom's many travels. Russel predicted our adventurous life would basically come to an end if we had a child.

That didn't make sense to me, since he spent much of his childhood traveling with his parents; his dad was so eager to leave on summer vacation each year that little Rusty would come out of school to find the long black Chrysler Imperial at the curb, loaded up with all their luggage; his parents would be in the front seat ready to head out from Carlsbad to whatever destination they'd planned—up to Canada or down to Mexico or back to Iowa to visit family and friends.

Little Rusty always had the big rear bench seat of the huge car to himself, and happily played with his toys in between stops.

His mother liked to visit cultural sites and shop and his dad liked to drive nonstop to their final destination. They compromised by stopping at roadside diners for meals and at nice hotels to sleep. Rusty grew to love traveling in a way that eventually leant itself to the cruising lifestyle, meaning bring everything you need and stay in the nicest places.

I'd heard a lot about Russel's childhood by this point. He thought his mom married his dad *specifically* because he was supposed to be sterile. He'd adopted a child with his previous wife who died young, leaving him with a young boy, Jerry. Alice was probably surprised to find herself pregnant at thirty-five, but she grew into a caring mom, if a tad over-protective in Rusty's youth. His parents were around all the time as he grew up, and they were financially stable, so his childhood was rather idyllic.

Russel's fears of parenting were mostly born, he had told me, of the anxiety of us not being able to support ourselves and a baby in style. I never worried about style, or about being able to get work. There were always tables to wait or bars to tend. Perhaps he was unsure about what would happen when our family was more than us two.

Humans are never ready to take the next step in life until we do it, and I had faith that we'd figure out our family plans as we went. It was a bit overwhelming for me at times, simply doing the shopping, cleaning, and cooking, and generally taking care of the two of us. Having a baby might end my career or cause me to give it short shrift.

And what career would that be, Jennifer?

It was hard to reassure Russel when I couldn't even be sure of what I wanted.

Changes in Latitude

I N ESCONDIDO WE GOT RIGHT back into the social scene: dinners at Tripui trailer park or over at another boat with friends; frequent trips into town with Keith or other local cruisers who kept their beat-up cars in the dirt parking lot.

One warm day, we strolled past the trailer park and kept walking inland, assuming we would catch a ride from someone on the road out to the highway. We were passed by a dozen big RVs and fancy camper trucks, but not one stopped for us when we waved and stuck out our thumbs. When the last tourist passed us by, his face carefully averted, I called out, "Thanks for the ride. . ." then turned to mutter "fucking guy!"

Russel almost fell down laughing and we tried out versions of the line while we kept walking to the junction. Highway 1 stretched empty for miles in both directions. No way could we walk to Loreto, and there were no local buses. Just then, a pickup turned off a dirt road onto the highway, heading in the right direction. We stood up straight and waved as it passed by. The driver, obviously a local rancher, slowed immediately and waved us in. Squeezing in next to him, we chatted in Spanglish all the way to town.

Later in May, Roxanne arrived, and we had a blast showing her around Loreto. Roxy showed her true colors when we took her to a bar perched above the beach and known to be a local watering hole

for salty sailors. She'd trotted to the top of the stairs well ahead of us and strode into the cool, dark room only to be greeted with a cranky shout.

"Shut the door behind you!"

To which she instantly retorted, "Fuck you, I got friends comin'!"

Needless to say, we gave that line quite a few encores during the next few days.

Keith escorted us to and from town and took us motoring about on *Shangri-La IV*, one night taking us all the way from our anchorage in Candeleros Bay the 10 miles up to Puerto Escondido for the Cruiser's Sock Hop. We danced all night and slept in very late the next morning back at the anchorage.

I showed Roxy around underwater, too; we snorkeled around the beautiful anchorages of Candeleros and nearby Baby Candeleros. Russel caught fish, Keith brought us plenty of fresh clams and cold beer, and we ended each seafood feast with a treat from Roxy's care package, like chocolate-covered espresso beans or chocolate peanut-butter cups.

My birthday was another day in a week full of parties. Twenty-nine seemed momentous to me—*next year I'll be thirty*—but as I was still the baby of the group, no one let me obsess very long. The water was warm, the drinks were cold, and the sun was hot in a clear blue sky.

We sent Roxy home with a bit of a sunburn and myriad Baja memories. Keith was still mooning over her after we'd seen her off at the airport. I needed a ride to the store in Loreto for some final supplies and he agreed to drive me, probably still hoping my influence with Roxy could help him win my friend's heart. I was pretty sure I knew better, but he was enjoying the idea, so I let him dream.

* * *

All stocked up with water, diesel, food, and ice, our next adventure was heading north again. It was time to see more of what the sea had to offer.

This time, we sailed straight from Escondido to San Juanico, and anchored there almost a week. The bay was as beautiful as we'd remembered, but this time it was empty. We would have stayed longer if our 30-gallon drinking water supply had not been dwindling fast, due to too many fresh-water rinses after diving and swimming. Roaming ashore, we were shocked to find our contribution to the Cruiser's Shrine had been pirated, or perhaps blown away by the spring winds. The next day we brought in our replacement token, one we hoped would be much more permanent. It was a chunk of stone, with the word *Watchfire* carved into the pale rock and the indented letters painted black, to boot.

We got a couple days of heavy rain up at Punta Pulpito when Hurricane Boris passed by Baja and headed up to the US, but the rainstorm was a nice change from the hot days that preceded it.

The rest of the month of June was full of hot days, slow sails, and quiet nights. For weeks the wind blew off the shore when it blew at all, and we slowly drifted northward, visiting each small indent that offered any sort of protection. At Punta Chivato, we visited a modern fly-in fishing resort and were able to fill our water tanks. We also bought more lures to replace the ones we kept losing to sharp-toothed Sierras and hard-fighting dorados.

I'd always thought of myself as an animal lover and a pacifist. But here in this desert Eden by the sea, I was coming into my own as a hunter. Next on my list was learning to spear fish. It was fun to troll when we were motoring, but I didn't enjoy bottom fishing, with its endless sitting and waiting for a bite. I wanted to find the fish where they lived, and to have it be more of a fair fight.

Russel had brought a speargun along, but the long thick rubber bands that propelled the spear were so taut that I couldn't

even cock the gun. So, the first time I went spearfishing, on Isla San Marcos near Santa Rosalia, I had him cock it, and dove below to see what I could find. I shot at one fish and was appalled by how far off my spear was when I missed. Bringing the speargun back to Russel to have him re-cock it, I promised to aim more carefully the next time. Clearly, it was necessary to compensate for the refraction of the water, which meant I should be able to hit the next one if I aimed slightly ahead of it. I took a breath and headed down with a bit more confidence.

I peered into a few crevices and behind some rocks and then was surprised to spot a lobster walking across the sea floor, only a few feet below me. I went up to take another breath and then dove back down toward the brown shell moving across the gray sand bottom. It was about noon and I knew it was unusual to see a lobster out and about at that time of day. But we were at a very remote bay that day, so perhaps before so many people came all the lobsters used to go out, like mad dogs and Englishmen, in the noonday sun.

Needless to say, I speared the innocent crustacean, and Russel was suitably impressed. I like lobster, but I don't love it as much as scallops or crab, so, knowing he'd get the lion's share, he was a happy camper. He quickly re-cocked the gun, saying he would do so as many times as I liked.

I did my best Schwarzenegger-as-the-Terminator imitation. "I'll be back."

"I'll be standing by to stand by!" he called, saluting me with a flourish.

Underwater, the natural wall of the small cove was a maze of rocks and sea plants. My dives took me deeper now, passing from the warmest band of bright sunlit water and into the dim green below. Clouds of shiny fish flew by me, mostly brightly banded blue and silver sergeant majors, but many other small reef fish as well.

I'd initially been told that reef fish were inedible, but then I'd learned that Tacos El Rey in Loreto, which made the best fish tacos on earth, often used parrotfish and that triggerfish made great ceviche, so I was on the lookout for them. Since both species are narrow bodied, bony, and tough skinned, I needed a large specimen to make it worth my while to clean.

The dim, cool silence underwater was addictive. After I let out my breath in a trail of bubbles on the way up and surfaced, I breathed deep and dove again. I loved gliding through the water, fins moving only enough to propel me over the rocky outcroppings, spear held at the ready, to enable quick aiming. Like a shark, or some other hungry predator, I slipped through the water.

Staying at about 10 to 15 feet below the surface, I occasionally dove deeper to peer under shady overhangs. There were no rock scallops to be found so close to the cruiser's fleet. No surprise there, as they can't swim away and relocate when hungry divers find and plunder their community.

A brightly painted parrotfish spotted me and darted behind an underwater castle of mossy rock. I circled one way, the iridescent fish circled the other way. If I doubled back, it mirrored my move. When I surfaced to breathe, it slipped away into the deep and vanished.

Below again, I glimpsed a triggerfish as it disappeared into a tunnel that led to a hollow place in the rock. Hovering outside the aquatic cave, peering in, I caught a swish of scales and slowly paddled in place, waiting, suspended. The curious fish turned again, trying to see me. I carefully took aim at its broad side, as close to its head as I could get, and pulled the trigger.

There was an explosion of movement, and a sharp tug on the line to the gun I held. I'd hit the fish "dead to rights," as Russel would say, but somehow it wasn't dead. Each quiver sent a small shock wave through my arm and I held the gun tight, reeling the line in with my free hand, grabbing the end of the spear, fighting to keep the

wounded fish from getting away. It thrashed at the end of the silvery spear as I pointed it skyward and followed it up.

Breaking the surface, I gaped at the twitching spear. Not one but two triggerfish were on it. The one I'd been aiming at was quite dead, and a smaller one who'd been hiding behind his big friend was stabbed through the body. I couldn't throw the second fish back, as it was too badly injured, so I swam up to the boat with both victims. A generous splash of cheap white rum in the gills did in the littler fish and I turned to cleaning my two victims.

Once I had the white flesh completely filleted, I tossed all the guts, bones, and skin overboard to satisfy the needs of the underwater community. What the fish didn't gobble up, the eels would, and any tiny bits that escaped would be food for the anemones and the hundreds of spritely red Sally Lightfoot crabs that inhabited the reefs and rocks.

Tossing the chunks of raw fish into a glass bowl, I added the juice of a few *limons*, some diced onion and tomato, then tossed it all with some fresh cilantro. The last avocado would be chopped up and added before I served the appetizer.

While the ceviche marinated, Russel lit the barbecue so the coals would be ready for the lobster, and broke out our last two beers. As the sun sank, we honored the two reef fish and the wandering crustacean with a toast. My own personal *Sea Hunt* had paid off handsomely.

Heat and Dust

SANTA ROSALIA IS A GEM, a European-style village in the middle of the Baja peninsula, right on the Sea of Cortez. The town's iron church was famously designed by Eiffel, so quite a few tourists stop to have a gander at that while enjoying an *exquisito* (hot dogs with everything, including roasted onions) on the square, and pick up a dozen of Baja's best *bollilos* (short baguettes) at the local bakery.

For us, coming to Santa Rosalia was an oasis in more ways than one. The extremely hot weather had intensified with the addition of breathtaking humidity. The short motoring trip from Isla San Marcos into the town's small, crowded harbor was exhausting. Both of us were pale, sweaty, and shaky by the time we were safely anchored off the marina.

Moments later, as we sprawled in the cockpit, guzzling water, Barney from *Gypsy* dinghied over to greet us. Russel commented about the heat, and Barney's expression was immediately serious.

"It's not just *hot*, man," he said quietly, with a glance around as if watching for a hidden enemy, "It's like, *mental*."

Barney invited us to join him and Mary and the other cruisers for happy hour at the nearby palm-frond shaded patio known as The Palapa of Knowledge, perched on a slight rise beside the motley collection of buildings that marked the marina. Still wiped out,

we declined, but said we'd be there the next night for the early Fourth of July celebration.

The next day I checked us in at the local immigration office, which is housed at the ferry building south of the marina. Crowds of people were packed in the building when I arrived, and I despaired of getting done with the paperwork before lunchtime, when most government offices in Mexico close for siesta. As I wormed my way inside the door, a horn sounded, a voice spoke in Spanish over the PA system and everyone in the vast open building swarmed onto the waiting ferry, bound for San Carlos, across the gulf in Sonora. In minutes I was the only person left in the vast building, and I walked into an empty office with three people behind the counter to help me.

The immigration officer was a delight, speaking enough English to help me, but encouraging me to try out my Spanish. I rattled off my few sentences about who we were and what we were doing as I presented him with our boat documents, passports, and visas. Looking at our passports, he mentioned the upcoming *cumpleaños* of my *esposo*—it was almost Russel's birthday. Somehow that lead to my saying that "mi esposo" and I were on our "luna de miel." The man looked up at me and smiled, saying he and his wife had been married ten years, had two children, and were still on their luna de miel.

"*Siempre es una luna de miel.*" It's always a honeymoon.

It was a lovely thing to say and I could see he meant it.

"*Eso es perfecto,*" I said.

As we filled out the forms, I asked about his children, and he proudly showed me a photo of his family. He stamped my customs papers and I pointed out our own boat home, anchored within sight in the crowded harbor. We parted all smiles, wishing each other the continued best of luck in life and love. Sometimes it is amazing how the universe speaks to you through someone else's words. It was good advice to try to keep our honeymoon going forever.

Walking back to the marina, I passed a charming building with a sign out front proclaiming it as Biblioteca Mahatma Gandhi.

The Gandhi Library. Stunned, I had to walk up the steps and peek inside, though it was closed for the afternoon. From around the corner, two rows of children dressed in smart green and white plaid uniforms marched along like little soldiers. I followed them to the nearby park where they lined up in rows and sang for an audience of parents and local dignitaries. Speeches were given and a few children received awards to much applause. I had no idea what the occasion was, but I was lucky to have happened upon it.

Shopping in the town was a treat, with three supermercados lined with aisles of canned and packaged food, instead of the recent stores with one or two items stocked and very few choices. I walked the long way home to take advantage of the opportunity for some window shopping, as I was starved for commerce and commercial enterprise; it turned out that the quaint winding streets had enough stores full of clothes and gifts and assorted items for my eyes to get their fill.

Buying items for that night's potluck before heading back to the marina, I got to the boat with fresh French bread from the bakery, a few bananas picked up from a fruit stand, and enough potatoes, eggs, and celery for a big bowl of my mom's potato salad recipe.

That night was the first of many under the dry fronds of The Palapa of Knowledge. We shared drinks, stories, and an early July Fourth dinner that featured hot dogs and hamburgers grilled on the BBQ and fruit pies for dessert. Having been starved for such things, I overindulged a bit, and Russel ate until he was ready to bust. Rowing us the few hundred yards over to *Watchfire* was an uncomfortable chore, as his tummy had a big "food baby" in it.

Back on board, he picked up the VHF and announced: "Attention the Fleet, I've had too much to eat, I cannot see my feet." Many mic-clicks signaled that he was not alone in his painful predicament.

* * *

Our time in Santa Rosalia was interrupted by a quick trip up the peninsula by bus, to get some money out of the bank and buy boat and art supplies. The 20-hour road trip was too long, the few days north of the border too short. And I got sick from drinking tap water, something we hadn't given a thought to. Clearly, after months of drinking good clean Baja water, my stomach rejected the stuff that came from San Diego faucets as foreign and dangerous.

Russel stayed at his mom's tiny apartment in Carlsbad, and my friend Mary put me up since my mom had no room for me in her single room; Diane was working for an elderly lady and living on her estate in Coronado. Mary and Diane were old friends, so we three had a good time hanging out. I soaked in a hot bubble bath every night, had Thai food and pizza, and even went out to lunch and a movie with Nena.

All this while Russel shopped for boat parts, some tools, and two new fans.

My brother Joe and his wife Teresa drove us back down to the bus station in Tijuana, so we didn't have to carry all our new purchases and our luggage over the border on foot. We said hurried goodbyes and soon were hurtling back down Hwy 1 under the protection of a plaster Virgin of Guadalupe, who gazed out at us all benevolently from the driver's small dashboard altar.

We were surprised to discover that the bus didn't pick up a new driver every few hours as we'd assumed on the way up; the driver who was off duty actually rode below the bus with the baggage, sleeping inches above the asphalt in preparation for his shift at the wheel. Knowing how little rest could be gotten in such quarters made it difficult for us to sleep during the next driver's fast descent through mountainous twisty passages and around the hairpin turns of Hwy 1.

Arriving back in Santa Rosalia, worn out and anxious, we pressed our faces to the window and saw *Watchfire* safely floating right where

we'd left it. Our local cruising friends had kept an eye on things, and all was well. We rowed out to our home, loaded up the cockpit with our boxes and bags of goodies, and collapsed into the v-berth for a well-deserved sleep.

We moved to a slip in the marina the following morning (yes, we could have left the boat in the slip during our time away, but were economizing to be able to afford the trip north). The next two days were a jumble of tasks, mostly centered around cleaning everything on the boat. I did our dirtiest wash, like the greasy engine towels, in a big bucket, and then schlepped the rest of it six long hot blocks to a *lavanderia* in town.

A few days later we were off into the sea again, heading south along long empty stretches of coves and inlets.

Peace in the Park
1986–88

I N 1986, MY MOM QUIT her sales job, moved out of our
old rental house, and joined the Great Peace March for Nuclear
Disarmament (GPM). She was one of six hundred people who
left LA in March of 1986 to walk across the country to Washington,
DC. She also worked for the grassroots organization and was often
sent by car to be part of the advance guard in each town the GPM
visited, but she walked a good part of the route on foot, camping out
with the other marchers in fields along the way. I tried to follow the
progress of the GPM in the papers, but there wasn't much coverage
in the national news.

On May 25th, 1986, Phil and I joined thousands of people in
New York to be a part of Hands Across America. It was also my
birthday, and a wonderful way to celebrate turning twenty-five.
Once again, it seemed as if the world and our country were coming
together. I felt that even more strongly when the GPM crossed
the George Washington Bridge and I spotted my mom among the
marchers. She and I hugged and chatted as we walked along with
the march for a couple of miles. They were bound for the nation's
capital, and my mom was soon working in the nonprofit's offices in
Washington, DC. Not long after that, she flew to Russia as part of
an international peace delegation.

In the summer of 1987, when Jimmy and I heard about the
Harmonic Convergence, the world's first synchronized global peace

meditation, set to happen on August 16–17, we knew we had to be part of it. The free event, celebrating an unusual alignment of eight planets in our solar system, sounded like the Woodstock of my generation, and it was only one night. So, we met at Jimmy and Michael's apartment, the three of us plus Neil and another actor friend Jeffrey, and walked across Central Park to Cleopatra's Needle, where we met up with Kathy Najimy, a writer and actress from San Diego.

We six strolled over and joined the gathering at the Great Lawn, lying down in the middle of the meadow, close enough that our hands easily touched. All night we stared up at the sky—meditated, talked, sang, giggled, and communed under the stars with hundreds of other like-minded people. Someone dubbed the event "Harmonica Virgins," and we laughed until we cried. At dawn we walked over to Strawberry Fields to join the chant circle and were swept up in the river of people leaving the park as it dispersed. A stranger walked by saying, "Yeah, I went, it was a big bust. Nothing happened." We all looked at each other and burst out laughing. Where had *he* been?

That summer I took my first vacation in years, traveling to Spokane to visit my brother John and his family. My niece Erin, at seven, was a delight—bright, funny, and excited to be camping, hiking, and exploring with her dad and aunt in the gorgeous, densely wooded mountains of northern Idaho. Paddling a canoe across clear, cold Priest Lake, struck by how deeply I'd missed being surrounded by nature, I vowed to get out of the city more often.

Back in NYC, I auditioned for Phil's alma mater, the Asolo Theater in Sarasota, Florida, and was cast as the princess in a children's theater tour of Rumpelstiltskin. The cast would live in Sarasota to write and rehearse the show before going on a statewide tour for seven months, doing two to three shows a day. The key thing is that the show was under an Actor's Equity union contract, which meant finally getting

my Equity union card, the Holy Grail for aspiring stage actors, since membership allows you to audition for professional shows and tours. I was unsure about being away from Phil for so long, but figured if our relationship was meant to last, it would.

It didn't. No sooner had I returned to NYC, in the summer of 1988, then we broke up. There was no real reason for me to leave Phil, but I had to. On tour, I'd seen a small sailboat pull into Key West at sunset, calling to mind an image of Russel and bringing a sharp pang of regret. I had no idea if I'd ever even *see* Russel again, but it wasn't right to live with Phil and dream of another man.

We lived together as roommates for a while, but it was painful for both of us. Feeling terrible about the whole thing, I offered to let Phil stay in the apartment that had been mine before it was ours. He felt terrible, too, but he accepted. An actor friend had a teeny studio in Chelsea and wanted to sublet it, which housed me for a couple of months. In a classic rebound move, I started dating a guy from Warren's acting class, also named Phil, and referred to by Jimmy and Michael as "Philip the Second, King of France."

It soon became clear that the studio apartment cost too much; the rent, combined with my acting class fees, was depleting my meager savings. It had seemed living alone would clarify my life goals and push me to commit myself fully to acting, but instead I simply sat and thought, to no great effect.

Jimmy and Michael offered to let me rent their back bedroom, and I jumped at the chance, moving my three cardboard boxes of clothes and books uptown in a Checker cab to their digs in the Hotel Belleclaire. The massive building was a strange combination of prewar splendor and recent Single Room Occupancy that easily camouflaged the glory that was their spacious two-bedroom apartment. Ensconced in their guest room, I relaxed fully for the first time since returning from the Florida tour.

Michael had gotten me a job waiting tables at Table D'Hote, a tiny country French restaurant on the Upper East Side owned and run by a warm, friendly couple, Laurie and Vivek Bandhu. The place was tiny and charming; the prix fixe meals we served, and the "family" meals we ate, were delicious. The tips were good enough that I could afford to work three nights a week and Sunday brunch—the pinnacle of food service in Manhattan.

One fall evening, Jimmy and I went to a theater audition, which turned out to be a cattle call with every type in town waiting for way too long to be seen. We were reading over the scenes we'd been asked to read, when he leaned close and said in a low voice, "This play is crap." I quietly agreed that we'd never go see this show unless we were cast in it, which struck us both as humorous. As we talked, it became clear that it wasn't funny at all. If we got roles, we'd be working our asses off (after long days of waiting tables to pay the rent) to be a part of something we'd be ashamed to be seen in, produced by people who couldn't even run an audition effectively.

We marched up to the front table where a young woman from the theater company was shuffling papers. I said we couldn't wait any longer, and Jimmy politely asked for his headshot and résumé back. I asked for mine, too. She looked surprised and said she'd hang on to our materials in case we were right for something else they might put on in the future. We said we didn't *want her to*, and she insisted she was *supposed to*, and it got pretty silly. Finally, we grabbed our stuff out of her hands and walked out.

Back in the apartment, we went over options for our future, with Michael. We all agreed that Jimmy was clearly a gifted playwright, so we would put on one of Jimmy's latest one-act plays, *The Girl Least Likely*. I would play the lead, the handsome and talented Michael would co-star, and we'd soon all be famous. Or at least get someone important and discerning to come and see us onstage. We formed a theater company, Scooter G Productions, and began casting.

My old friend Elissa was cast in the role of a gorgeous blonde actress, a bit of typecasting that didn't extend to the character's bitchy personality.

The play would be put on in March at the West Bank Cafe, a cool but way-off-Broadway venue with the ideal mixture of seediness and old-school charm. Rehearsals wouldn't start until mid-January. My co-workers at Table D'Hote were willing to cover my shifts for two weeks, so I could fly to San Diego on Christmas to see my family.

My dates with Philip the Second had petered off a bit, and neither of us was pursuing more. I needed something deeper and more meaningful from a romantic relationship. But what exactly?

Elissa summed it up for me one day as we walked through Central Park. "You always sweep guys off their feet. You need someone to sweep you off *your* feet."

Damn, that sounded pretty good.

Reception in Conception
July, 1990

THE MID-JULY AIR WAS HEAVY and hot. Bahia Conception was on the horizon, but all Russel and I could see was the peninsula that hides the southern half of the big bay. The day's sailing had been slow, with not enough wind to move us very fast, or cool us off.

We rounded the point into the huge bay. Not quite sure where we should head first, I pulled out the chart again and compared the small illustration to the half-page-sized drawing in *Charlie's Charts*. Russel steered as we consulted both books for a few minutes while the mainsail and jib pulled us along. When I turned to look behind us, it was more out of habit than any sort of forewarning.

"Uh-oh," I whispered. "Oh, *shit*."

The anvil-shaped dark cloud was less than a mile from us, the area below it blurred from rain and wind, the combo coming toward us fast from the open sea. The locals call these sudden summer storms chubascos. We'd experienced them while at anchor, but this would be our first experience of a chubasco while under sail.

Russel quickly headed up to the bow as I took the tiller and tried to evade the storm. Each time I changed our heading, the dark cloud also altered course, seeming to follow us. Russel brought down the big jib as fast as possible, stuffing it into a sail bag to prevent it from being blown off the deck in the high winds that would soon

surround us; we had to drop the mainsail as there was no time left to reduce the sail by putting a reef in it. Then the storm was upon us.

The massive rain cloud filled the bay, and the wind blew 35 knots. Russel took the tiller and tried to keep *Watchfire* headed directly into the wind, but the blasts were clocking around us like a tiny hurricane. Luckily, we were blown off the shore, and not toward the shallow beach.

The next few minutes were a blur. Rain pelted us, and the boat shuddered and heeled in the strong blasts of wind. I sat gripping the edge of the cockpit with both hands so I wouldn't get blown off the boat. Glancing at the wind speed gauge, I saw it was gusting over 40 knots.

As quickly as it had come, the squall roared off across the bay, leaving us dripping wet and a bit shaken. In minutes the sun was shining down again, the humidity had doubled, and we were literally steaming.

Cutting across the narrowest part of the long bay, we soon saw a long line of RVs and tents on the beach at Santispac. The chubasco had spared the land campers, who all waved at us, seeming oblivious to what had passed them by. We sailed up to the north end, anchored, and were soon heading to shore.

Conception was a different sort of place than we'd visited so far. The beach was packed with "gringos," or "bringos" as someone dubbed the RVers who come south every year with all their toys: dirt bikes, jeeps, tents, vans, Baja Bugs, even some scuba gear. Every palapa was full of people, and the radios all proclaimed that particular air space to be theirs, with possessively high decibels of rock or country or pop music.

We rowed south and eventually found a quiet location at the far end of the long sweep of sand to beachcomb and lounge. It looked like the right sort of spot to find some clams, so I tiptoed through the

shallows, searching until I spotted the telltale signs of the delicious brown chocolates.

Gathering enough to fill a small bucket, I topped it with seawater to keep the clams cool while they rid themselves of sand, dirt, and grit. Back at the boat, my haul went into a larger bucket of cool seawater to continue their cleansing ritual. We hid the big bucket in the shade of the cockpit awning, ready to be plundered for appetizers and dinner.

The next day was Russel's birthday, and we celebrated in style, with clams for breakfast. He had requested a clam omelet from the chef, and though I was unsure about the combo, it turned out better than it sounded, thanks to the addition of sautéed onions.

We met some land cruisers on the beach that morning and were quickly invited along on their road trip over to Mulegé. What a treat to jounce along on a dirt road going 20 miles an hour! The old van seemed to be moving at jet speed, after floating along at an average of 3 knots. We wandered happily around Mulegé, a semi-touristy town on a tropical-looking river; we visited the famous church, found a great cafe for a lunch of fresh ceviche, and did some shopping at a tiny tienda that surprised me by taking my travelers checks.

Back at the boat, we found that not all of our bounty of clams had survived the day in their bucket of salt water. I hadn't considered how many bivalves were sucking the oxygen out of that water all at once, nor had I counted on the day warming up to over 95 degrees. I tossed out the few that had opened, feeling guilty as they went overboard. At least they would feed the bay's gulls, fish, and crabs—the circle of life and all that.

I kept a couple dozen clams that were still tightly closed, transferring them to a fresh bucket of cool salt water. As the sun set over Conception Bay, we sipped cold beers in the balmy breeze and watched pelicans skim over the flat waters of the big bay. Then it was time for the birthday feast. After steaming the clams, I placed them

atop plates of linguine tossed with olive oil, garlic, and herbs. Russel had envisioned having seafood for breakfast, lunch, and dinner, and by the time we'd cleaned our plates he was quite content.

I presented him with some silly gifts I'd gotten, along with a mushy handmade card full of hearts and flowers and poetic flights of prose. In the cockpit, as twilight turned to a night full of stars, we sat with our arms around each other. I struggled for words, trying to tell him how much more I loved him with each passing month we were together, and that it was impossible to sum up what he meant to me. We headed into bed, and I was able to *show* him instead.

Blank Canvases

NOWADAYS, WHEN WE AND NEARLY everyone have roller-furling headsails, it is hard to recall what it was like to have the sort of sail inventory that we had on that first voyage; there were six headsails alone, plus the main (and a backup main). Having a lot of sails is like having a huge wardrobe; you feel compelled to change clothes often.

Once we started sailing back from Conception Bay, the wind kept coming up from the south, as if to push us further up into the Sea. We yearned to head further north, but we needed to go back to La Paz and get ready to finally sail on to the mainland.

There wasn't going to be any income until we got back to the States. I had no doubt I could get work (I got a bartending job as soon as we hit Florida) and no doubt that Russel's paintings would sell when they were stretched and framed and shown (they did, but the process wasn't as quick as we'd hoped).

The wind was not being cooperative, so every day went something like this:

Get up and have some breakfast and then motor out of the night's anchorage and into the open where the wind would be blowing off the land, if there was any. If not, motor a bit farther out and hope.

As soon as we see or feel any real wind, lift up Mrs. Norman Maine. If the main flies and we are not sailing too close to the wind, hank on and hoist up the big jib. Sail along with both the big sails

as long as the wind holds. Once it shifts onto our nose and we are sailing into the wind, drop the big jib onto the deck, unhank the many clips, and stuff it back into its big bag. Drag it into the cockpit and go below to pull out the slightly smaller jib in its slightly smaller sail bag. Drag that jib up on deck, hank it on, run it up to the top of the mast, and sheet it in as tight as you can. Sail that way as long as there is enough wind.

When the wind dies almost completely, it's time to drop the smaller jib and stuff it back into its sail bag and pull out the reacher-drifter, the colorful one that looks like a spinnaker and lifts in the lightest of air. Hoist that sail up and see if you can sail enough off the wind to fly it. If the wind dies more, pole the big drifter out with a whisker pole, so the lightweight sail's far edge is suspended far from the boat to catch the slightest breath of wind. Drift along like that until the mainsail starts flogging, then drop the main and sail with only the poled-out drifter.

Don't worry—as soon as you get comfortable and start to think that this is more of a basking day than a sailing day, the wind will come back, usually from a different quarter altogether.

Raise the mainsail again and snap the preventer on to the boom so that if you misjudge the wind and steer too far one way or the other, the boom doesn't fly across the deck and clobber one of you.

When the wind picks up again, drop the drifter (after you unhook it from everything) and go back to the medium-sized jib, hanking that on and hauling that up as soon as you have cleared the deck of the slippery drifter.

Lather, rinse, repeat.

All this labor is performed under a relentlessly bright sun, which you try hard to hide from, stringing up shades and Biminis and dodgers and all manner of screening contraptions to keep yourselves from broiling in the cockpit under the sun's rays. Often the heat is not altered by the wind, because when it is blowing from behind the

boat, you can't get any cooler at all. But it was all part of our active lifestyle, as we reminded each other often.

One day, we changed our headsail nine times. We knew that we were not living a tough life, and we couldn't compare ourselves to field workers or fruit pickers, but it was tiring and frustrating. One could almost wish for the strong, dependable wind of the west coast of Baja California. Almost.

So, what did we do while sailing, since there wasn't enough time off from sail trimming and changing and tiller adjusting to get anything really done? We talked about the future, we dreamed, we listened to music, we watched the land slip by, oh so slowly, as we floated past at the speed of someone walking. Mostly, we got caught up in what we called the Zen of sailing; one moment turns into another, and they turn into hours, and in that fascinating way, the day somehow speeds right by.

At night, with no energy to create anything, but plenty of ambition, it seemed clear to me that mañana I would find the time to sit in the cockpit with my notebook and write. Surely that was a job that could easily be dropped at a moment's notice, for a minute or ten, and quite readily picked up again. I sometimes brought out my notebook, but always ended up leaving it lying.

And that, as far as writing goes, is sort of The Big Problem. It isn't only hard to write while sailing, it is hard to start writing at all. In that way, it is completely unlike other art forms. You begin each day faced with the most discouraging vision in the universe, a blank page—which isn't the same thing as a blank canvas, not truly.

If you are an artist like Russel, you will sketch or snap a photo of the scene you want to paint. Then you have that sketch or reference photo (once you get it developed) sitting there bugging you, so eventually you draw it on to some canvas or art paper. Once you've done that, it's easy to start coloring in the shapes, picking hues, dabbing around on your palette, choosing the right shades to

illuminate the rough composition you have created in pencil. And once you get started on a painting, just try to stop working on it! You won't want to, I can promise you. You'll paint until the light fades and be cleaning your brushes by the light of the setting sun, while your dinner is getting cold.

But a blank page, a truly blank page, that is a whole other story. Or, more accurately, a lack of story. How does one come up with an idea? You can't simply walk outside and look around you, find a lovely view and say, "Hmm, that looks promising." No, you have to use your imagination, have to envision the whole thing. The setting, characters, plot, climax, resolution, all of it. Dream it up out of whole cloth as it were.

And even when you get started with what seems like a good idea, more often than not, it turns out that you run out of creative steam before you run out of story. Or the story itself runs out of steam. Or the cool idea you had falls flat on its face, right out of the gate, and lies there, wooden, static, and boring. Or phony, cutesy, and trite. It begins to feel like you can't win.

But occasionally, as with sailing, you start scribbling, and your mind connects with your hand somehow, and everything flows; you leap out into the unknown waters, and the sails fill, and you are off across the vast reaches like a shot. You might have only a vague idea of where *exactly* you're going, but you are possessed by a vibrant vision of where you dream of being, and that vivid dream place is what draws you onward until you reach that strange shore.

Sail change by sail change, tack by tack, mile by nautical mile.

Page by page, line by line, and word by word.

Island Interlude

BAJA CALIFORNIA'S LANDSCAPE HAS AN eternal quality. There's a sense here that one has stumbled into a sort of time capsule of ancient earth, untouched by eons and humanity, a prehistoric world preserved in amber: breathtakingly beautiful yet inhospitable and potentially dangerous.

Like a generous peasant, the land welcomes you with open arms despite its empty pockets, beguiling you with easy warmth and charm. Taking in all the beauty, you ignore your rumbling stomach and leave leaner yet fulfilled.

Steinbeck's *Log from the Sea of Cortez* was my first exposure to Baja, back when I was only vaguely aware that the peninsula existed a few hours south of my childhood home. The book is a wonderful journey, full of intriguing oceanographic and biological wisdom as well as profound musings and a few humorous tales. To Russel and me, re-reading the stories, the funniest were the ones about the Sea Cow, the outboard engine that plagued the boat's crew and visitors.

Our own small Johnson outboard had been as temperamental as the Sea Cow, and we were rowing our inflatable dinghy more and more. Inflatables are not made for rowing, but when you only have one option, you learn to enjoy it.

After provisioning in Loreto, we sailed out to the far side of Carmen, the big island that lies off the town. There were a few

close-in anchorages that everyone from Puerto Escondido went to in the heat of summer, but the east side remained unseen by us. A long empty bay with what appeared to be an abandoned town looked intriguing, so we turned the tiller and headed in.

We anchored safely well before noon, taking care to avoid the submerged shipwreck marked on our chart in the middle of the bay. After lunch, we went to shore and wandered the long beach, with me shelling and Russel shooting the tiny flowers and cacti that bloomed above the tideline. He got very involved with his photography session, so I set off down the beach toward the ghost town.

I was a bit irritated—no, I was damned frustrated. Russel had his photography, his paintings, and the promise of art buyers in his future. What did I have? The idea of going back to being an aspiring actress seemed like trying to fit into jeans you've outgrown. I was unsure what rewards theater held for me, and if I still loved acting, since I'd done so little of it over the long years of waiting tables. Sure, it was a blast getting cast in a soap opera for a day or playing a small part in an industrial film or a commercial, but it didn't seem worth going back to waiting tables at night and spending my days begging bored people to let me show them I deserved to be a part of their project. As the weeks passed, I was more and more convinced that my acting days were over, but I had no idea what was next for me as far as work, not to mention a career.

I mentally shrugged and looked up from the sand passing under my feet.

Among the deserted remains of that village on Isla Carmen, a tiny church sat, with its small brave bell atop, as if waiting for its congregation to return. An abandoned school building, its two lavatories still complete with child-sized doors, echoed emptily. Cypress trees waved their needles crazily and moaned in the strong winds that funneled across the empty salt fields.

Wandering around the empty houses, staring through broken glass and open doorways, I found a tiny, perfect vista. Seen through two windows and an interior door frame, was our boat anchored in the bay. The small scene was magnified by the four frames, like colored mats, the first and largest a pistachio-colored wall pockmarked by years of weather.

Looking through those rooms was strange, almost painful. People leave so little of themselves behind: tin cans, a rag of curtain, some broken pencils, and the black-marbled cardboard cover of a school composition book. The salt fields that once provided employment for a dozen families and brought trade to this huge, windswept bay had closed many years before. Like in the forgotten towns of California's gold mining country, all that survived here were facades and trash.

I plopped down to make notes for a poem about a ghost village, if that was the right term to use. I could compose an *Elegy on an Island*, perhaps, or *Ode to an Abandoned Church*. The empty buildings gave me a melancholy feeling, like walking in an ancient graveyard, wondering about the lost lives.

It is always too easy to imagine the dreams of people who lived long before us being as simple as their surroundings. Instead, sitting on a stone bench to jot a few lines in my notepad, my mind conjured the image of a young woman who once sat here, consumed by her own creative dreams.

She was a writer, a poet, writing her stanzas in the language of her people on cheap school paper or in old magazine margins, only infrequently looking up at the long white crescent of beach or out to the rocky points that encircle the wide bay. She read a classic tome, making her way through the stilted, formal language of her ancestors painstakingly, studiously. The book, Don Quixote *let us say, had been loaned to her by a once-eager teacher long bored with his place in the world.*

The teacher was watching her out of one of those schoolroom windows, his own dreams of recognition long sublimated, never mentioned, even to himself. New possibilities had been fostered by this gifted child, this natural poet, a girl with enough raw talent to inspire him all over again. His hopes for her have been taken up by the entire small village. When she walks alone, they nod and point and smile; she is admired and cared for, but she is somehow different now, set apart from them.

The focus of all this attention sits alone, fighting to design and create her own future. She tells no one, not even her teacher, of her wildest, most dreamy dreams. Visions of living in Mexico City, maybe even in Los Estados Unidos. The exciting thought of leaving her village, the only world she has ever known, is well tempered by anxiety.

She puts the book down carefully and picks up a piece of salvaged paper and a stub of pencil. Scrawling a verse, she thinks it over and then rubs out a word, ponders a replacement, sighs, and lays her tools down, her forehead knotted.

How could she, a poor girl from the islands . . . or, perhaps, could she? After all, her teacher, well known to be an educated man, perhaps a genius, had told her she showed promise. He had even kept one of her poems, carefully copied in ink, in one of his treasured books.

Youthful optimism quickly overcomes her fleeting self-doubt and her brow clears. A moment later and the pencil is again poised. A new line, then another and another are added to the page, the lines gathering speed as they appear on paper. Finally, she reads it over and laughs aloud, delighted at her own abilities.

Before she can lose her nerve, she folds the paper, stands, and walks over to the schoolhouse. Inside the building, she knows her teacher is watching her approach. He will read the poem, smile

perhaps, and, without too much fuss, he will let her know that
she may keep dreaming.

An insistent whistling brought me back to reality—the wind was up, keening in the cypresses and through the empty rooms.

I looked down at my notebook and found I'd covered half a dozen pages in a fast, childlike scrawl, quite unlike my usual handwriting. Glancing over the story of a young writer from this island, the words were as strange to me as if I hadn't written them. I didn't believe in haunted places or ghosts, but I liked the idea of having channeled something from the ether.

Talk about raising your spirits!

Closing my notepad carefully, I put it and the pen back into my pack. Joy bubbled up inside me, and I giggled in amazement. A person existed now who had never been born. I had created an entire human being, with a past and a future. This was even better than acting out a part someone else wrote.

Leaping to my feet, I grabbed the pack and strode down the bay toward our dinghy. It was time to share the words I'd written with the world, starting with Russel.

Gods and Monsters

ISLA MONSERRAT IS ABOUT 15 miles southeast of Puerto Escondido. Though not far in miles, the island is so untouched by humans as to seem to exist in another century. Russel and I had been anchored in the cove for days and hadn't seen a single boat on the horizon or even heard an engine go by.

Monserrat is lovely—its dry hills as colorful as a patchwork quilt, all done in tans, yellows, rust reds, and pale greens. Our cove had one tiny beach of dark pink sand and another covered with gray pebbles. The cliffs were dove gray and mauve, almost violet at sunrise. Rocky reefs nearly surrounded us, and water washed over them with the sound of a brook running. Each sunset found us rolling a bit in the swell, before the breeze over the island came up, bringing a scent of earth, sage, and honey.

I took a morning walk, after the VHF net and breakfast dishes were done. Russel stayed on the boat to finish a painting, caught up in the creative moment. I rowed to shore and pulled the dinghy a few feet above the lapping water. Past the beach, I saw a broad streambed and followed it inland.

The rock-strewn sand path led around a bend, and there the scenery changed abruptly. From the water, it'd looked like a desert island, but inland, there were trees and even grass, though it was dry and yellow. The streambed wound between and around small

elephant trees, acacias, palo verdes, and palo blancos. As predicted by our new *Baja California Plant Field Guide*, I spotted galloping cactus, old man cactus, and a few cardons.

The sky overhead was a clear blue canvas, framed by red hilltops and green leaves. Many of the trees were in bloom, and hundreds of bees bustled among the myriad blossoms. Now I knew where the sweet smell came from that wafted out to our boat nightly. Birds chittered and sang from branches a few inches above me, seemingly unafraid. None of the trees were over 7 feet tall, and many were only my height. I was a giant striding down the riverbed, my head even with the treetops.

Though the physical exertion of walking was a treat, it was hard to not stop at each turn of the trail, as new glimpses of the way ahead revealed themselves and new plants and creatures were spotted. I watched where I put my feet, not only for the obvious reason but because there were so many small plants that would otherwise be missed. In a spot the size of a footprint there might be tiny gardens of cacti and succulents, as well as miniature flowering hedgerows that lined the rocks, their blossoms no bigger than the head of a pin. These Lilliputian landscapes needed close inspection by this modern Gulliver to fully reveal their wonders.

Spotting an anthill covered with red ants, I stepped quietly to the side of the anthill and knelt, surveying the minuscule scene below me like some curious but indulgent deity.

The ants, red and equipped with pincer-like jaws as large as the rest of their somewhat overly large heads, scurried in and out of their gently sloping entranceway. As I watched, each emerging ant carried out a bit of matter, which it took to the farthest part of the door yard to drop. Perhaps it was earth brought up from excavating, or perhaps some sort of insect refuse. The ants entering the colony door were empty-handed but purposeful; they marched steadfastly into the narrow mouth against the exiting flow, resulting in pedestrian

congestion that rivaled the sidewalks of New York City at lunchtime. But the ants jostled each other gently, it seemed, and somehow those wanting ingress achieved it while those bearing the garbage got out.

A lone ant came from behind my right foot, bearing a yellow mesquite blossom. It was easily twice as large as the ant's body, and though relatively light, it must still have presented a steering problem akin to that of a man carrying a 12-foot aluminum Christmas tree down a busy urban avenue. The ant, having no staircases or elevators to deal with, swiftly approached the anthill.

As the incoming ant met the first outgoing ant, he bowed down with his burden as if to show this compatriot his valuable find. The other briefly smelled, tasted, or in some way examined the fragrant load and then continued on its way. Subsequent encounters along the way were much the same, but eventually the nurseryman ant got closer to the entrance.

At the crowded doorway of the ant apartment house, it was like watching that same Christmas-tree-bearing man negotiate a crowded hotel lobby. There were a great many hesitations, but none of the others even glanced at the lovely blossoms—they clearly wanted to avoid them. Each encounter was only long enough for the insect version of *excuse me, pardon me, you first, no after you*, then both ants would press on.

Leaning closer, engrossed in the tiny scene, my scent or my shadow fell upon the tiny population below. First one outrider, then another, began to run in aimless circles, and I could almost hear them shouting *Fear Fire Flood!* Or some such hobbit-like alarm. Soon the panic had spread, and the mouth of the anthill had miraculously absorbed all the ants that once worked around it. Only a few were left outside—to protect the colony? Observe the enemy? Sacrifice themselves?

One ant near my foot ran about with its head lifted and mandibles open, looking every millimeter like a fierce guard dog. With nearly

audible growls, he retraced his circle, increasing it each time until he encountered my toe and backpedaled hastily. He sped back to report, no doubt, that a *monster had been sighted*. When his path led him across a tiny piece of driftwood, I lifted him up for a closer inspection. Unable to go onward, the guard ant ran the length of the twig twice before attempting to scale my fingertips. Aware of the painful sting that accompanies a red ant bite, I hastily dropped him to the ground again, where he shook himself like a dog before hurrying home.

The tiny black hole soon swallowed his form, and I wondered if the ant would tell a horrifying tale of extraterrestrial abduction or weave an inspiring vision of a celestial audience with a great and powerful deity. No doubt his vulnerable and gullible audience would believe either story and be either amazed or inspired. An instant hero to be celebrated or prophet to be adored, the guard ant would eventually be relegated to the deepest of basements—stuck among babbling, drooling ex-workers whose mental antennae had long before snapped.

Watching the formerly industrious and oblivious ants cowering in the shade of their dirt awning, I was sorry to have caused such fright with my sudden presence. They seemed as unsure and awestruck as men contemplating a cruel and vengeful God.

Straightening up, I left them, hoping that their collective memory would prove short enough to allow them to become pagans once more.

I meandered back along the dry streambed to the beach, bemused by my impressions of this quiet island. Someone else could have taken this same walk and would have seen and experienced it completely differently. One of the many benefits of exploring Baja was feeling as if Russel and I were alone in the world and that surely no one else had ever seen this particular spot in quite this way.

Back aboard *Watchfire,* we watched frigate birds swoop and dive, silhouetted against a golden sea and crimson clouds. Like the sparkling clear nights when a billion stars were visible, the tropical sunsets could always awe me to an acceptance of my insignificance but also somehow make me aware of feeling right at home. It was clear that I had been chosen by circumstance to spend this part of my life traveling on a boat, and the choice pleased me more each day.

Creative Outlets

WHEN I WAS WRITING, WHICH was more and more often as the days lengthened into summer, I found it hard to listen to my old rock faves and was happier with a daily soundtrack of what I'd formerly dismissed as "music without words." Often, I would be writing for many minutes before I realized that the composer had been stealthily working on my subconscious and that the results were coming to life on the page. It was easy to see why Russel had always painted to this kind of music, because film scores are created to set imaginations free and to evoke emotions.

Much like playing an instrument, writing skills flourish in response to frequent practice. The more I wrote, the easier it was to sit down and let whatever was brewing in my heart and mind flow out through my pen onto paper. Sometimes it was a poem, or a few lines of doggerel, as I have never pretended my poetry was of a high caliber or even very poetic. I wrote some haikus and even attempted a few sonnets, loving the way the enforced structure helped me with rhythm and meter.

One warm night, anchored in Evaristo, I lounged in the cockpit, head thrown back on a cushion, looking up at the sky. The small bay was quiet, the deep silence unbroken except for the occasional slap of a fish or the *whoosh* of a whale breathing as it hunted for dinner out in the channel. Above me, the Milky Way was brilliantly clear and

seemingly close enough to be reached, the circular arrangement of the galaxy clearer to the naked eye than I'd ever seen it before.

I called for Russel to come up and stargaze with me. He finally replied, saying he'd been looking for exactly the right music.

A few moments later, he stepped out into the cockpit.

"I think this might be a good fit."

"What is it?" I asked, straining to hear it.

"The score to *E.T.*"

That movie seemed a bit too predictable a choice, but I said nothing, simply looked up and let the music come.

John Williams' score starts with a solo flute, light and gentle, almost whimsical, but the music soon filled the space around us with sound. The minutes flew by as we too flew—rocketing into space, circling the planets, visiting the stars. The invisible orchestra played some lively pieces and heartfelt passages, all culminating in an uplifting crescendo and a simple but poignant resolution.

"That was better than a movie," I whispered, when the final sounds faded to silence and we were left in the afterglow.

He chuckled, and I saw his smile glimmer in the moonlight. He didn't have to answer, as he'd clearly discovered that long before.

* * *

As summer waned and we approached La Paz, I was writing daily, filling a series of notebooks with journaling and story ideas. I had no idea how to turn my new passion for writing into something people wanted to read. But if I wasn't able to, then what was I going to *be* when I grew up?

Floating in the middle of a desert sea, with my new life partner painting away in the cockpit each day, I found myself jealous that Russel had applied himself to one thing for so long.

He laughed when I told him that.

"Remember, I started off as a theater geek in community college, then went to film school to be a screenwriter. My first job out of UCLA was as an art director in local-access cable television. And you know the rest. . ."

Only after we met at the Old Globe in 1975 did he start doing the fabulous theater posters that led to the illustration work that became his livelihood. And the first paintings came even later.

Whew! I had some time to figure it all out. I had been acting since I was a kid, and it was logical for me to be considering a career change.

The thing I liked best about writing was the freedom to create without having to be *chosen*. I didn't need to audition. I could get up in the morning and simply write; what happened next was not my problem. Maybe I'd publish a book one day, maybe not, but writing gave me the creative outlet I needed, day after day, in a way that nothing else had in a long time. And let's face it, I was doing something pretty unusual here on our little boat that could probably be turned into some articles or essays for magazines.

When we were sailing back to La Paz from Espiritu Santo, the idea for a short story arrived in my head, complete. It was a different sort of story than I'd ever written—fictional, magical, and romantic. Anchored in La Paz I spent a couple of days writing it and rewriting it, while Russel was working on framing a few recent paintings for an impromptu art show Mort and Jane had offered to host (we couldn't legally sell any art in Mexico, but it was nice to see people's enthusiastic reactions to his paintings).

Finally, I wrote the story out as legibly as I could and gave it to Jane to read. She read it, set down the pages, and looked at me strangely.

"Has anything like this ever happened to you?"

"I wish! No, it just came to me."

"Oh," she said, "then you're a *real* writer."

A real writer. Having a person who enjoyed literary books say this to me was like getting a standing ovation—a gift you didn't think you wanted until you received it.

Starting that day, I began to expand my notebooks of ideas, vignettes, and anecdotes into stories and articles. The end of each workday filled me with a sense of accomplishment, like you get when you've painted a room or planted a garden. When you have been useful.

My mom wrote a poem that perfectly summed up this feeling. It begins:

"What a strange hobby to write words down, and sigh in satisfaction, like I'd baked bread, cleaned house, instigated action."

Maybe I am a real writer.

* * *

I'd changed my last name to Redmond without giving it much thought. Russel was a Redmond, I wanted to be a Redmond. But my full married name, Jennifer Shea Redmond, sounded like someone who should run for the Irish parliament, and I had never even set foot in Ireland. I dropped the Shea and started using Jennifer S. Redmond.

Now, contemplating the possibility that I might publish some of my stories, perhaps one day a book, I looked at Jennifer S. Redmond with a jaundiced eye. The pointless "S" made me think of Harry S. Truman.

I loved the sound of Silva, Nena's maiden name. It represented her long-ago family in Mexico and their families before them. Nena had shared her vivid childhood memories with me, of life with her father in Mexico City. The comfort and security of her little hand in his as they strolled the streets of that ancient city was as tangible to me as if I'd experienced it myself—a vision recalled each time I saw

a girl with her father at the beach or walking around the *zocalo* in La Paz. There was more to my visceral connection to this country than a story I'd heard, and my racially tangled roots were not unlike the *mestizo* culture that was Mexico itself.

My cousins Kirsten (Kiki) and Maya had both separately decided to use Silva in their professional lives. Maya because she danced and taught flamenco and had spent time in Spain. Kiki because of her graduate work in Spanish-language literature and time spent in Cuba and New Orleans. I figured the name would suit me, too.

Working on my Spanish, though I might never be fluent, I was determined to embrace the Mexican side of my heritage. Mexico had called me here, it seemed, and I could not imagine ever leaving it fully behind again. The land and its people were part of me now—in my *alma*, my soul, forever.

I was growing up to be a writer, or so I hoped. And becoming Jennifer Silva Redmond.

Time to Make a Plan
San Diego, January 7, 1989

TODAY WAS THE DAY—I WAS seeing Russel again and taking my first sail on *Watchfire*.

I'd originally planned to spend the whole weekend with Joe and Teresa, so Russel had invited the three of us to go sailing with him on Saturday. Teresa said she loved sailing, which was a relief. Joe loved being at the beach and in the water as much as the rest of our family, even if we hadn't done much sailing.

I'd tried to bring Teresa up to speed on who exactly Russel was, but finally gave up and said, "Bottom line, he's the one who got away. The guy I really loved. The man I thought I would marry. The man I would still marry, if. . ."

Both Teresa and Joe looked shocked, so I left it at that.

We drove down to Harbor Island at midday, and Russel was waiting at the gate of the marina. He led the three of us down to the dock, and I spotted *Watchfire*. The sloop's glossy navy-blue hull and tan deck was an eye-catching combo among the sea of white-on-white boats that surrounded us. Russel gave us a quick tour, explaining how he'd just recently finished the last of the big upgrades to make the little sloop seaworthy for blue-water cruising. We went below to admire the spare and tidy interior, where my height was just right for a change. Though none of the other three could stand all the way up, the top of my head cleared the ceiling.

Russel's boat neighbors Ron and Joan popped out of their sailboat to say hi, and we all chatted as Russel started the boat's outboard engine. It was clear they had been quite curious to meet me (much later, I found out that Russel had been pacing up and down the dock for an hour before we arrived, muttering about a certain young woman who he was pretty sure would turn out to be "a great deal of trouble").

Ron and Joan helped us shove off, and soon the four of us were sailing out past Tom Ham's Lighthouse into San Diego Bay. The day was sunny and windy enough to be an ideal sailing day. Joe and Teresa had only been married a year and were happy to share their hopes and dreams. Questioned about our plans, we said they were still being formulated.

"We need a plan for our Big L," Russel said, looking into my eyes as Joe and Teresa took turns steering the boat.

"We do indeed," I told him, losing myself in his sea-green eyes.

The day was a joy, full of laughter and stolen kisses, but once the boat was back in the slip, Russel and I turned down their offer to go on to dinner. It was clear that our planning session would have to turn serious quickly, as I was booked on a flight back to New York early Monday morning and the sun was already sinking in the sky.

We said goodbye in the parking lot, with a suitable amount of ribald comments when I got my luggage out of their car. Back onboard, Russel asked if I wanted anything to eat or some champagne, which he just happened to have on ice.

While he pulled out the bottle and glasses, I explored the tiny living space, poking my head up into the v-berth and checking out the hanging locker.

The cork came out of the frosty bottle with a small pop, and I asked what we were celebrating. He didn't answer, just grinned at me, and poured us each a small plastic tumbler full of bubbly.

He raised his glass and toasted. "To us being together again."

"To us!" I agreed, and we clicked glasses.

We sat side by side on the small settee, and he asked me why I had to rush back to New York on Monday. Well, there was the problem of covering my shifts at Table D'Hote, since only a handful of waiters worked in the tiny Upper East Side temple to French cuisine.

More importantly, there was my part in Jimmy's play—I was starring in our new company's first production—with rehearsals beginning next week.

He asked me what would come next, and I rambled on about what might be on the horizon and how happy I was living with Jimmy and Michael. I described their stunning apartment, complete with a baby grand in the living room.

"I'd love to see it."

"You should. You could play the piano."

"I love New York, you know, though I haven't spent much time there. An illustrator can work anywhere, and let's face it, some of the greatest artists in the world have lived and worked in that city. It would be exciting."

"You mean it? You would really leave San Diego?"

"In a heartbeat, for the right reason. With the right person." He was staring straight into my eyes. I stared back, saying nothing. My heart beat loudly in my ears.

Taking a deep breath, Russel asked what I thought about getting married.

I swallowed. "In general, I think it's a fine thing for the right couple to get married . . . or do you mean me marrying you, specifically?"

"Yes, that's what I mean. You, marrying me."

"When I tell this story one day to our grandchildren, it would sound better if I could say you got down on one knee and asked me."

He shook his head and laughed, but he got down on one knee. I set aside my glass, and he took my hand.

"Jennifer, I love you. Will you marry me?"

I looked into his eyes, feeling both stunned and perfectly at ease. Somehow, all our shared history had led us to this moment. I said yes.

The next morning, I woke up for the first time aboard *Watchfire*. Russel was still sleeping beside me, so I took in the moment, recalling every detail of the previous night.

When he opened his eyes and saw me, he smiled. I put a finger to his lips and spoke softly. "Before you say anything, if you've changed your mind, it's okay. It was still an amazing day . . . and night."

"I haven't changed my mind about any of it. I love you and I want to be wherever you are. Let's get married and live in New York."

I said yes again.

A couple of months later, on a cold and snowy March day, we sat in the aforementioned glorious apartment and looked out at the busy streets as the traffic honked and revved outside.

On a whim, I asked Russel what he would do if he could do anything, and he said he'd take me sailing on *Watchfire*. That we could sail from San Diego all the way down the coast of Baja and up into the Sea of Cortez.

The Sea of Cortez. The name was familiar to me, and it sounded perfect, clear and warm and sunny. Pulling a big atlas off the bookshelves, I sat beside him and spread open the biggest map of Mexico.

"That sounds wonderful," I said. "Tell me more."

An Unexpected Addition

LATE IN OCTOBER OF 1990, nearly one year after leaving San Diego, we were again anchored in FidePaz, this time to avoid an approaching hurricane. One night, we decided to treat ourselves to dining out at the only nearby restaurant, complete with cocktails and wine; it was dark before we were wending our way back to the dinghy through a sudden tropical rainstorm. I heard whimpering in the distance and veered off our path, tracking the faint sound through a muddy, empty lot.

"Come on," I called to Russel. "There's a dog somewhere out here."

"It's Mexico, there's a dog everywhere," he grumbled, following me reluctantly.

I stopped at a collapsed section of old sidewalk where the whimpering was loudest. Looking down into the hole, we saw a tiny, big-eyed face peering back up at us. The puppy was standing on its hind legs, already belly-deep in muddy rainwater, and scrabbling its little paws against the steep concrete slab in a vain effort to escape. I picked the pup up.

"I can't just leave it here. We'll take it home." I tucked the wet ball inside my jacket.

Russel sputtered, "But, we, why can't we just take it over to—"

"It's just for tonight, honey, I promise."

We took the orphan out of the storm and rowed back to *Watchfire*, where a warm bath and dry towels went a long way toward making her look like a small canine instead of a drowned rat. She was skinny but not starved, golden with white markings, with scrawny bowed legs and a nose long enough to fit a dog twice her size. She fell asleep as soon as we'd given her some canned wieners, which she wolfed down greedily; this proved that she would eat anything, since the reason we had them on hand is because canned hot dogs are mushy and taste awful.

The next morning, she was gamboling around the boat, cracking us up with her clumsy entrances, usually headfirst, down the companionway stairs. She ate whatever we gave her, including cold cereal and stale bread, and seemed willing to try anything, including riding in a dinghy and walking on a leash.

We'd put out an "Attention the Fleet" call on the VHF net, asking if anyone had lost a puppy, which was met by dead silence. Once ashore, we tried to locate her owner and found out that she'd been living on the grounds of the restaurant we'd had dinner at the night before. She and her mother were part of a group of street dogs who were fed daily by the restaurant's softhearted owner.

The woman came to the door of the restaurant at our knock, though it was only 10 a.m. She squinted at the three of us, looking disappointed, and said she thought the pup was the last of a litter a local female had birthed before she'd gotten her spayed. It was obvious the woman had hoped the pup scored a home, but we explained about the small boat, our upcoming travels, and the challenge of bringing a dog over international borders. She smiled and shrugged, gestured at the handful of stray dogs circling not far off, and headed back into her restaurant to start making lunch.

The pup ran over to her mother as soon as we sat her down, so we turned and walked away as fast as we could, refusing to look back. Though the front of the property was only a few feet away from the

highway everyone sped along to the airport and beyond, we figured it was as good a home as any in this neighborhood.

We returned the next day, and the scrappy little pup won our hearts with her feisty attitude. Her gruff little barks warned the world of our approach before she recognized us, and she battled tenaciously over food scraps with the bigger dogs. I'd brought table scraps just for her and fed the morsels to her one by one. The puppy licked my empty hand, then wandered over and licked Russel's hand for good measure.

Each time we came back, basically every day that week, her welcome was a little wilder, complete with happy whines, licks, and squirming leaps. Every night, lying in bed, we heard dogs howling. Each time, I wondered aloud if it was "our" puppy, and whether she was safe. Russel began to listen for her, too, but we were never able to hear her shrill yap over the sounds of the other dogs.

We had assured each other that it would be insane to bring a growing dog onto a small boat bound for foreign countries, but soon I began to question our very reasonable decision.

I had found this little being and saved her. But was she, as the ancient Chinese saying goes, now my responsibility for life? All I knew was that even the idea of leaving the tiny yellow pup behind for good was heartbreaking.

By day six, we were discussing what a big change it would make in our life to be responsible for another being on our travels. Russel pointed out how much it would constrain our future land journeys on the mainland of Mexico.

None of the cruisers we knew had dogs—a few had cats, but they were strictly inside pets, which would be impossible with a dog. We didn't even know how big the puppy would get, since no one knew which of the dogs was her father; she was small, with rather stunted legs, but she could end up corgi-sized or more like the many short-legged shepherd mixes we saw all over La Paz.

I lobbied hard for us to take the pup. My argument began to be why *shouldn't* we have a dog? Russel came back with very good reasons why not, including the cost of veterinary care and the difficulty of finding dog food in Central America (packaged kibble was rare in Baja, at the time, and many people bought large bags of Milk-Bones instead). He was also becoming familiar with the many rules for entering new countries that would be coming up as we journeyed south to the Canal and predicted it would be a major hassle to add a dog. Costa Rica's customs information said any pets brought ashore would *be destroyed*. Boy, were they strict.

I argued that people all over the Americas had dogs that surely ate *something*, that not every dog had any serious health issues, and that the legal problems were sure to get resolved if we cared enough to try. It had to work out. My hearing her, our finding her that night, was meant to be, after all.

Russel shook his head, growling about not being able to make any headway against my completely unrealistic cosmic outlook.

The next day we were lying out by the pool at Mort and Jane's, basking under the clear blue sky, taking a break from going around, once more, about the pros and cons of adopting the puppy.

I was biding my time and biting my tongue. Lying quietly on a lounge chair, my mind raced as I searched for a new opening.

Russel sighed and turned to me, asking, "How long do dogs live, anyway?"

My breath caught, and I swallowed, heart pounding.

"It's hard to say, at least twelve years, maybe as much as fifteen or sixteen."

He sighed again and nodded up at the clear blue sky, seeming to see that entire expanse of time unrolling before his eyes.

I smiled to myself. The tide had turned.

That afternoon, we began planning what to do to prepare ourselves, our small boat, *and* the pup for life onboard together.

The owner of the restaurant was overjoyed when we said we were going to adopt the puppy and take her along with us. As a "puppy shower present," she treated us to all the puppy shots as well as driving us into town to the vet for a check-up. The little yellow pup was examined, dewormed, vaccinated, and given a clean *carte de salud* or bill of health, a necessity for travel to other countries. The report stated our new dog was officially a *criollo* (mixed breed), the color of miel (honey). Like a honeymoon!

We had a hard time picking a name, as she was a funny-looking tomboy sort of dog, hardly a cute little Fluffy or Fifi. Then we thought of *Travels with Charley* by John Steinbeck, and Charlie sounded just right. Russel and I had read the book together, and the concept fit us perfectly.

We brought her to Mort and Jane's, and she managed to make friends with Maggie and the cat, which boded well for her social skills. She ate bowl after bowl of Maggie's dwindling supply of kibble, which Jane brought back in carloads from the States.

Back on the boat, Charlie fit right in. Early morning and evening walks became part of our daily schedule. She quickly learned all the no-nos of boat-dog behavior and was a constant amusement as she chased sand flies and the shadows of gulls around the cockpit and up on deck.

Charlie's first week aboard ended with lots of rainy weather and some thunderstorms as Hurricane Trudy passed by Socorro Island off the Pacific coast of Baja, also known as *way* too close to us for comfort. It never made landfall, so we were spared 115 knots of wind, but we got plenty of unsettled weather.

We had been joined in the little anchorage by a couple of other cruising sailboats, as the completely enclosed man-made harbor of FidePaz beat being at anchor out in La Paz harbor in a hurricane by a long shot. We'd rowed extra lines over to the shore and tied them off until *Watchfire* looked like a big fly caught in a spider's web.

Since she was so newly "boat trained," Charlie stayed aboard when we dinghied 100 feet over to visit our friends Kopi and Dean on their boat *Martha Rose*. Their teenage son Fritz took us out for a spin on his handmade skiff, named *On the Fritz*, and Charlie calmly watched all the excitement from behind our lifeline netting and didn't howl at all when we stayed for an early dinner. When we worried out loud to the three of them about all the things that could go wrong with having a dog on our future travels, Fritz advised us to "Quit your geezing!"

Not wanting to be geezers, we did.

Our last afternoon at the anchorage was still rainy, but I needed one final trip to the grocery store to stock up on fresh fruit and veggies for our trip to the mainland. I walked over, having arranged with Russel to pick me up at the grocery store an hour later in Mort's truck. At the appointed time I stood outside the store under the awning with a full basket of groceries.

He pulled up at the supermarket sopping wet, with the tiny pup looking again like a wet rat, wrapped in a towel beside him. The story turned out to be short and wet, too. He'd been afraid to leave her on the boat, as it was pouring, and he thought she'd be scared all alone, so he put her in the dinghy with him. But when Charlie saw she was being rowed away from *Watchfire* into the rainy bay, she leapt out, trying to get back to the safety of her new home. Her swimming skills were poor, and Russel had to dive from the dinghy, fully clothed, into the bay and pluck her out of the dark waters.

I managed not to laugh at their woebegone expressions, and kept my own expression fairly serious, but inside I was overjoyed. After all, *he* had rescued our little orphan puppy this time, so I knew Charlie was ours for good.

Our family had begun.

Transitioning and Transiting

MY PILGRIMAGE TO AN ANCIENT city began haphazardly. Russel and I were headed back to where art meets commerce—New York City, via the Panama Canal. After crossing the Sea of Cortez, we spent Thanksgiving in Puerto Vallarta and Christmas in Zihuatanejo. Then we sailed south along the mainland, ghosting along day and night with only our big, colorful drifter up in the light but steady offshore breeze.

The famed Gold Coast was beautiful in a wholly different tropical way, but each harbor was busier than the last, their high-rise hotels and crowded beaches seeming a world away from Baja. South of Acapulco we sailed into Puerto Angel, a quiet fishing village whose bay was roomy and calm, with quite a few cruising boats in it.

Consulting our map, we saw one of the grand old colonial cities of Mexico was quite close by. Just beyond the coastal mountains lay Oaxaca, famed for its beauty and for the nearby ruins of Monte Alban. Some new friends in the anchorage offered to keep Charlie for us so that we could journey there by bus. We hadn't seen any of Mexico's pre-Columbian treasures, so we planned to end our inland trip with a day at the ruins.

A week later, we watched the stately buildings and tree-lined boulevards of Oaxaca slowly give way to fields and hills. For two days

we'd strolled the streets, listened to music in the plaza, and browsed through the shops. Now it was time to see the ruins of Monte Alban.

The ride took two hours because of a traffic jam at the edge of town. Our stalled bus sat there, gridlocked, its windows wide open to the warm air, diesel smoke, and blaring horns, its seats filled with impatient travelers from all over the world, carping in their native tongues about the delay. Beside us was another bus, returning from the morning market with crates, bushels, and livestock strapped, tied, and balanced upon it. A goat stood upon the roof, bleating piteously as the slow minutes ticked past, and I began to wonder if we'd made a mistake.

Finally, the cars all began to move, and soon we were speeding up a winding road as the driver tried to make up for lost time. At the top of the mountain, we descended slightly into a verdant plateau, and the bus rumbled over to a dirt parking lot at the base of a grassy hill. The driver directed us up to the site's information center, where a guide gave us maps and told us not to buy anything from the vendors who would approach us in the ruins, hidden from sight beyond yet another steeply sloping hillside. Glad to be out of the bus, Russel and I quickly headed up the hill and were somewhat winded by the time we reached the summit.

We were standing atop the outer walls of a stone city; we'd been climbing the sides of its fortifications. Tall stone walls marched away before us, encompassing a vast expanse of grass, crisscrossed by walls and walkways and dotted with the shells of ancient buildings. The walls joined again, many hundreds of yards distant, at the base of an immense pyramid as high as the one upon whose base we now stood.

It was cooler up here, and a breeze lifted the hair off my sweaty brow. Far away were blue-gray mountains, some with icings of snow on their peaks, ringing the high green valley that surrounded us. Beyond the mountain ranges were white banks of cloud, which

seemed held in place there, for above us the sky was as blue as some celestial sea.

Without speaking, Russel and I clasped hands and walked through a narrow stone gate toward the center of the pyramid, then turned and began to climb the steep stairs. Each of the steps had a slight dip at its center, where generations of holy men, soldiers, prisoners, and slaves had placed their sandaled, booted, or bare feet while ascending the awesome giant.

Silently, we stepped up and up, our shoes making no sound on the stone, the voices of people behind us falling away as we climbed higher. Even with the altitude and the steepness of the stairs, my breath came easily, but my head and chest seemed to lighten with each step until, at the top, I was almost faint. Turning to survey the scene spread before us, I sank down upon a slab of rock whose surface had seen offerings long before written history.

Below us, the two dozen other visitors had dispersed into the immensity of the grounds, their tiny forms nearly lost among the low walls and tall grasses. One family was climbing the staircase toward us, and when they had nearly reached the top, we gave up our spot and headed back down. When Russel and I passed the others, we noticed that their conversations were hushed and reverential. In fact, there was little sound at all as people climbed and wandered about, and none of the calling and shouting that often accompanies large groups out of doors. Even the children seemed overwhelmed and stood quietly staring, clearly struck by the site's awesome scale.

We walked wide pathways of gray rock between high walls and above ledges, pausing to examine the intricate carvings and cunningly laid stonework at every turn. Plazas and boulevards, courtyards and playing fields were ruined or overgrown, but even ringed as they were with tumbledown stone fences, the grand design was abundantly clear. It had been a city of open markets and meeting halls, but one where private spaces could be found for quiet contemplation

or conversation. It was eerie to stand alone in the middle of a huge central mall that once teemed with vendors and shoppers, its stalls full of colorful fruits and vegetables. Sitting on the raked stone bleachers that overlooked the ball court, I could easily imagine its stands filled with spectators joyously cheering on their favorite athletes.

During the bus ride, I'd read a pamphlet that conveyed the little that was known about Monte Alban. It was inhabited by the Olmecs, Zapotecs, and Mixtecs, though perhaps other peoples that modern scientists have not yet named had lived here as well, earlier than those we can prove or between those generations we know of. No one was sure of how the incredible structures were built, by whom, and, chiefly, when and why the original inhabitants left. Also unknown was the meaning of some of the bas-relief carvings of people on the inner walls; they look like dancers but are believed to be diagrams of physical ailments or maladies for future physicians' reference.

All these facts circled inside my head like the eagles that flew high in the vault of blue above me. None of it meant anything as I gazed unseeingly at the sky, feeling my pulse race with more than exertion. This place had all the mystery of Stonehenge and Easter Island, but there was more here than that. This had been a city, and it still felt populated. Not with history, but with life. Living people, families, had lived in these rooms, walked these paths, watched games played on these ball courts.

And they worshipped here, certainly, as well. Brought wine, corn, or cattle, and yes, undoubtedly, human beings—the chosen ones whose blood would spill for the pleasure of the gods. We can't begin to understand why they believed as they did, but that this was a temple to the gods those people chose to worship, there seems little question.

I have been to many churches and cathedrals in my life, some modern, some hundreds of years old. Only a few of them have the

simple, wondrous quality of a holy space: a peaceful, serene quiet, and a sense, even when the buildings themselves are empty, of fullness. I've always believed that feeling comes from the quality of the time spent there, in individual and group prayer, at weddings, christenings, and funerals, over years. Many years of love and belief, of faith, can permeate a physical place, whether it be an illustrated mountain cave or a soaring Gothic cathedral, and persist long after its inhabitants are gone. This ancient vessel of a city, hewn by hand from native stone high in the mountains of Mexico, had been full for centuries and felt holy.

I saw no visions at Monte Alban; no heavenly voices spoke to me; and I didn't feel the need to pray or leave offerings. There was no primal urge to research and delineate my family's complex genealogy, though the blood of some of the city's former inhabitants may run through my veins, passed down from Nena to my mom.

But something did happen to me there, an epiphany both unexpected and ephemeral. Standing on those centuries-old stones with the wind of that timeless valley in my hair, I saw that humans had created all of this, not just to be a part of something great but to aspire to something greater. They carved beautiful designs into solid rock and built their majestic temple as far into the sky as they could, and then they worked, played, worshiped, and danced in the shadow of it. It was stunningly clear to me at that moment, because the stones they laid are still there to prove it.

Not long after that inland trip, Russel and I motored *Watchfire* into the first of the massive locks that make up the Panama Canal. That first locking-through was so full of things to attend to that the physicality of the Canal didn't sink in, past *whoa, this is big*.

After the second lock, we began to relax, confident in the handling of our boat by the adept (and mandatory) hired captain and line-handlers. Moving into the last of the Pacific-side locks, I was finally

able to look around and appreciate the labor that had gone into this modern wonder of the world.

High atop sheer cliffs of cement that lined the sides of the lock, small figures made us fast to the massive cleats. Charlie followed my line of sight, spotted the people, and barked. I laughed, and she relaxed, tongue lolling, happy to have warned off the intruders. The water level quickly rose in the immense square vat until it was full, half salt and half fresh. Then came the grinding of the monstrous gears as the immense doors slowly parted to reveal a waterway, a channel cut by human hands through the lush jungle and earth of a continent to join two oceans.

As we moved out into the canal, between the cliffs of red clay, I was again struck by the ability of humans to conceive of an incredible goal and make it a reality. Perhaps that is why people journey to pyramids, aqueducts, cathedrals, and bridges, to catacombs deep below the ground, great temples in the middle of vast deserts, and statues or shrines carved from solid rock atop towering peaks. Seeing and even touching the wood, steel, or granite engenders a response that resounds within us. If this tremendous undertaking could be realized, what task cannot? If faith could build this monument, belief this city, determination that bridge, there is nothing, then, that humans cannot achieve.

That being so, we two could surely fashion our own unique relation-*ship* aboard this boat, and continue to create our art, and our life, together.

I grinned over at my husband, holding the tiller lightly as *Watchfire* was pulled along through the waterway, still safely bound to the boats beside us. Russel caught my eye and beamed. The voyage was far from over, but we shared a thrilling moment of completion, of achievement, of joy.

Fifteen years earlier, we'd been two strangers among a crowd of hopeful actors, in the rehearsal room of an old wooden theater,

set in a vast green park not far from the Mexican border, near the sea. United at last, many years later, we'd taken off from San Diego, untying the dock lines and stepping off into the Pacific on our small boat. But, in fact, we had taken the first step of our journey in New York, huddled together as the dirty snow fell outside the windows, leaning over a map of Mexico like it was a crackling fire, warmed by dreams of our future together.

AFTERWORD
A Simple Life
Port Townsend, Washington, August 2023

THOREAU ONCE WROTE THAT WE must *Simplify, simplify, simplify.* (When I read this to him, Russel quipped that if the guy truly embraced simplicity, he should have only said it *once.*) At Walden Pond, Thoreau learned that it takes time and concentration to simply *be.* That the more we simplify life, the easier it becomes to pause, to look, to listen.

When I can manage to do this, there is so much to see, hear, and appreciate. The lesson of the pared-down life turns out to be learned not from what we do without but from what we keep, much of which are not things at all. No-thing is not *nothing.* In fact, when you give up things that don't fit into your life, you discover the ones that truly do. These chosen items not only mean something, they do something—make you smile or cry, encourage you, or remind you who you are.

The simplification process turns out to be addictive as well as exhilarating. Each object discarded hastens my progress and lightens my load, like the sacks of sand cut from an ascending hot-air balloon. And there's another unexpected benefit of life on a small boat, not only knowing what I have, but most of the time where to find it.

Whether one is holed up in a woodsy cabin by a pond or at sea on a small boat, no way of living guarantees simplicity. The choice of an ascetic life in a Zen monastery seems a bit extreme; I aim for

living a consciously simpler life and for *enjoying* it. Objects aren't evil, as long as we're aware of their true value, or lack of it, in our lives. And the process may be what matters most. Trying, as Thoreau put it, to live *deliberately*.

My love of reading and writing always meant stacks of books and papers; in Mexico I added shells and other natural tchotchkes. Tossing out a shell for every one I brought aboard, I also left as many paperbacks as I borrowed. Today, both of our libraries are digital and stored in the cloud, so our boat's shelves contain only those works that benefit from physical pages: a knot book, a manual, some guidebooks to the San Juan and Gulf Islands, a first aid book for boaters, and a cookbook or two.

With the Sea of Cortez as my backyard, I never had to worry about being entertained. I loved living by the ocean and could spend hours beachcombing or floating mere inches above a reef, happily watching the inhabitants inhabit it. That was true of our time sailing in Florida and on the Intracoastal Waterway along the Gulf of Mexico, on the last glorious leg of the honeymoon journey that began with our first trip south to Baja.

In 1993, we trucked *Watchfire* from Houston back to San Diego, where I went to work and Russel concentrated on stretching, framing, and selling his paintings. Jimmy's mom and her husband fell in love with Russel's art and purchased at least one painting a year for years; they now have the largest collection of his artwork in the world.

Jimmy died of AIDS on December 1st, 1993. Thanks to his mother's generosity, I was able to be with him when he died, along with Michael and another close friend. It was one of the most beautiful experiences of my life, though I miss Jimmy to this day. In addition to his humor and heart and kindness, I regret that the world won't get to see more of his witty and insightful plays, as only one was published by Samuel French.

Russel and I sailed *Watchfire* back down to Baja in 1996, and in 1997 we got pregnant, the first time we tried. We drove our VW bus up to San Diego for a big family reunion, and while we were there, I had a miscarriage. Surrounded by a loving family, I rallied and enjoyed cuddling our newest niece, the adorable Emma. Back on the boat in Baja, we decided to wait before trying to conceive again, and we happily wrote, painted, and appreciated the beauty of our surroundings for another three years.

Thanks to my editor dad, two of my essays were published in *Science of Mind* magazine, then I got articles published in *Sail* and *Cruising World*, and even sold Charlie's story to *Dog Fancy*. Writing, editing, and marketing three annual issues of *The Sea of Cortez Review*—an anthology of Baja writing we founded, illuminated by Russel's drawings and paintings—led me to Sunbelt Publications, a small press in San Diego, where I worked from 2000 to 2011, eventually working my way up to editor-in-chief.

During those years, Nena, Grandpa Jim, and Alice Redmond all left us, with Russel's mom sharp to the end, at ninety-five. We lost Charlie to cancer at twelve years old, ancient for a Baja street dog. On the positive side, Russel kept painting and began teaching screenwriting, and we wrote two screenplays together. I started a writers' group with a friend from Sunbelt and Diane, my mom; our core group of seven became like family, and Diane loved having younger people to share her writing with.

The original *Watchfire* burned to a pile of ashes in 2003, when the Cedar Fire engulfed a friend's backcountry property where we were living, so Russel and I briefly lived and traveled about in our RV. After *Watchfire 2* was purchased in 2004, Russel spent many years working on boat upgrades and improvements before and after days spent teaching. I helped with boat work, did some writing and editing, and enjoyed spending time with my family, including our lively new niece, Beth.

Our own plans to start a family, put on hold after our return to San Diego in 2000, were postponed repeatedly. Then a serious car accident resulted in years of back pain for me, and by the time my body was fully recovered, that door had closed. Staying creative in other ways, I started teaching at San Diego Writers, Ink, and the Southern California Writers' Conference, where I found my tribe. When I began blogging, I took one of Russel's nicknames for me, Jenny Redbug (taken from my unpublished children's story about a ladybug named Redbug) for my site, jennyredbug.com.

Russel and I spent our summers cruising the coast of California from 2011 to 2015, though we skipped a season when Diane had a stroke. When she was diagnosed with dementia, the two of us stepped in as caregivers and eventually housemates. My family and mom's friends pitched in to help us out, and stayed in her life to the end, especially Carol, Peter, Reverend Jonathan, and our playwright friend Janet Tiger.

All of us gathered to celebrate her memorial, a sunny and joyful event in Balboa Park, where Joe, John, and I led the group in singing our mother's favorite show tunes.

Our loving family thrives and continues to expand. Erin, Emma, and Beth all embrace their crazy Aunt Jenny and Uncle Russel, and our far-flung family spends as much time together as our traveling life allows. My dad is entering his tenth decade gracefully in Thailand, where he walks and swims daily. Jerry Redmond's son Michael married the intrepid Kate, as eager to sail the seas as he is, so now we have another niece and another sailboat to visit. Our great nephew Milo has recently become a forest-firefighter, perfectly rounding out this adventurous family.

Russel and I began our latest adventure in San Diego, sailing north in June of 2020, with a long stop in the San Francisco Bay area, and thence to Washington, where we are cruising Puget Sound for the second summer. We joined the welcoming Port Townsend

Yacht Club, and found *Watchfire* a semi-permanent berth nearby, where our view includes the Olympic range to the west and, on a clear day, the Cascades to the east.

May of 2023 marked thirty-four years of marriage for the peripatetic Redmonds, and all but a couple of those years were spent aboard a sailboat.

Despite all our practice, it still takes daily effort to live a simple life, to limit the number of items that are supposed to enhance our lives and instead distract us from experiencing it.

What we do possess I truly love: a snug and sturdy boat with just the right amount of room for two determined and loving people and a small mixed-breed dog, plus enough solar power for lights, refrigeration, music, work, and communication.

We can travel lightly in our world, for there is plenty here.

ACKNOWLEDGMENTS

MY FIRST AND LAST GRATITUDE is to my parents, who taught me to love reading and writing. They read a lot. They read widely. Most importantly, they *never forbid us to read any book*. My mother, who taught me how to love and be a good friend, also set an example by writing, almost daily, all my life. My father limits his writing to emails, but he was an eagle-eyed copy editor for years, no doubt inspiring me to become an editor.

To my brothers, Joe and Jack, who are both talented writers and teachers, I am grateful for your ad hoc parenting of me, always leavened with plenty of humor. I'm so glad we're willing to work at staying close through all mediums; our exchanges began with great letters, and live on through calls, texts, emails, and even Wordle. I also treasure your feedback on this book and my other writing.

To my teachers, including Ruth Glatt, Janet Martin, Drusilla Campbell, and Warren Robertson, you all touched my life in profound ways, and your wisdom resounds daily. Thanks to Carra Robertson for taking such good care of your dad. Diana and Lowell Lindsay were teachers, too, along with being my bosses and friends. Thanks to Kathy Wise, Laurel Miller, and Leah Cooper, for showing me how to make beautiful books.

To the women of my Writers Circle, you have my deepest gratitude. Not only my support system, you are my closest friends

and compatriots. You have listened to so much of this book and all my other projects and always brought enthusiasm, encouragement, and incisive feedback. Thank you, Lisa, Kara, Maria, Carol, and Laurie—extra thanks to Lisa, for helping me find the courage to become a freelancer and to Kara for being my first true Beta reader of this memoir—your questions and insights helped me make it stronger.

To the Southern California Writers' conference, especially Michael Steven Gregory, Wes Albers, Janis Thomas, Melanie Hooks, Laura Perkins, Cherie Kephart, and Rick and Linda Ochocki. You helped me find my tribe, and gave me a place to teach and to learn; I plan to keep at it as long as you'll let me. To my pitch witch partner Marla Miller, thanks for your great ear, always, and the helpful hint about this book's prologue.

To my editing clients who've become friends, I value your trust in me and love helping you make your fine books even better—Gayle Carline, Claudia Whitsitt, Richard Carrico, R.D. Kardon, Clay Savage, Dominic Carrillo, Jeanine Kitchel, Eric Peterson, Jasmin Iolani Hakes, and Leslie Johansen Nack—get their books, you'll be glad you did. To Gayle, thanks for your great feedback on the other memoir; Laurie Gibson and Leslie, thanks for your ongoing marketing help.

To Kristen and the staff of San Diego Writers, Ink, I remain in awe of your ability to keep the dream alive, to share knowledge so widely and well for so many years now. That leads me to the founder of San Diego Writers, Ink—my friend, client, and teacher Judy Reeves, thank you for being a mentor and inspiration to so many writers, including my mom and me.

Thanks to my other writer friends from long ago, Helen Landalf and Michael Milton, who continue to be helpful and loving readers.

Thanks to all our friends who shared their lovely homes and boats with the traveling Redmonds: Lurah and David, Dennis

and Paula, Jim and Suzy, Andy and Becky, Paul, Timo and Debby, Nancy, Aaron and Monica, Laurel and Andy, Mac and Mary, Pat and Connie, Don and Ellen, Diana and Lowell, Ron and Joan, Tom and Phyllis, Mary Lou and Chip, Mary and Monte, Joni, Erin and Tom, John and Deb, Dave and Pat, Allie and Bill, Eric and Teresa, Helen and Steven, Kiki and Rod. And, last but definitely not least, Neil and Brad, who kindly let us pretend that Blisters was our fabulous poolside Palm Springs vacation home, too, for so many wonderful years.

To Luis Alberto Urrea, Harry Crosby, Judy Botello, Daniel Reveles, Graham Mackintosh, Ann Hazard, Bruce Berger, Greg Niemann, and C.M. Mayo, thank you for sharing Baja California's magic with so many in your books. You inspired me to attempt to join your ranks. And much gratitude to Ann Patchett and Cheryl Strayed, neither of whom I know (yet) and whose memoirs were such an inspiration to me.

To Jerry, Michael, and Kate Redmond, thanks for being the greatest second family a gal could ever want.

To the wonderful Shea/Chafe/Gruesz/O'Shea/Silva family—Teresa, Emma, Beth, Kiki, Carl, Cheryle, Dave, Maya, Alishanee, Erin, and Milo—thanks for all of the shared love, meals, walks, and laughs.

To my editor, Deanna McFadden, thank you for showing me how great it is to be on the other side of the editing process, when you're in good hands. And to my publisher, Rebecca Eckler, thank you so much for loving my submitted manuscript and not being able to get it out of your mind.

And, of course, again, to Russel. For the talks, the joy, and all the laughter.